IMAGES
of America

POINT SUR

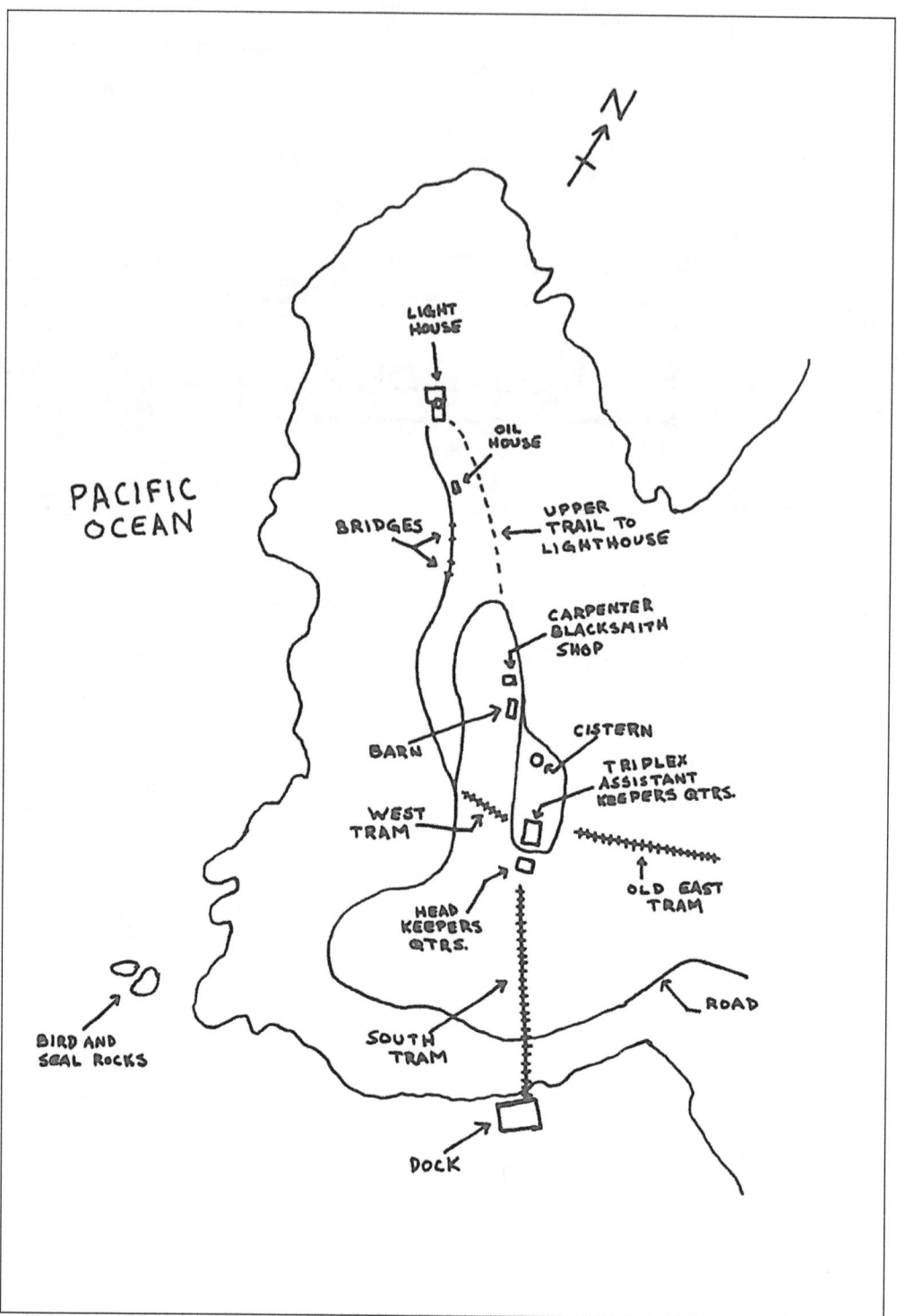

This is a sketch map of the Point Sur Lightstation, showing the locations of buildings and the historic hoist trams.

IMAGES of America
POINT SUR

Carol O'Neil

Copyright © 2003 by Carol O'Neil
ISBN 978-1-5316-1441-6

Published by Arcadia Publishing
Charleston, South Carolina

Library of Congress Catalog Card Number: 2003101679

For all general information contact Arcadia Publishing at:
Telephone 843-853-2070
Fax 843-853-0044
E-mail sales@arcadiapublishing.com
For customer service and orders:
Toll-Free 1-888-313-2665

Visit us on the Internet at www.arcadiapublishing.com

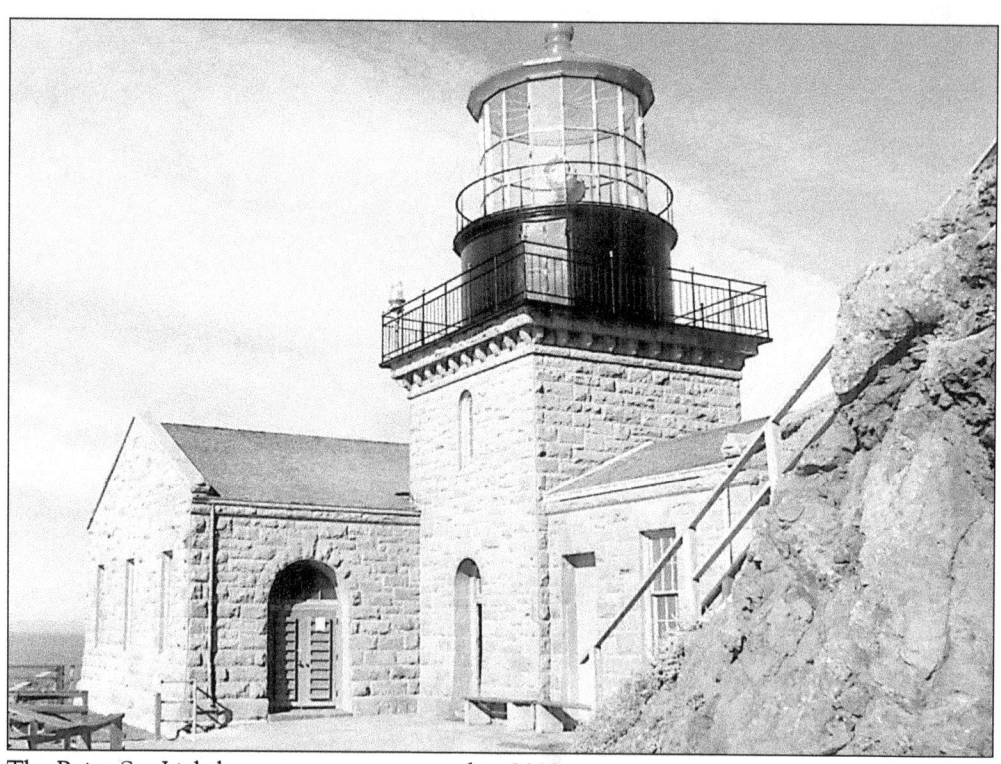
The Point Sur Lighthouse tower was restored in 2000.

Contents

Acknowledgments		6
Introduction		7
1.	Before 1900	9
2.	Supply Landings	17
3.	Fighting the Rock	39
4.	Water	51
5.	The Lighthouse	61
6.	Road Building	79
7.	1945 and Later	95
8.	The People of Point Sur	107

Acknowledgments

This history of Point Sur through its images could only be accomplished with the help of my fellow volunteers. Alan Rosen spent considerable time at the Coast Guard Archives in Washington, D.C. copying their extensive photographic collection of Point Sur, while Mike Baker has archived and documented all of the photographs in the Point Sur collection. This was a huge task. Anyone who uses a Point Sur photograph should be grateful to Mike, who is also a fount of arcane bits of Point Sur history. He helps make sure we "get it right."

This effort has been fortunate to receive photographs from several families who lived at Point Sur. Elsie Goff, Dorothy Delcenio, the late George Henderson and his wife Norma, Harry Miller, and Wally Stasek all have provided photographs in this collection. Jeannette Mollering donated a copy of the Point Sur School 1930 Yearbook, which gave us an insight into the little schoolhouse atop the rock. Betty Hoggerheiden's Aunt Ethel's 1890s letters provide a behind-the-scenes look at early Point Sur. Don Nelson's stories of his grandfather's family of early keepers and Jeff Norman's tales of early Big Sur are important to the tapestry that is Point Sur. Alpha Anderson, Bob Brown, and Mike O'Neill helped us understand the post-World War II years at Point Sur.

Most of all, I am grateful to Kathleen Williams who edits, gently and well. And, of course, I am grateful to my husband, John, who helped keep the facts straight, the grammar right, and the computer available while I finished this project.

Introduction

Point Sur, a rock formation that juts into the Pacific Ocean along California's Central Coast, was a landmark even before it had a name. Referred to as a "moro" rock by the Spanish explorers, it was first mentioned in the logs of Juan Cabrillo in 1552. Other explorers followed, including a mapping expedition under the command of Sebastian Viscaino in the early 1600s. Viscaino's map of 1603 identifies Point Sur as a "Punta que parce isla" or a "point which appears as an island." Almost two centuries later in 1793, British explorer George Vancouver described the still un-named rock formation as a "small, high, rocky lump of land lying nearly half a mile from the shore."

Meanwhile, Spanish missionaries were expanding their string of missions along the length of California. In 1770 and 1771, a presidio chapel in Monterey and a mission in Carmel were established on the Monterey Peninsula. The land to the south of these outposts was called "El Pais Grande del Sur" or "the Big Land to the South," which today has been corrupted into the familiar "Big Sur." A large Mexican land grant, including the moro rock, was made to Juan Bautista Alvarado, a future governor of Alta (Mexican) California, in 1834. He named his holdings "Rancho El Sur," and the ranch was traded to his uncle John Cooper eight years later.

The discovery of gold in 1849 changed everything in California. People poured into the territory, which had become the property of the United States in 1846. By 1850, California had changed from a sleepy territorial Mexican outpost to a bustling state with a booming population and almost no infrastructure. A survey of the coast was ordered and carried out by the Navy in the early 1850s. The moro rock was now referred to as "Point Sur," taking its name from the surrounding rancho. The point was identified as a "good mark for vessels" and a sketch was included on a coast map. It wasn't until 1866 that Point Sur was officially set aside for a future lighthouse. Coincidentally (or perhaps not) 1866 was also the same year that the deed for John Cooper's original Mexican land grant was certified by the United States government.

Topographic examinations of Point Sur noted its steep slopes and lack of level land for locating structures. Building a lighthouse on this isolated site would be difficult and expensive. A detailed topographic map was prepared in 1875, but it wasn't until the wreck of the steamer *Ventura* nearby, during the same year, that the public began to clamor for some kind of lighthouse. From 1877 until 1885, the Lighthouse Board annually requested funding for building a lighthouse at Point Sur. Congress finally made an appropriation in 1886 and construction began in 1887. Funding ran out and construction stopped for several months until a new appropriation could be made. The buildings were finished in 1889 and the light in the tower officially lit on

August 1, 1889. The light at Point Sur has been in continuous operation as an aid to navigation ever since.

The story of Point Sur Lightstation is both typical of most west coast lightstations but also unique to its place along the coast in the remote Big Sur area. Many lightstations used hoist railways to move equipment and supplies. They had keeper quarters and families. However, Point Sur was a large rock located a half mile from "real land" with only a sand bar to connect them. Construction of buildings was difficult, roads were expensive to build and maintain, rock slides were a constant problem, and it was dangerous to deliver supplies. The keepers of the light and their families lived without modern conveniences long after their contemporaries were enjoying indoor plumbing and electric lights. Meanwhile, the most advanced technologies were employed to keep the light and the fog signal operating. When labor became more expensive than the technologies to run it, the station was automated and the keepers left forever in 1972.

In 1984, the Coast Guard turned over most of its lightstation buildings to the California Department of Parks and Recreation. The Coast Guard retained ownership of the lighthouse, oil house, and 1945 mess hall. In 1987, volunteers began giving tours at Point Sur State Historic Park. The Central Coast Lighthouse Keepers (CCLK) was formed in 1993 as a co-operating nonprofit for Point Sur to assist the state in funding projects there. In addition to helping state parks fund restorations of the carpenter-blacksmith shop, the barn, the garage, and reconstructing the water tower, CCLK was the primary funding source for two large restoration projects on the Coast Guard-owned Lighthouse. Restoration will continue at Point Sur until all the buildings are restored to the style of the late 1920s. The Lighthouse and other Coast Guard-owned buildings are in the process of being officially incorporated into Point Sur State Historic Park.

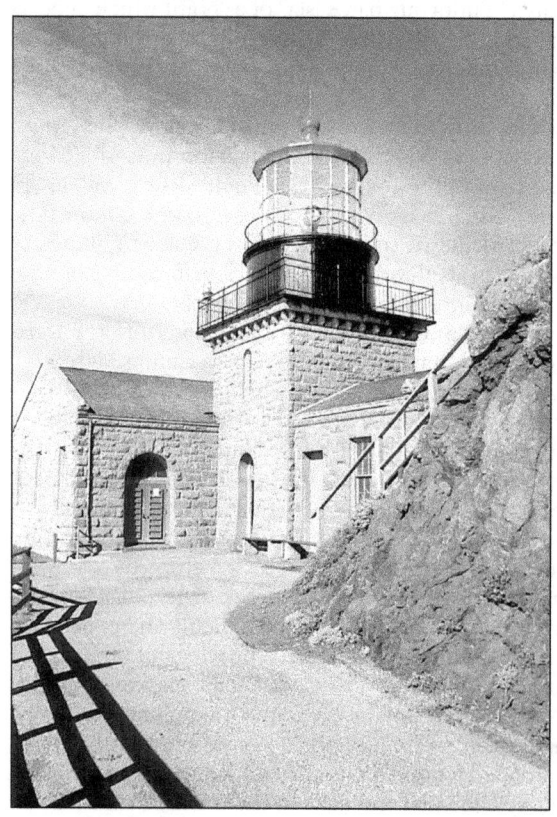

The light at Point Sur is still an active aid to navigation. Its light is located at 270 feet above sea level and emits a flash every 15 seconds.

One
BEFORE 1900

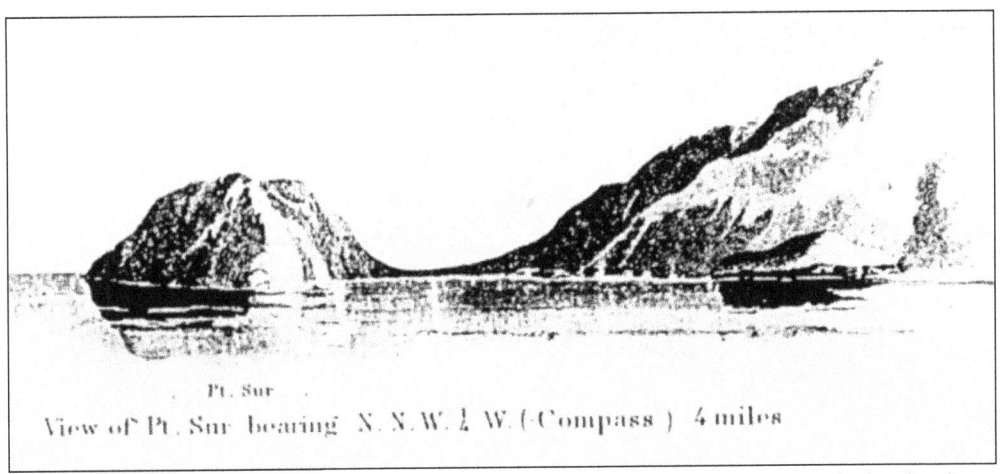

Point Sur Lightstation, 26 miles south of Monterey, sits atop a giant "moro" rock that has been a landmark for mariners since the earliest days of the Spanish explorers. Visible for 10 miles at sea, the rock was first sighted by Juan Cabrillo in 1542. Viscaino described it on his 1602 map as "a point that appears as an island," while British explorer George Vancouver described it as a "small, high, rocky lump of land lying nearly half a mile from the shore." Drawn before lightstation construction began in 1887, this rare image of Point Sur, showing a view from the south, is from an 1853 map drawn during the deployment of a Navy Hydrographic Party under the command of Lt. James Alden. Alden's naval party surveyed the coast of California, which had just joined the Union in 1850. (Courtesy U.S. Coast Guard.)

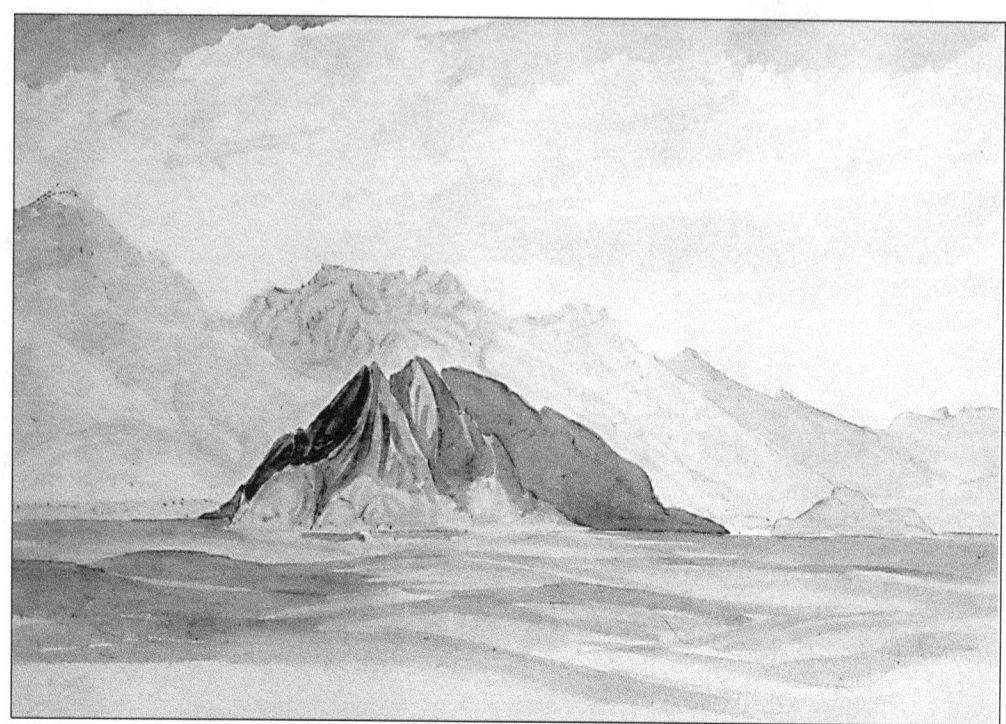

Lieutenant Alden, U.S. Navy, was an accomplished watercolorist and rendered this picture of Point Sur, labeling it "El Sur, Cali. June 14. 1859. (1:00 p.m.), East." Along with the map drawing on the previous page, they are the only known images of Point Sur created before the rock was altered for construction of the lightstation, which was begun in 1887. This view is from the ocean. (Courtesy California Historical Society, gift of Henry R. Wagner.)

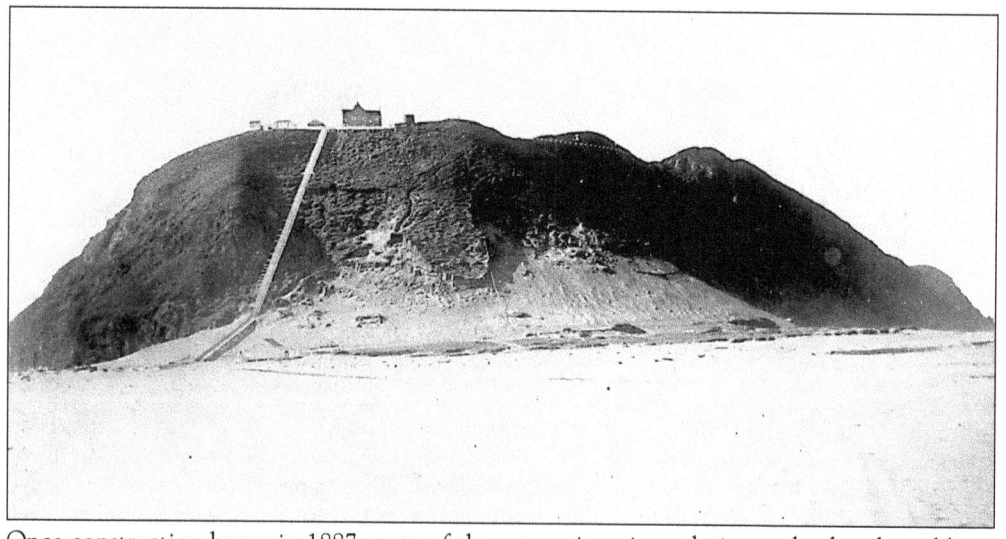

Once construction began in 1887, state-of-the-art engineering solutions solved such problems as the remote location and hauling construction supplies up a steep 360-foot grade. A corduroy road over the sand flats brought supplies from the landing at the mouth of Big Sur River, three miles away. Notice the flat top of the rock. (Courtesy Herbert Bamber, U.S. Light-House Establishment photo.)

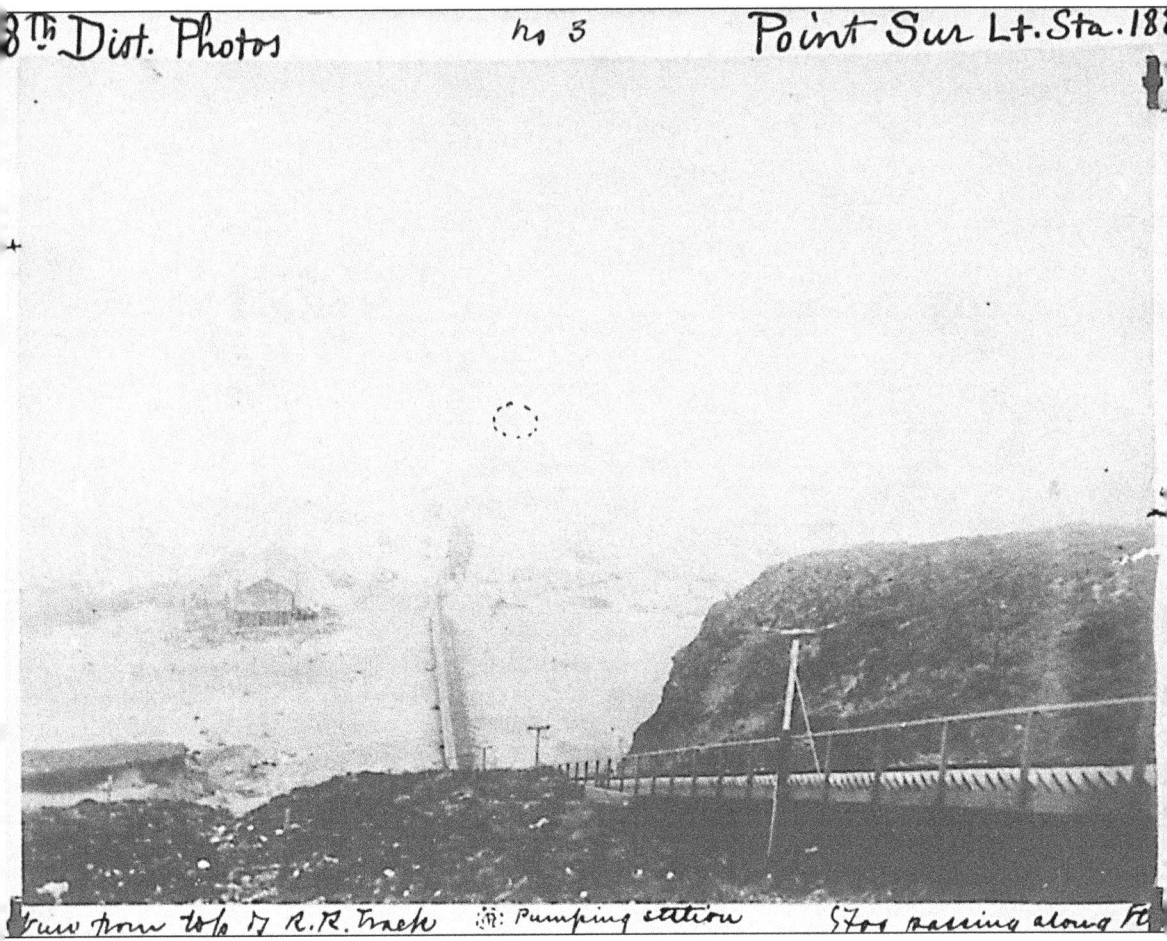

A hoist railway up the east face of the rock, across the top, halfway down the west (or ocean) face, then horizontally north across the west face of the rock, brought building supplies to the lighthouse. The hoist railway was later used to haul supplies, everything from coal and potatoes for the keepers to wood and kerosene for the light and fog signal. In 1889, just after the light was put in service on August 1, four photographs were taken at Point Sur. This one looks down the railway toward the east. Handwritten captions around the picture, starting on the left and going below the picture, read as follows: corduroy road, view from top of R.R. track, Barn, R (in dotted circle) pumping station, fog passing along far hills, sea reach handrail. (Courtesy U.S. Archives.)

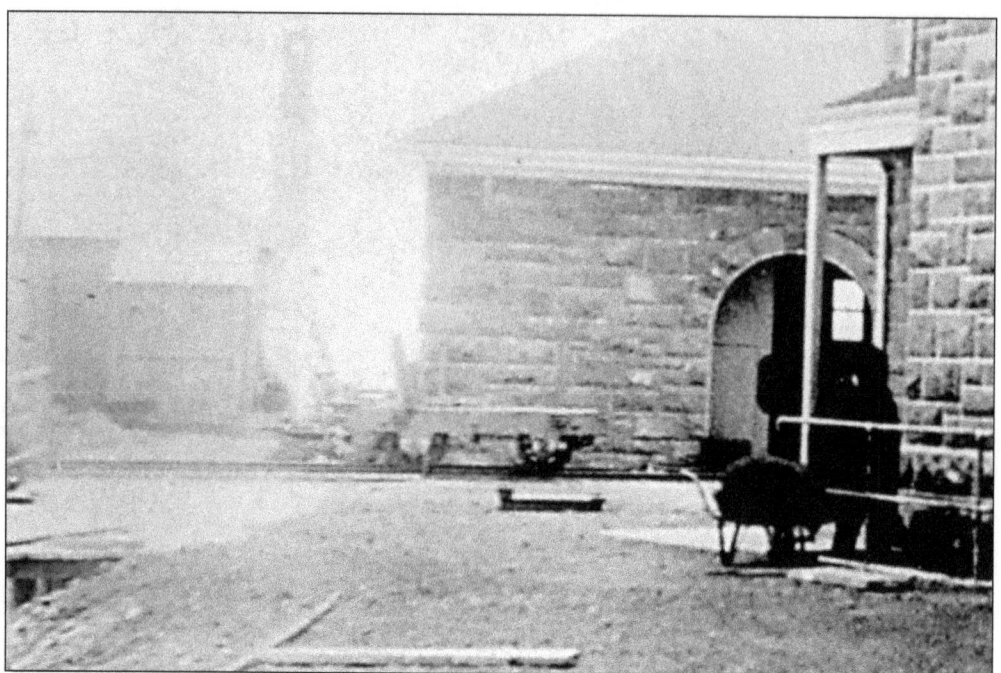

The hoist railway ran across the top of Point Sur between two buildings, the large keeper's quarters (right) and the hoist house (with the arched doorway). (Courtesy U.S. Archives.)

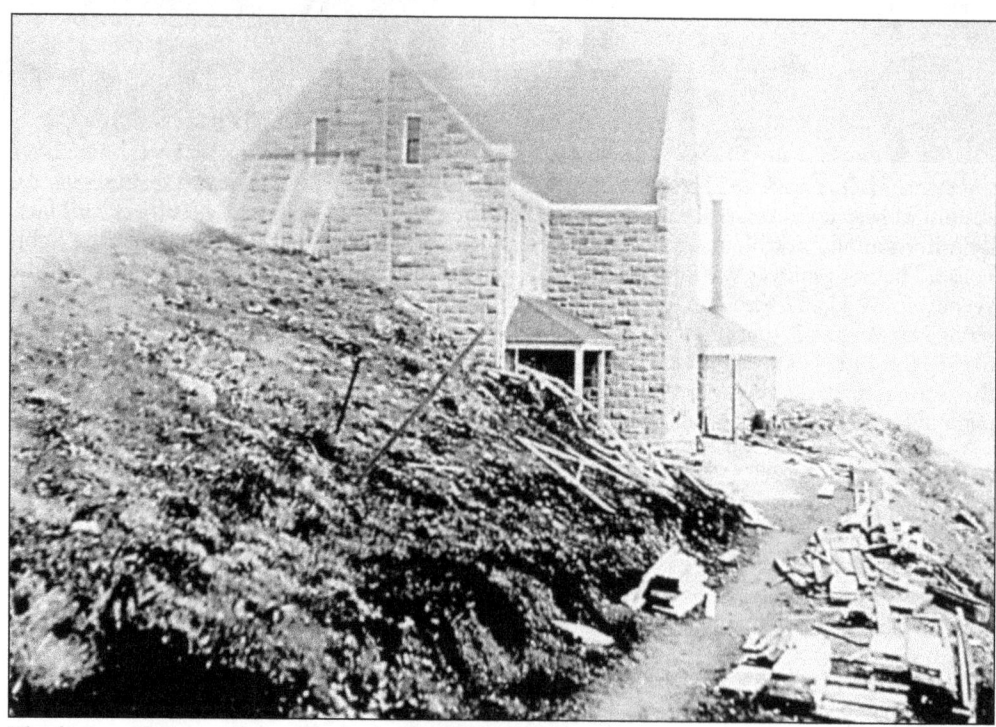

The hoist railway ran between the large keeper's quarters (center) and the east end of the engine house (rear). The railway is not visible in this view, but the tracks may have been laid in a trench that started its downward descent over the west side. (Courtesy U.S. Archives.)

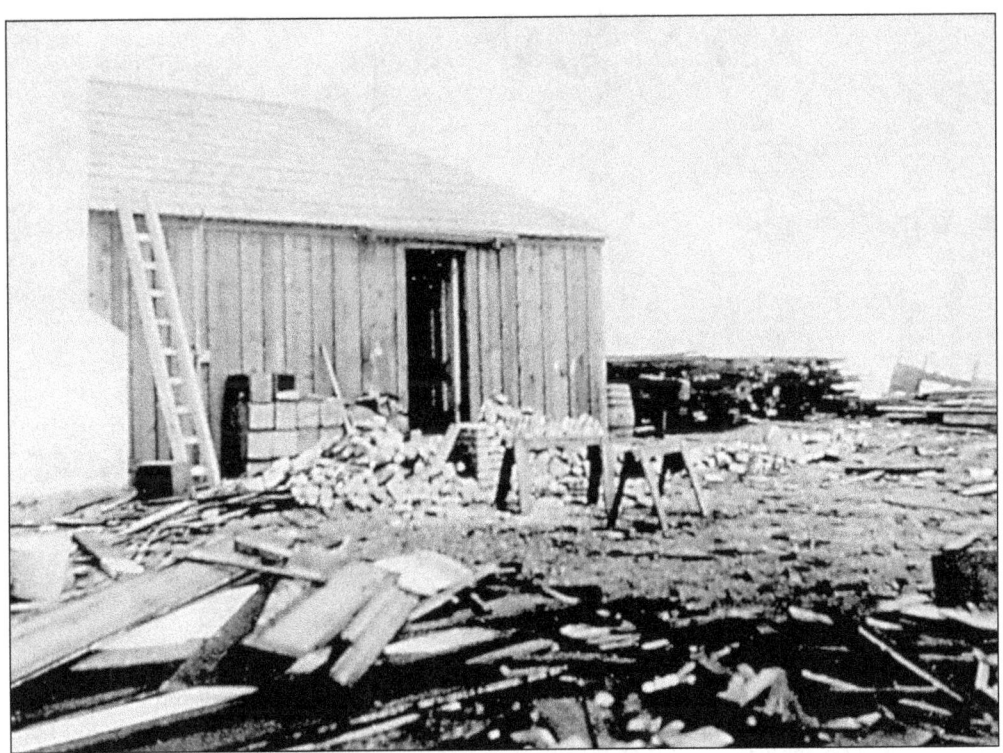

A house was built south of the engine house for the building superintendent. This 1889 view shows the "debris of old buildings." (Courtesy U.S. Archives.)

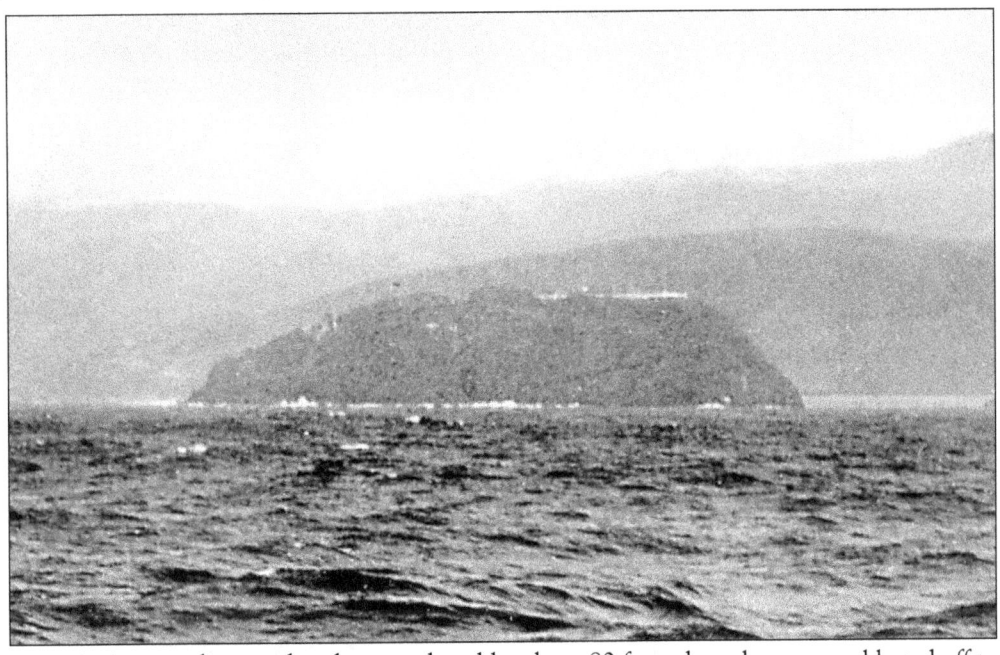

Point Sur's natural pointed rock was reduced by about 80 feet when the top was blasted off to provide enough flat area to build the lightstation buildings, evident in this 1904 photograph. (Courtesy U.S. Archives.)

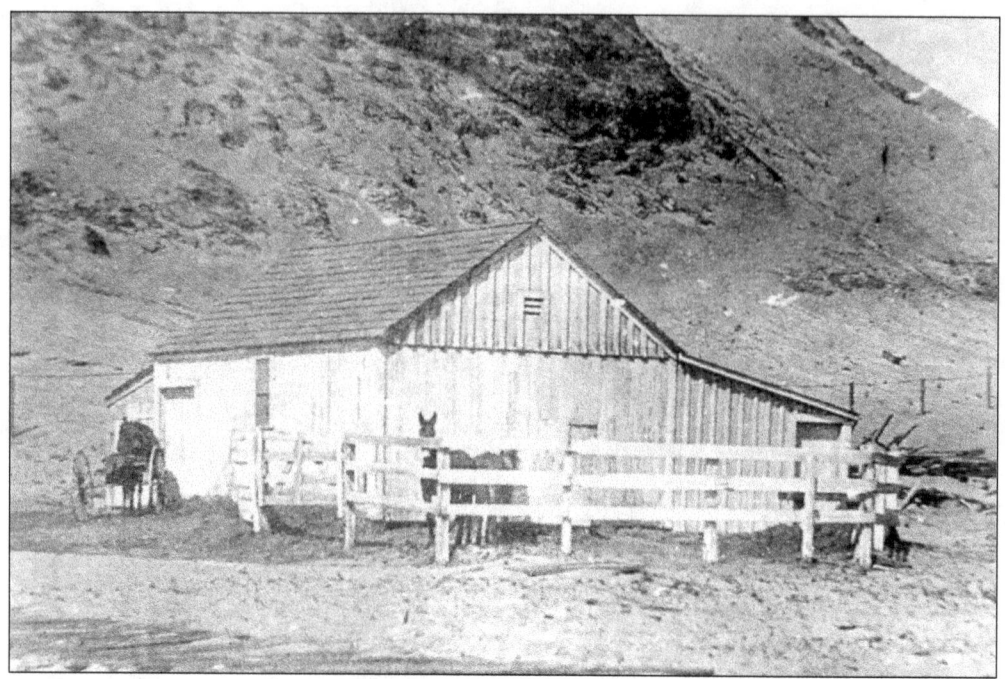
A barn was built at the base of Point Sur's giant rock for the station animals, probably a horse and some mules, and perhaps a cow. In this 1893 photograph, a horse and buggy stand next to the barn. The corduroy road that crossed the sand flats is plainly visible in the foreground. (Courtesy Herbert Bamber, U.S. Light-House Establishment photo.)

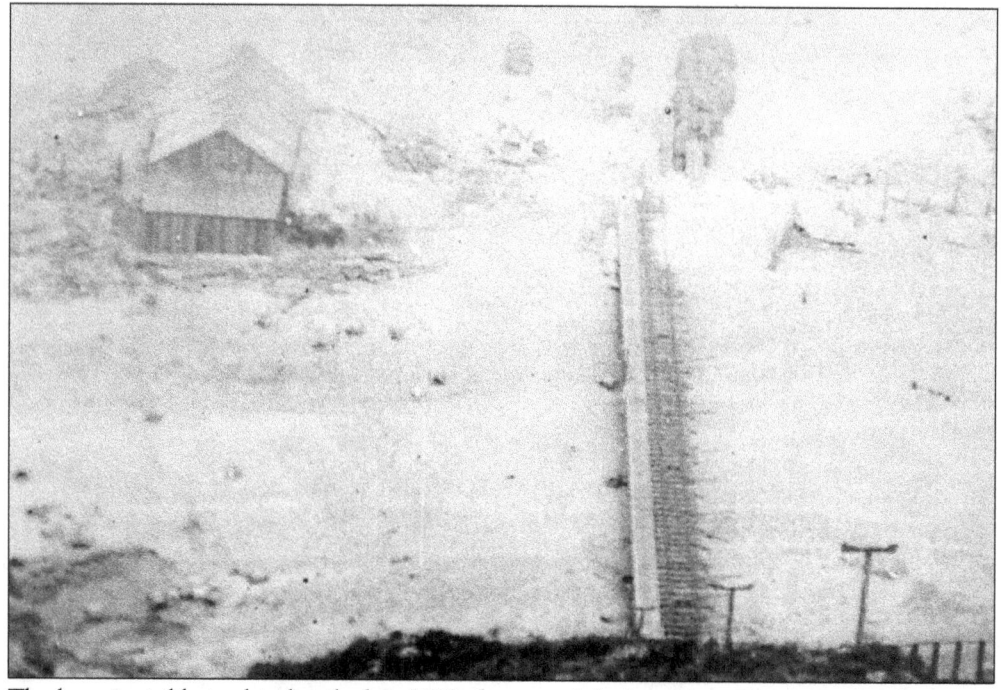
The barn is visible in this detail of an 1889 photograph looking down the tramway. (Courtesy U.S. Archives.)

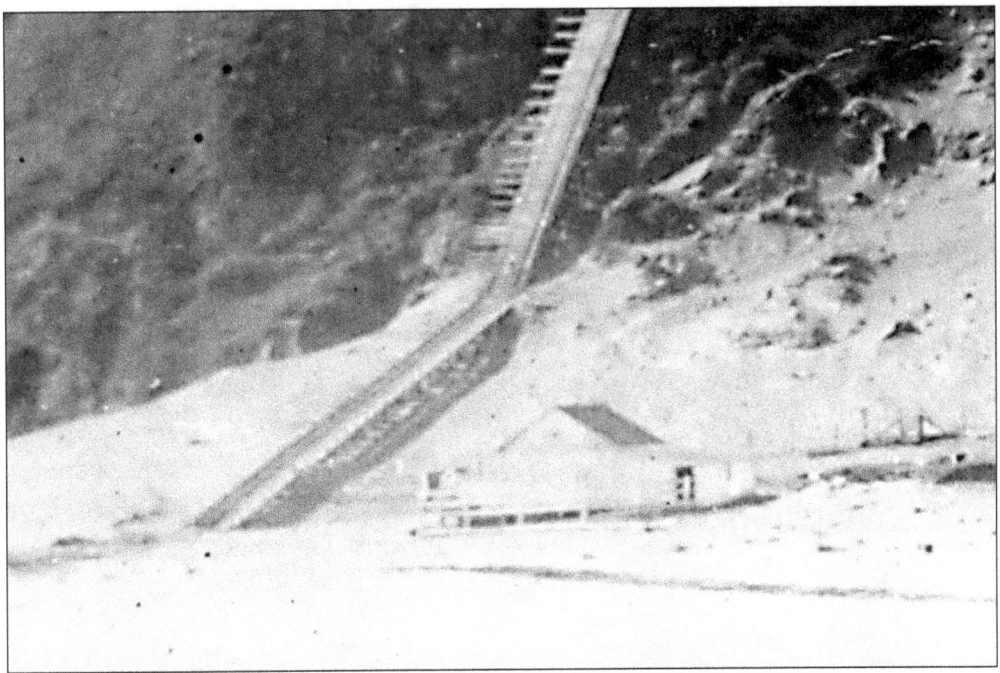

The barn was situated at the bottom of the railway in the sand dunes. This is a detail from an 1893 photograph. (Courtesy Herbert Bamber, U.S. Light-House Establishment photo.)

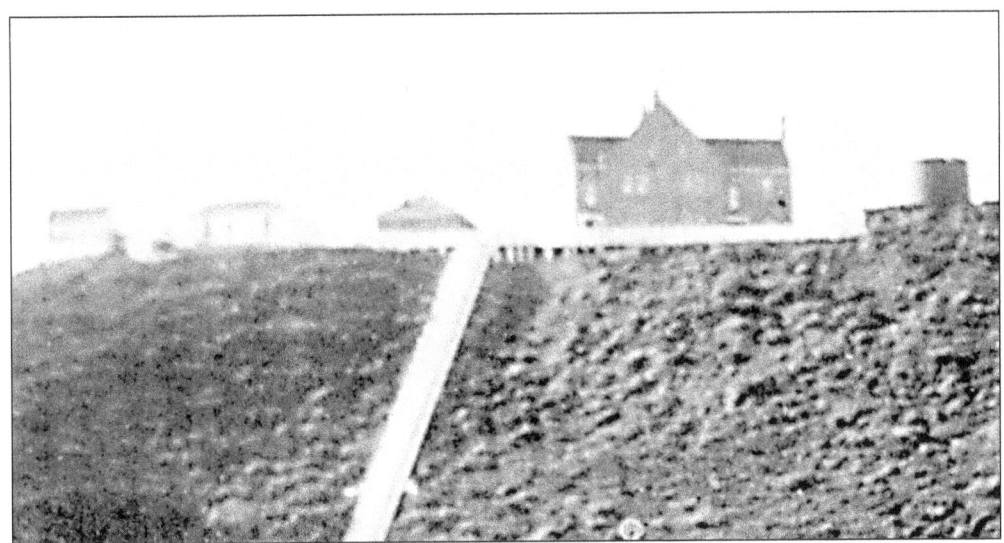

Most of the lightstation buildings were located at the top of the hoist railway. In this detail from an 1893 photograph, the buildings are, from left to right: the chicken house, building superintendent building, hoist house, keepers' quarters, and the redwood water tank. (Courtesy Herbert Bamber, U.S. Light-House Establishment photo.)

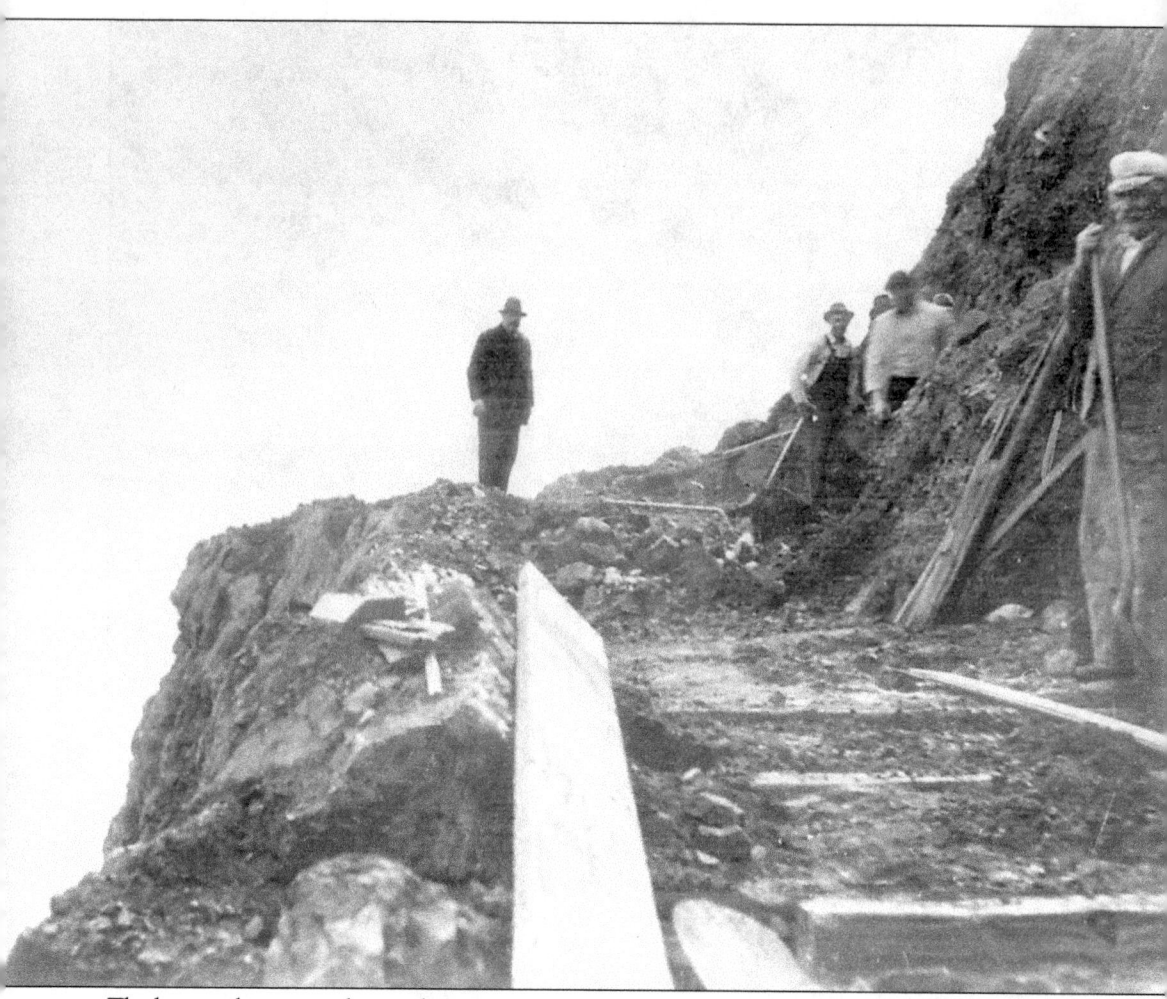
The hoist railway turned out to be more expensive than a road. In 11 years, many of its components had to be replaced. In 1899, the Light-House Establishment finally decided to build a road, which was constructed using dynamite and shovels. Work stopped for several months because of winter storms. The road was finished in the summer of 1900. (Courtesy U.S. Coast Guard.)

Two

Supply Landings

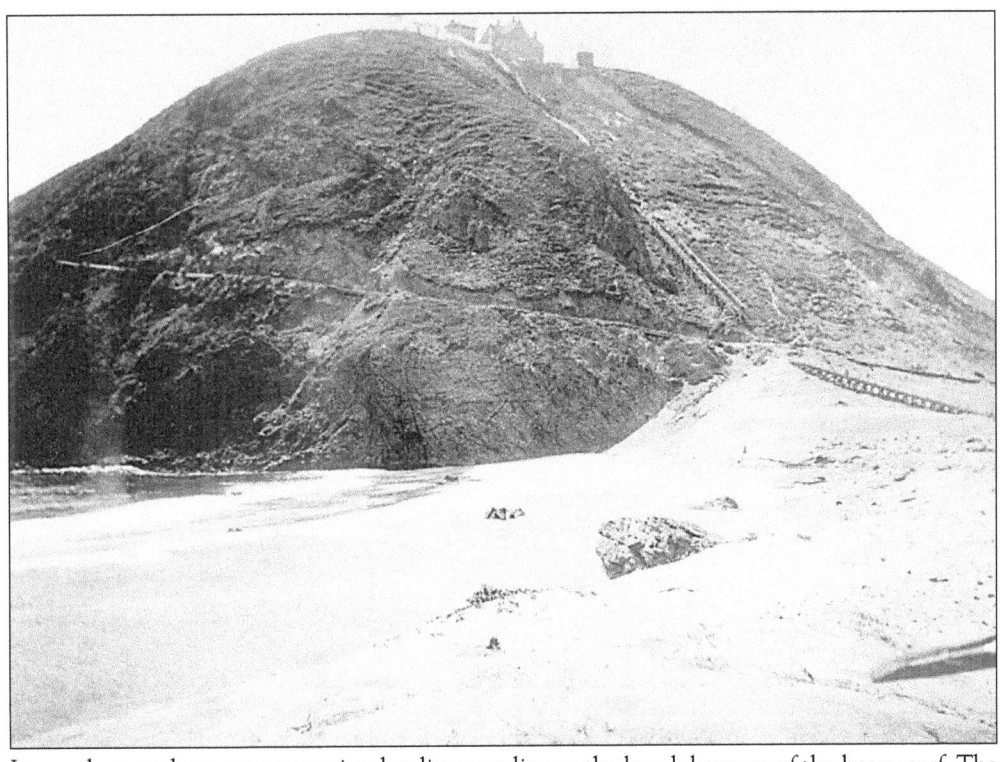

It was always a dangerous operation landing supplies on the beach because of the heavy surf. The Lighthouse Service labeled this 1907 photograph "Beach where supplies are landed." (Courtesy U.S. Coast Guard.)

Getting supplies to the lighthouse was difficult because of the remote location and near-vertical cliffs of Point Sur's moro rock. (Courtesy U.S. Coast Guard.)

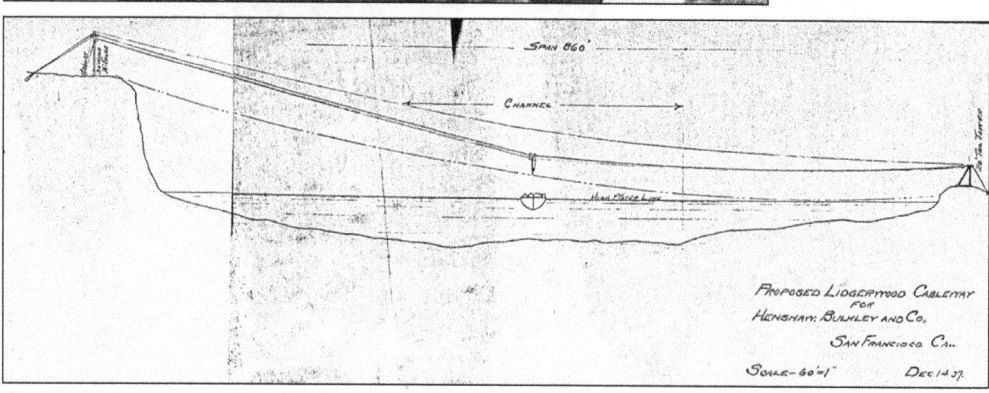

One scenario, suggested in 1907, was this dangling block-and-tackle system. This method would have lifted supplies from small boats by way of a line suspended from the top of Point Sur to a tower built on a rock on the beach 860 feet south. It was a system often used in the "dog-hole" ports in Big Sur. The idea was deemed too expensive. (Courtesy U.S. Coast Guard.)

Engineers soon began looking for a better landing site than the beach. In 1907 they considered looking at the cliffs to the south, or leeward, side of Point Sur for a possible landing with a hoist. A man is on the rocks in the center of this May 1907 photograph, labeled "Proposed landing site." (Courtesy U.S. Coast Guard.)

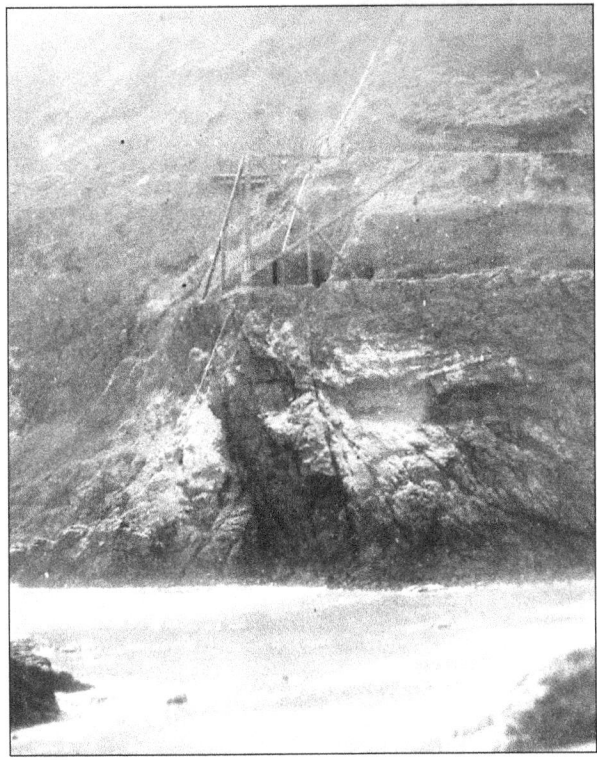

This view shows an updated system, built on the south side of the rock in 1911, in which a ledge was carved out of the cliff below the existing road. A hydraulic hoist, with a long arm and hook that swung wide over the surf, was erected for lifting barrels to the road. The hydraulic lines to the top of Point Sur are visible in this photograph. The site was eventually abandoned because it was built over the breaking surf, making unloading the small boats dangerous. (Courtesy U.S. Coast Guard.)

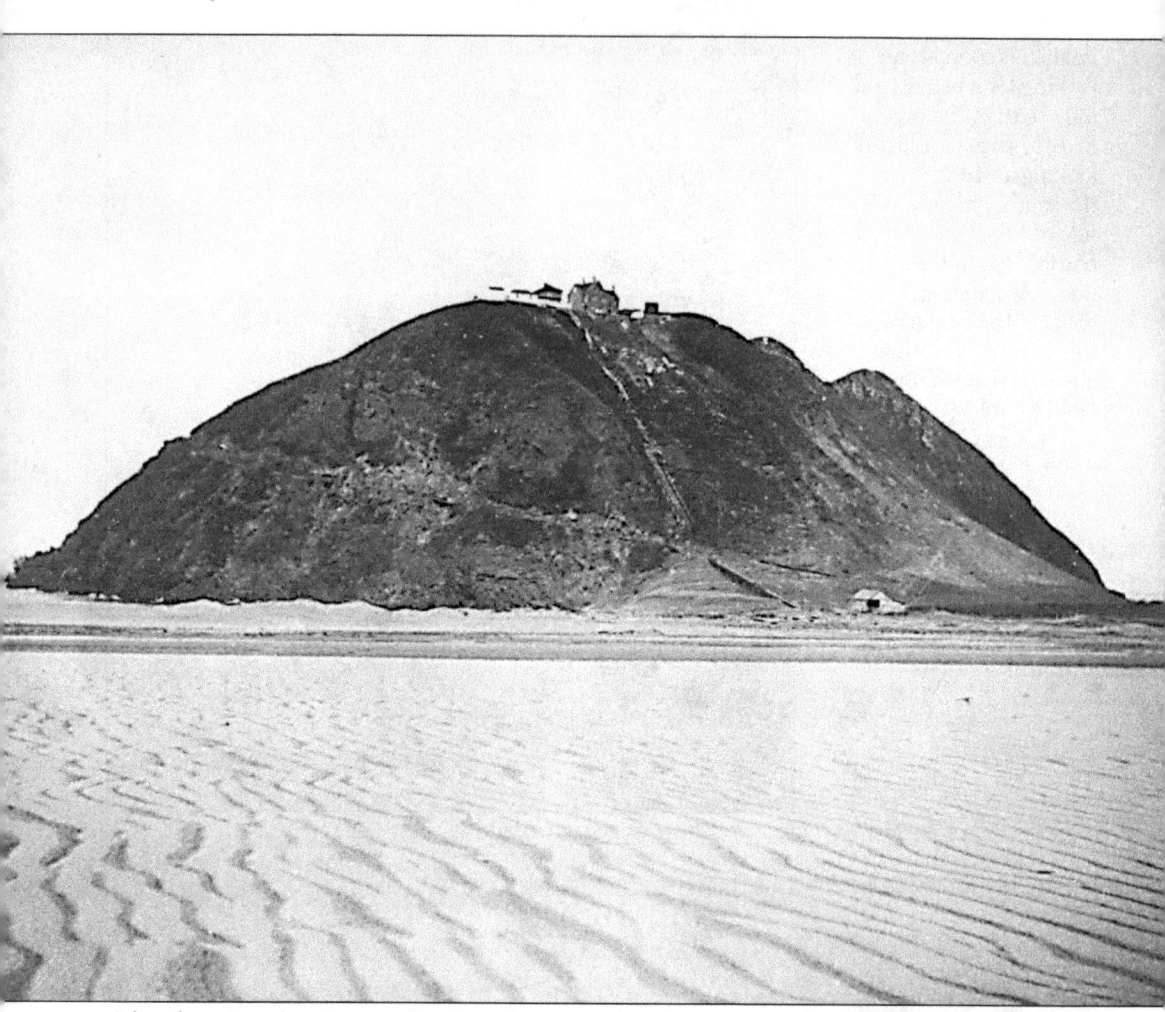

After the east-side tram was abandoned in 1900, deliveries of Big Sur redwood to the lighthouse to fuel the steam-powered fog whistle were made by mule-driven wagons across the sand flats and up the road to the lighthouse. This 1907 view is from the southeast, across the sand flats. (Courtesy U.S. Coast Guard.)

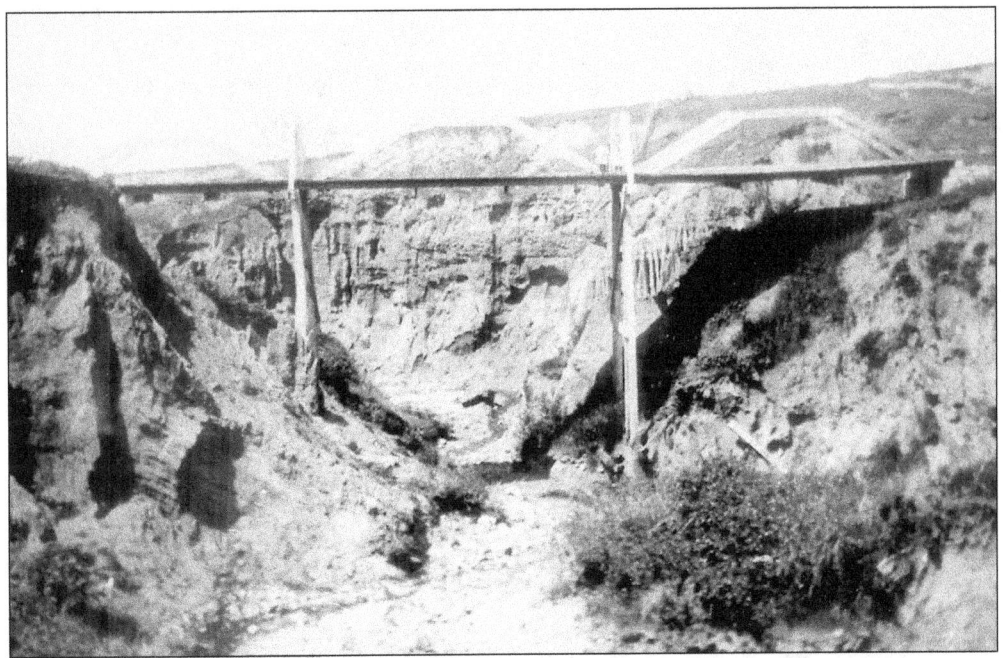

Mr. Gschwin, who delivered wood from Big Sur, petitioned the government to upgrade the road from his property to the lighthouse. Several small bridges needed to be repaired or replaced. This April 1907 photograph is labeled "Road bridge to be replaced." (Courtesy U.S. Coast Guard.)

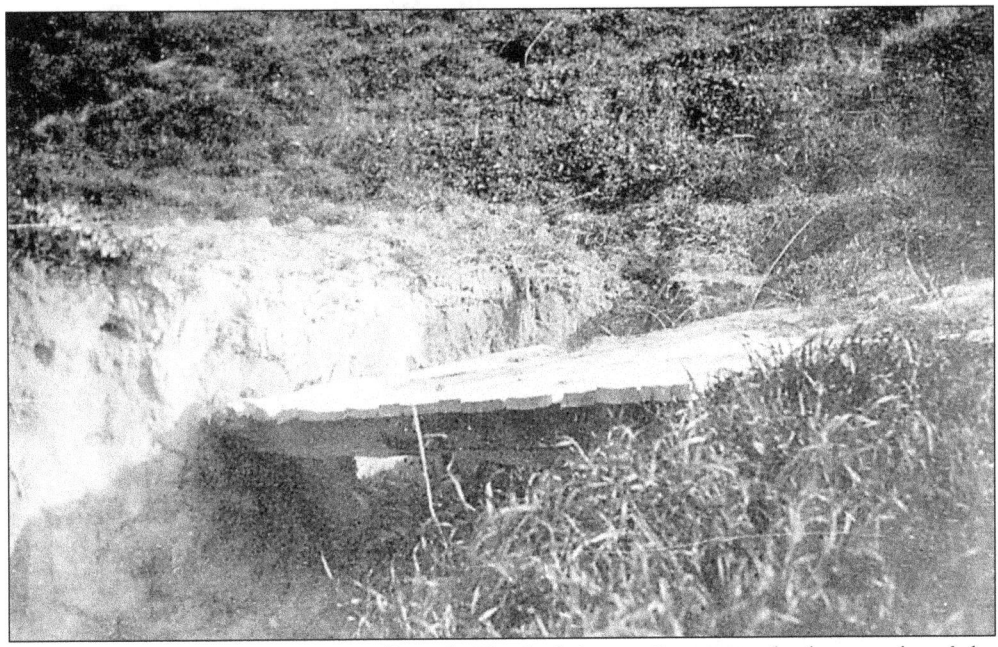

Some of the small bridges were collapsed. The Lighthouse Service took photographs of the supply route from the inland hills to the lighthouse. Gschwin's petition was met with suspicion about his motives, as he only delivered wood to the lighthouse once a year. Until investigating the situation more thoroughly, officials thought the proposed repairs were for his own benefit. (Courtesy U.S. Coast Guard.)

The Lighthouse Service documented Point Sur's roads and bridges in November of 1907. This photograph looks up at a bridge on the road to the lighthouse, along the south side of Point Sur. (Courtesy U.S. Coast Guard.)

This view is of the last bridge and the last turn before the lighthouse. (Courtesy U.S. Coast Guard.)

The road was extremely narrow; in fact, it was barely, wide enough for the wagon the Coast Guard used at the time. (Courtesy U.S. Coast Guard.)

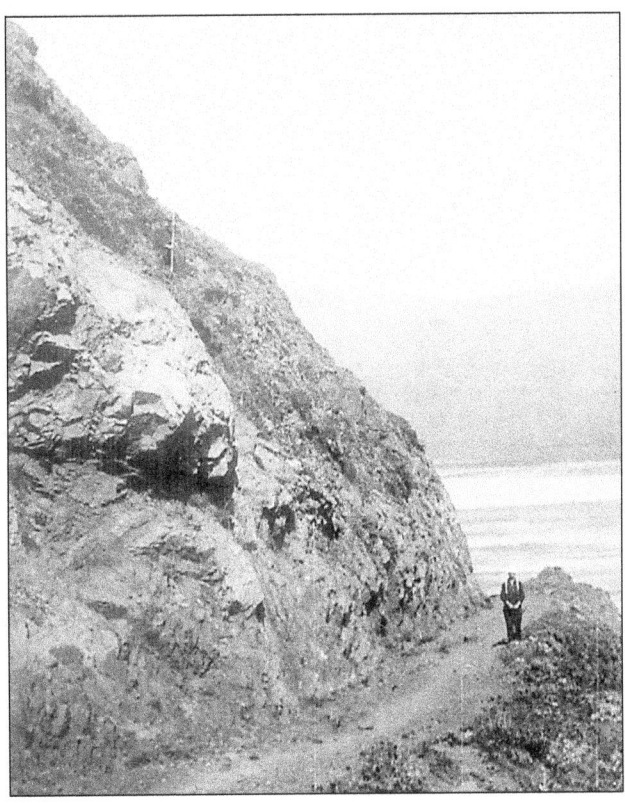

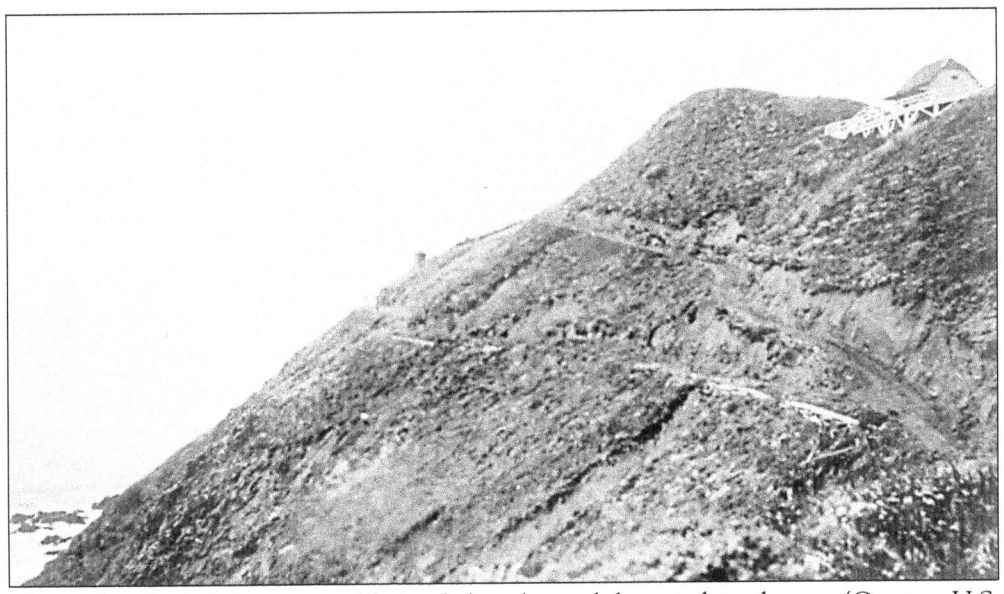

The road to the lighthouse is visible just below the road that winds to the top. (Courtesy U.S. Coast Guard.)

The lower road, as it approaches the lighthouse, was once a rail bed. (Courtesy U.S. Coast Guard.)

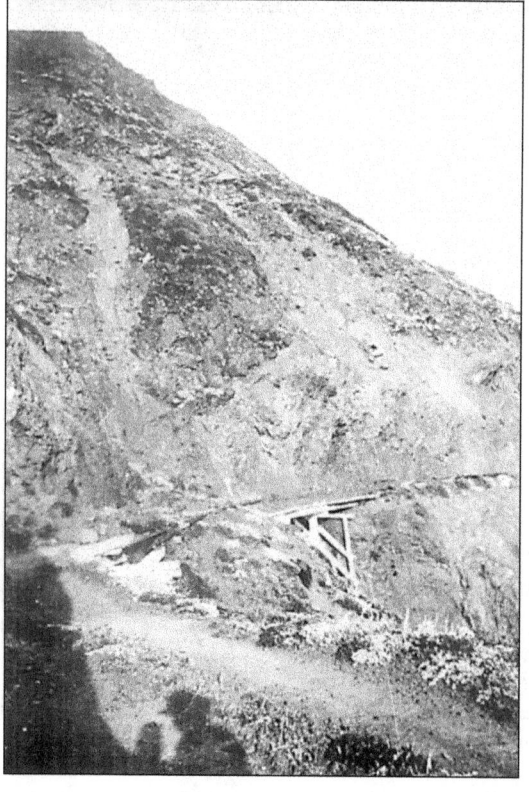

Bridges along the old railbed also had to be inspected and documented. The harsh climate takes a toll on Point Sur. (Courtesy U.S. Coast Guard.)

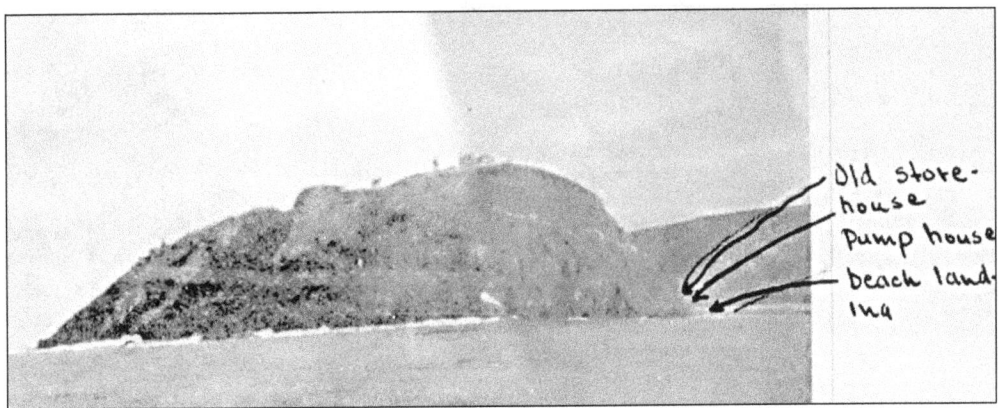

In 1908, the U.S. Lighthouse Service changed the fog signal from steam, which used local wood as a fuel, to one powered by compressed air, using an oil-fueled compressor. Ships delivered the heavier kerosene, and this demanded that a better system of delivering supplies be found. This two-photograph panorama illustrates the problems. It labels the "old store house" (original barn), the pump house (water source), and the beach landing. Delivering supplies through the surf to the beach was often dangerous. The loads had to be hauled from the beach up the steep road to the lighthouse by mule-drawn wagons. (Courtesy U.S. Coast Guard.)

A new landing for Point Sur was proposed. This time the engineers on site were given the latitude to put it in the best place west of the current landing (out of the surf). In 1914, the proposed site was photographed from the ocean. (Courtesy U.S. Coast Guard.)

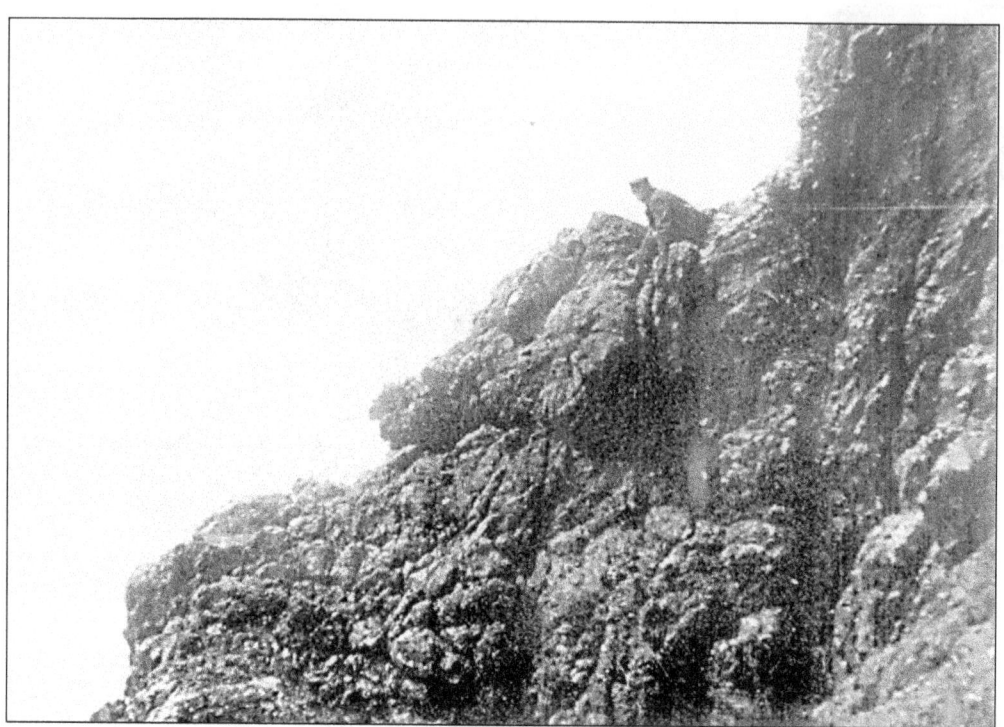
Point Sur's rugged rocks were surveyed for the best possible site. A man perches on the rocks of the proposed landing site. (Courtesy U.S. Coast Guard.)

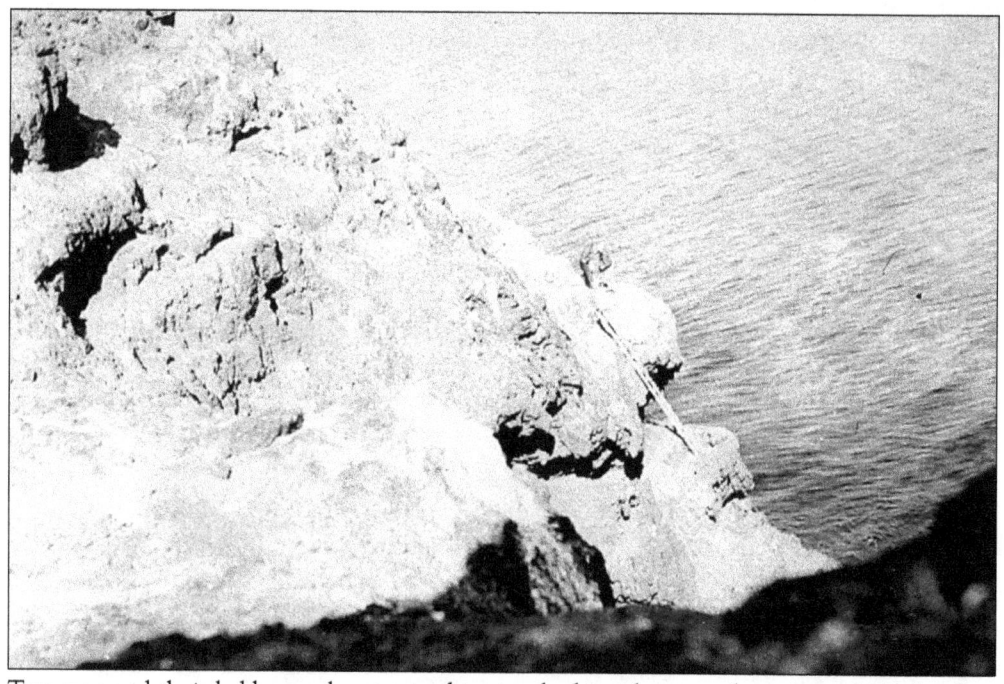
Two men and their ladder can be seen in this view looking down on the proposed new landing site. (Courtesy U.S. Coast Guard.)

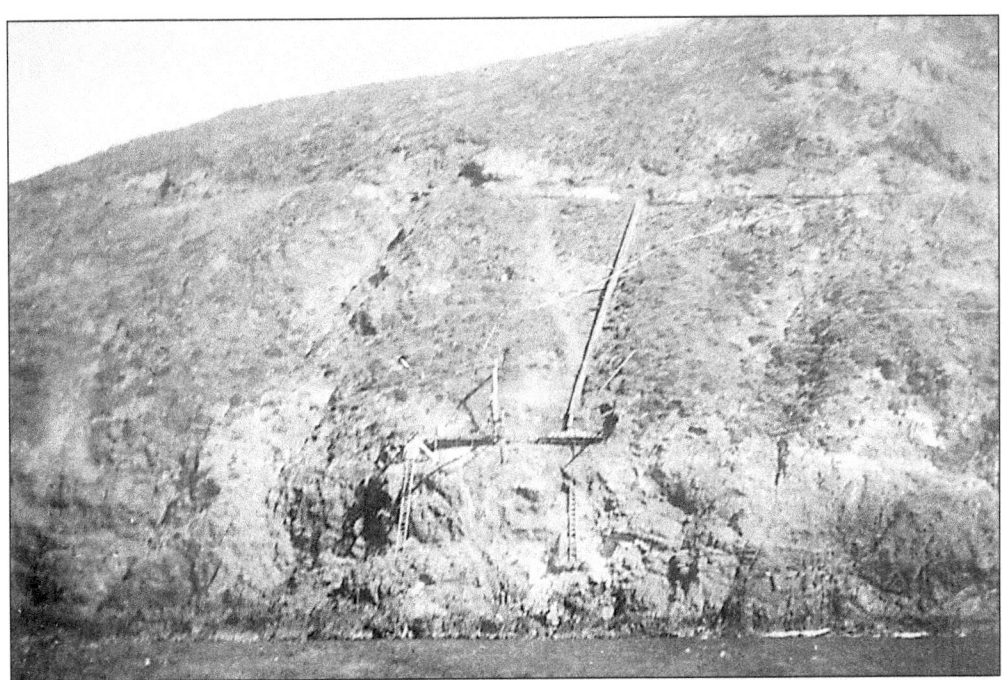

Once the site was chosen, construction could begin. A ledge was cut deep into the rock to support the new landing. (Courtesy U.S. Coast Guard.)

The landing was built 40 feet above the water on concrete footings. (Courtesy U.S. Coast Guard.)

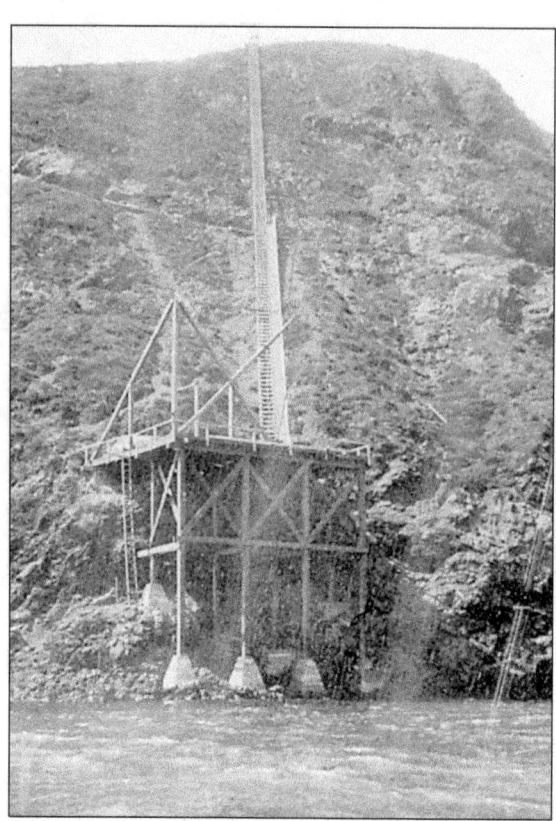

A hoist railway was built to lift supplies to the top of Point Sur. (Courtesy U.S. Coast Guard.)

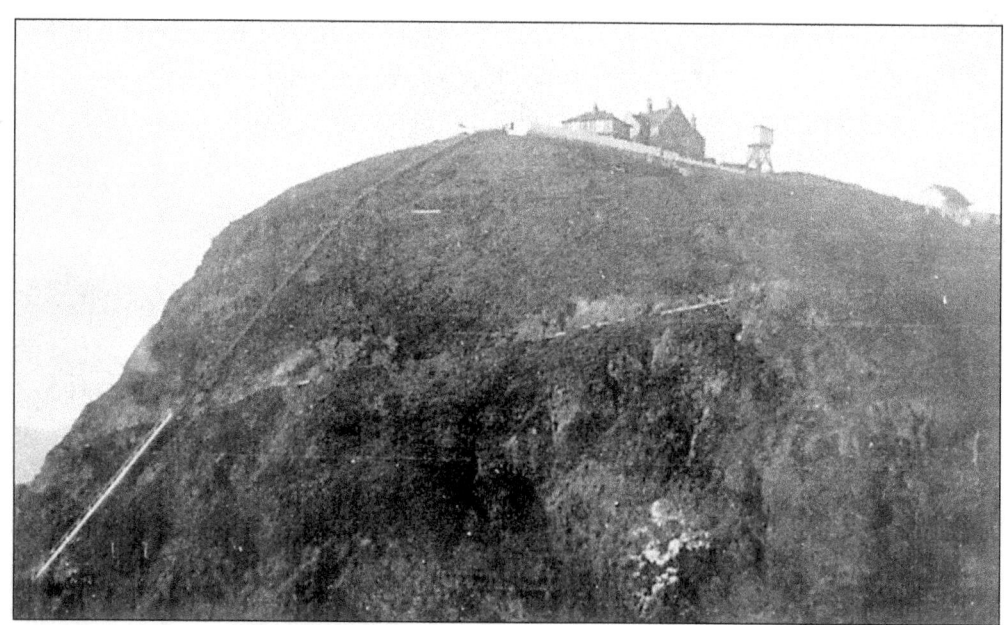

The hoist railway crossed the road to the top of Point Sur. (Courtesy U.S. Coast Guard.)

In this 1930s-era photograph, keeper Tom Henderson stood under the south tram crossing. (Courtesy U.S. Coast Guard.)

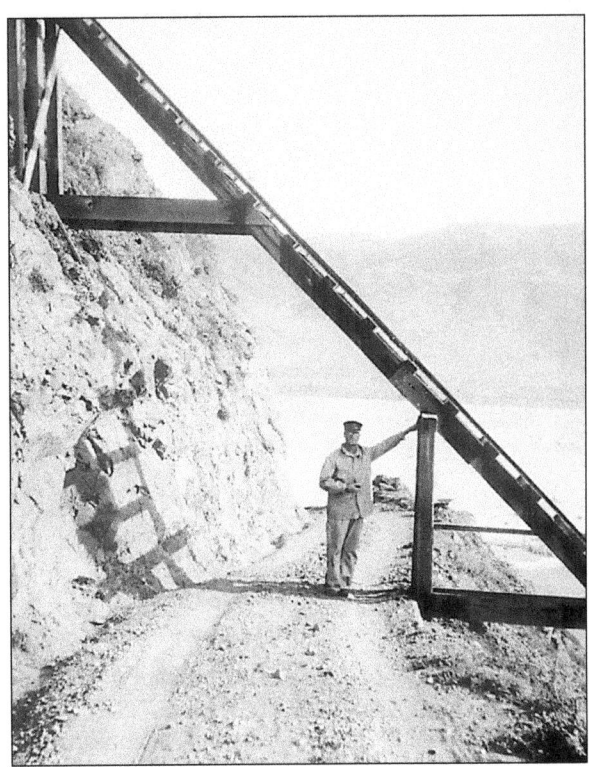

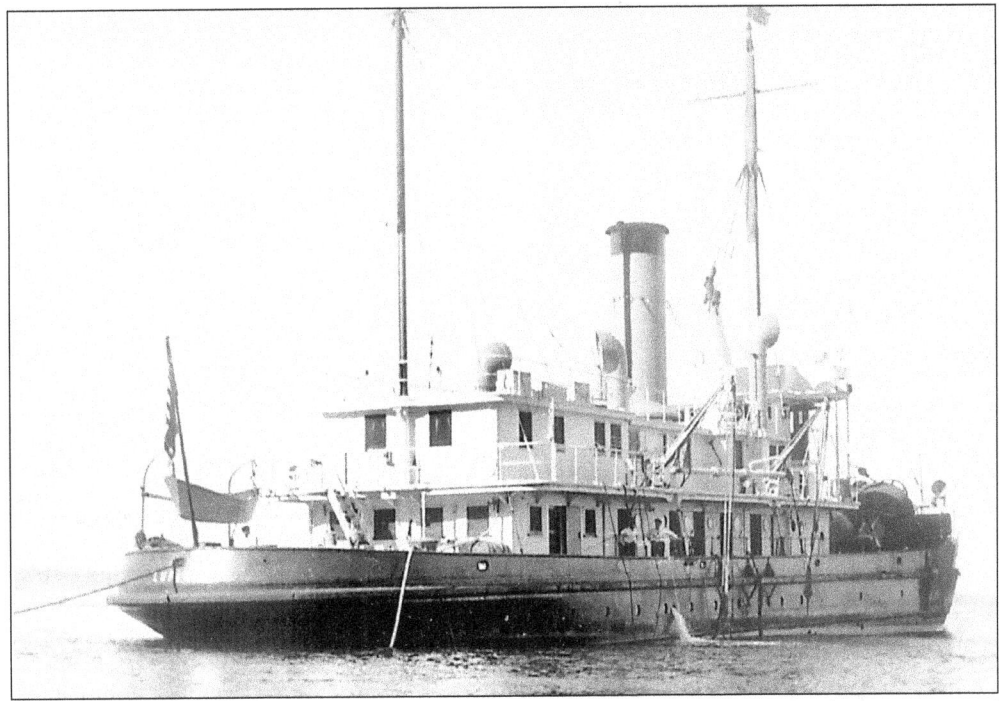

A lightstation tender brought supplies to Point Sur every four months. Tenders were named for plants, as evidence by *Lupine*, also the moniker of a native California shrub flower. Tenders typically anchored offshore in deep water. (Courtesy U.S. Coast Guard.)

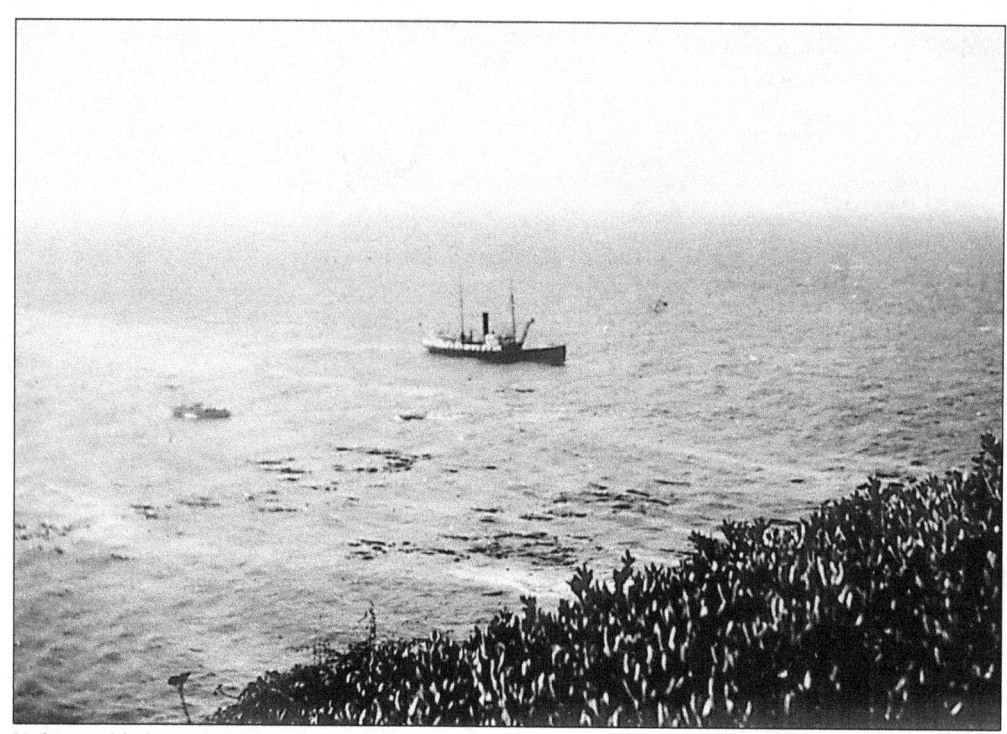

Kelp, visible here floating near the ship, anchors to rocks and is a good indication of underwater hazards. (Courtesy Elvina Fraser La Riviere.)

The tenders also brought the district lighthouse inspectors on their routine inspections. Here is the notorious and long-serving Captain Harry Rhodes. Captain Rhodes was the ultimate 'bean-counter,' authoritarian, and a stickler for detail. Legend has it that when 13 pencils were delivered to Point Sur instead of the dozen requisitioned, they were ordered to return the extra pencil at the earliest opportunity. (Courtesy U.S. Lighthouse Society.)

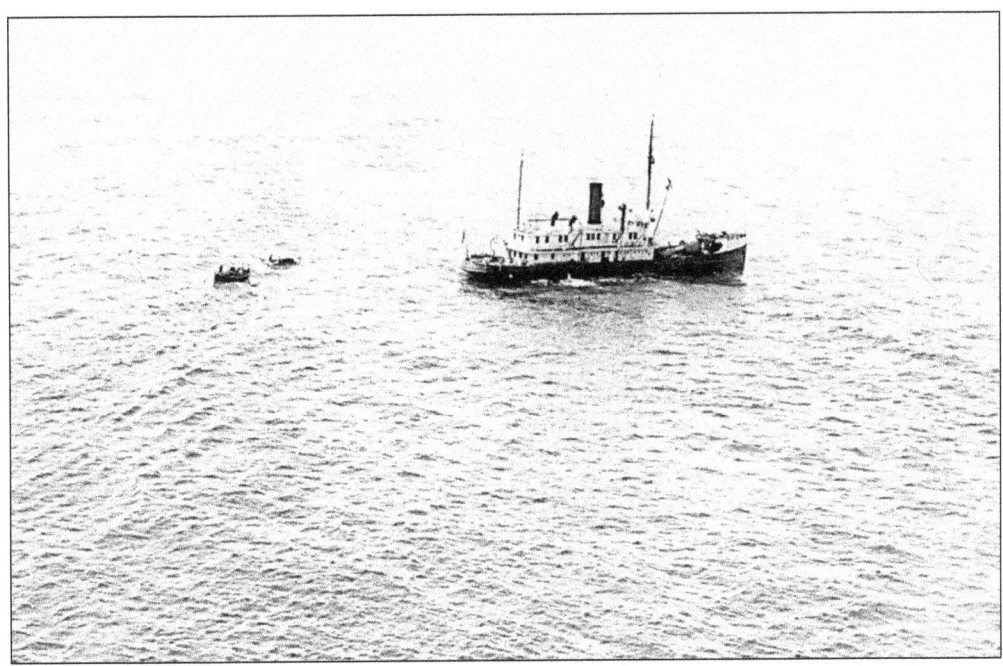
In this photograph, *Lupine* has off-loaded its supplies into skiffs floating nearby. (Courtesy George Henderson.)

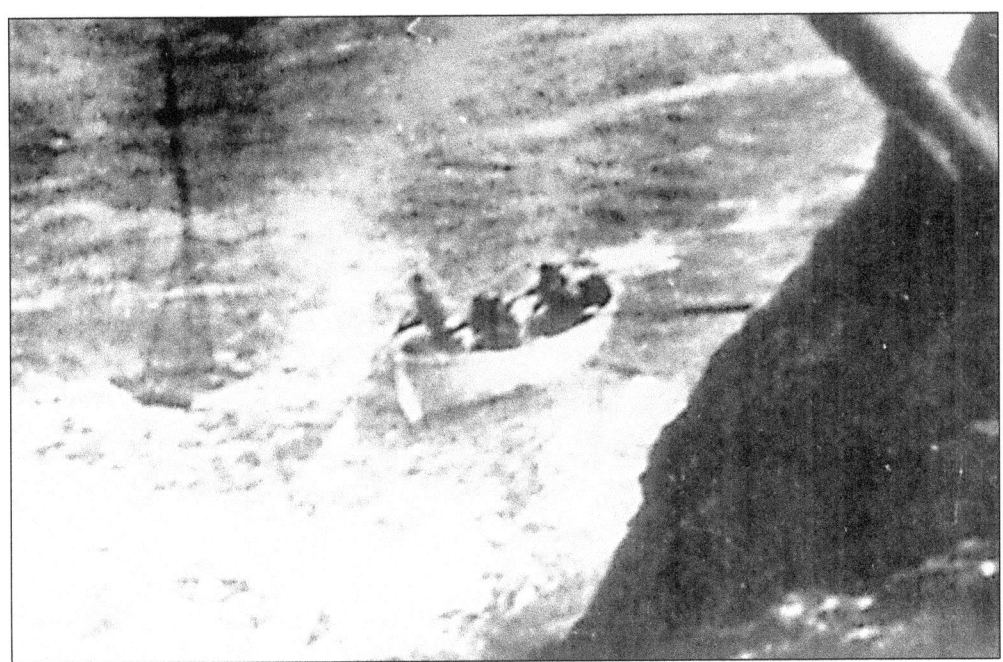
Supplies were often placed into barrels, which would float if they went overboard, and the barrels into small boats for the trip to the landing. The small boats could approach the landing only in calm weather. (Courtesy George Henderson.)

The derrick and its hoist stood ready to unload supplies. (Courtesy U.S. Coast Guard.)

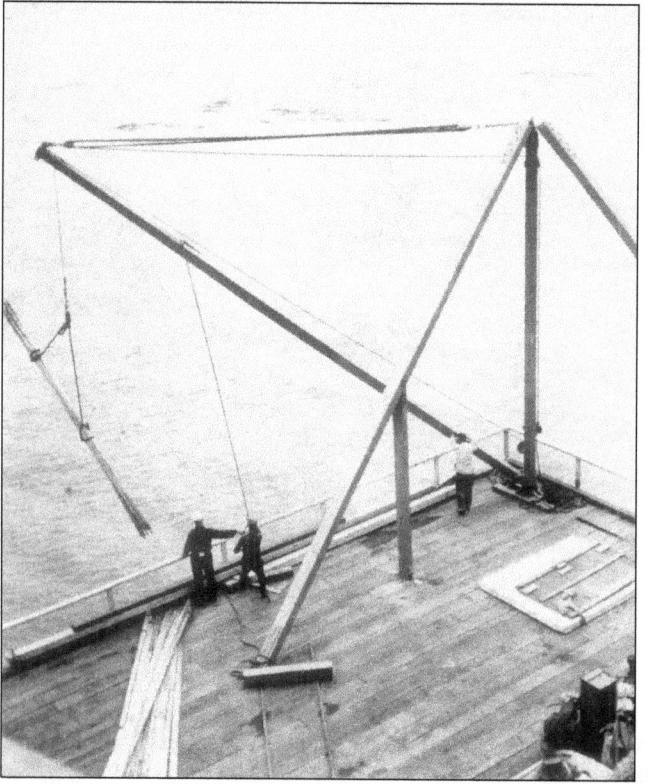

Lumber was unloaded by a block-and-tackle system attached to a boom that swings out from the derrick. (Courtesy U.S. Coast Guard.)

Two men were all it took to haul the heavy load of lumber 40 feet up from the water. (Courtesy U.S. Coast Guard.)

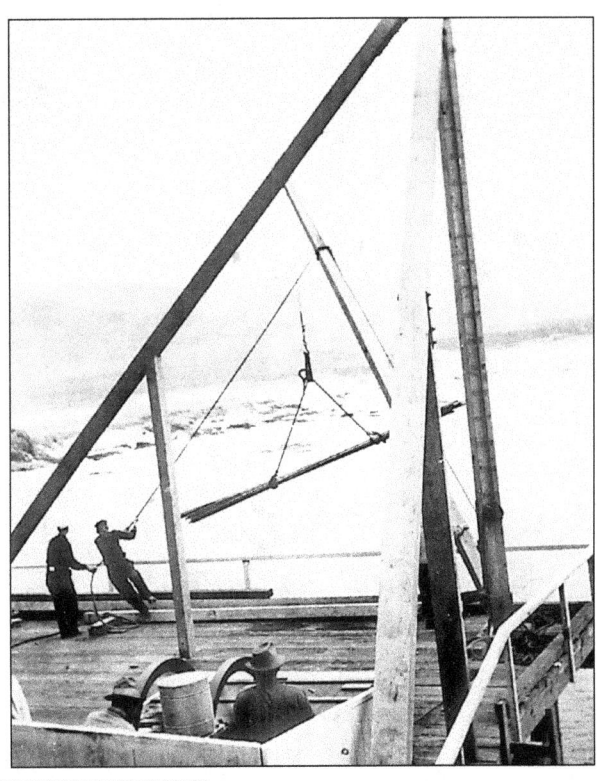

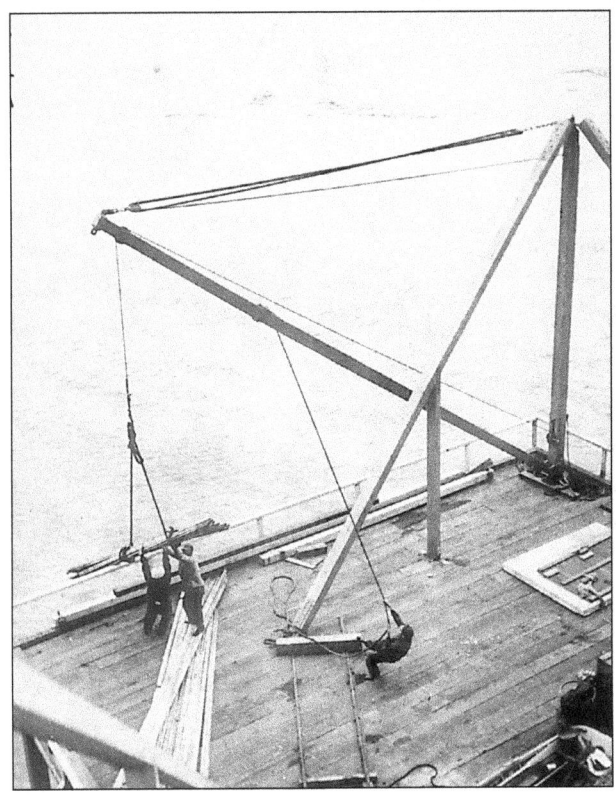

This load of lumber was safely ashore. (Courtesy U.S. Coast Guard.)

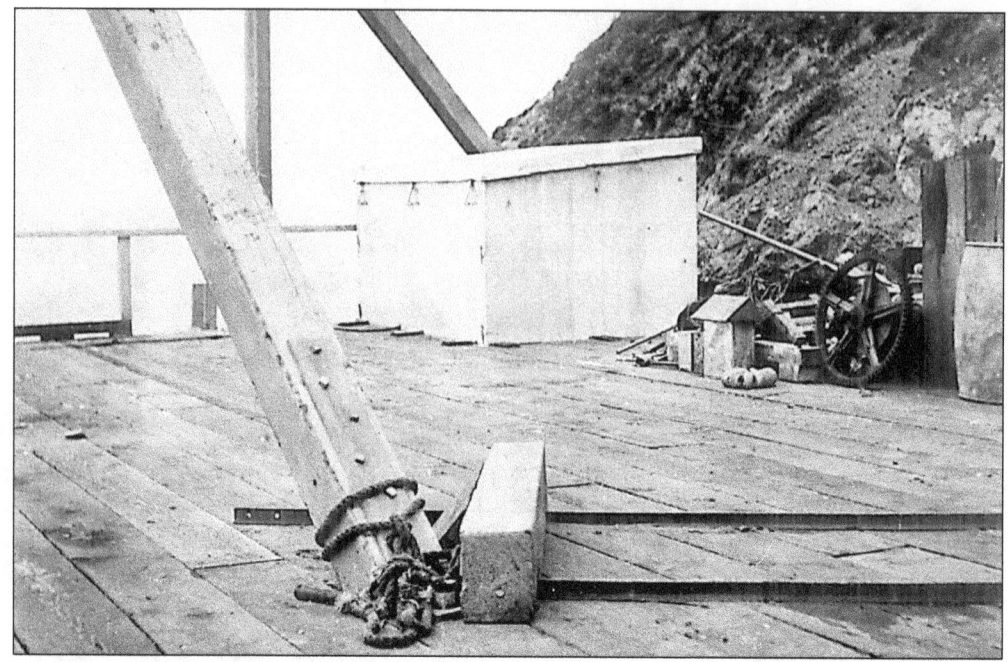

The derrick's legs were chained in place where they could also anchor the base of the tram rails. (Courtesy U.S. Coast Guard.)

This photograph shows bags of coal, brought up from the small boats in cargo nets, waiting to be loaded onto the tramcar. (Courtesy U.S. Coast Guard.)

Once unloaded from the boats, supplies were then carried almost 300 feet up the steep railway. (Courtesy U.S. Coast Guard.)

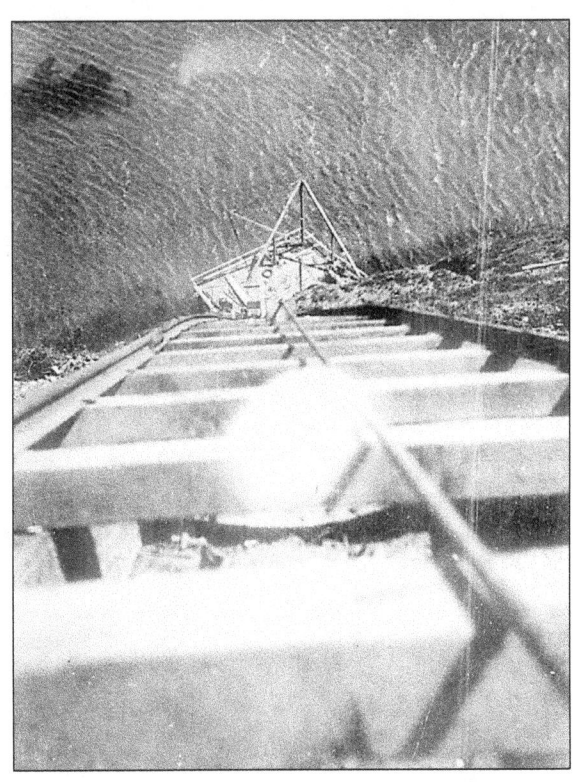

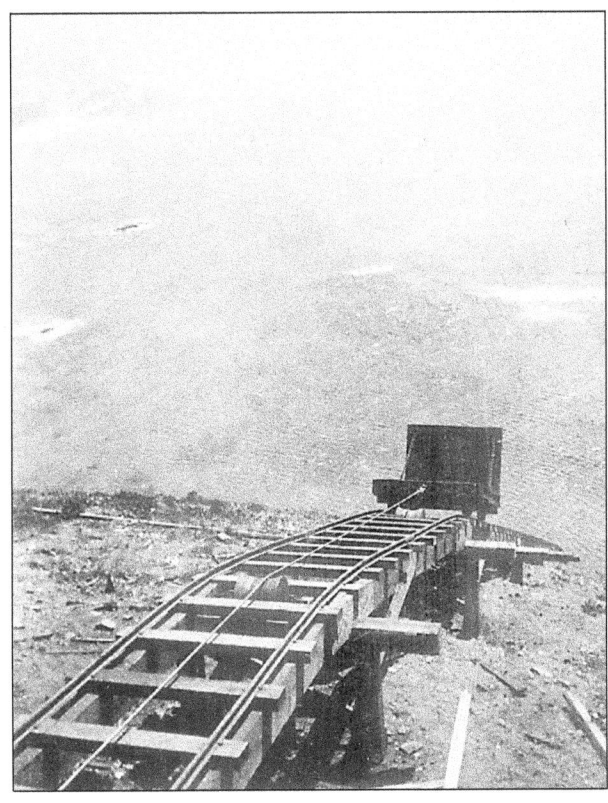

The simple, open tram car was pulled or hoisted up the rails by a steel cable. (Courtesy U.S. Coast Guard.)

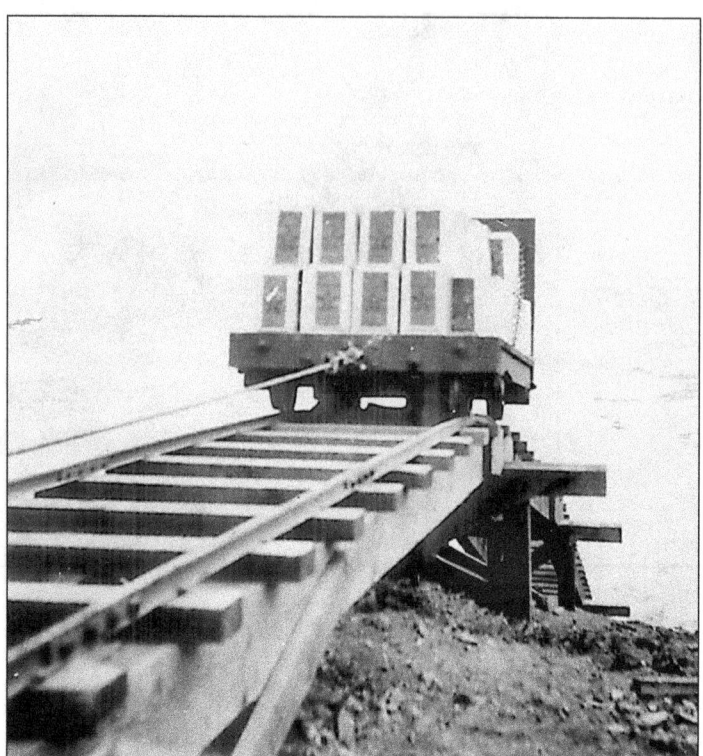

This car was hauling fuel, probably kerosene. The square cans are stamped with the "Texaco" star. (Courtesy U.S. Coast Guard.)

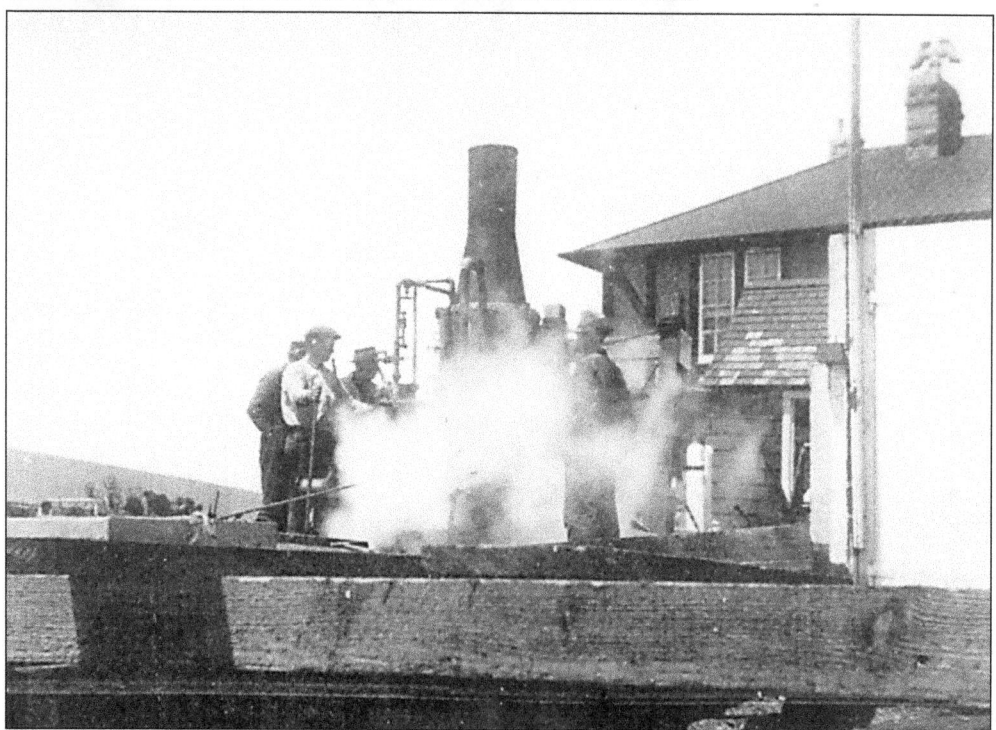

A steam donkey, or engine used to power a cable winch, powered the tramway from its location at the top of the rock behind the head lighthouse keeper's house. (Courtesy U.S. Coast Guard.)

The hoist railway and its boilers had to be ready for the lighthouse tender's deliveries, which came every four months. (Courtesy U.S. Coast Guard.)

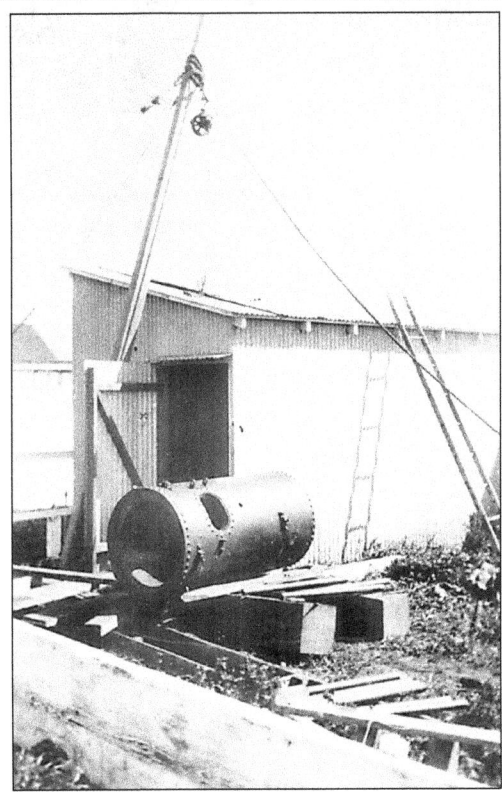

Eventually, a tin shed was built to house the steam donkey and the rail car. Shown here, the boiler sits outside the shed. (Courtesy U.S. Coast Guard.)

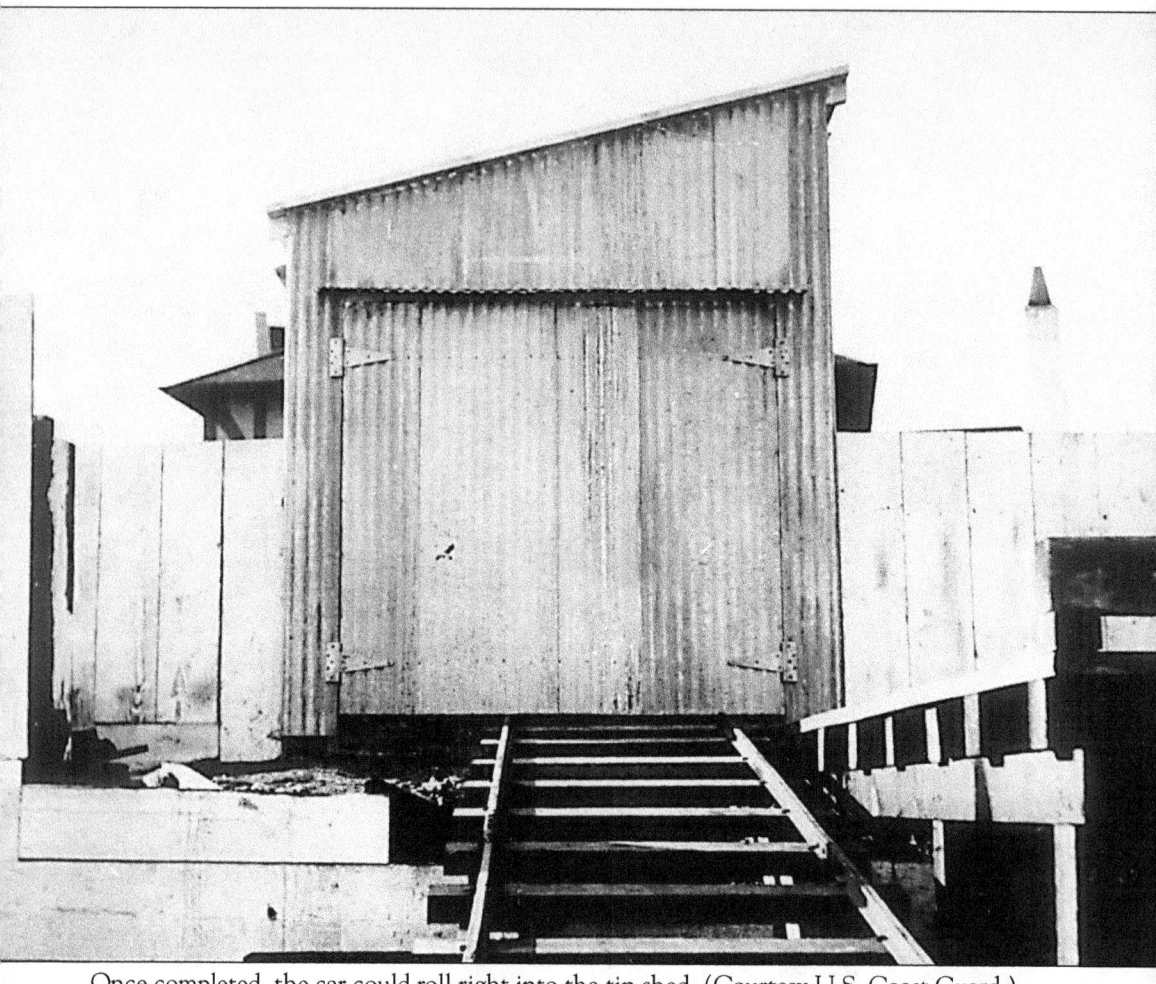
Once completed, the car could roll right into the tin shed. (Courtesy U.S. Coast Guard.)

Three

FIGHTING THE ROCK

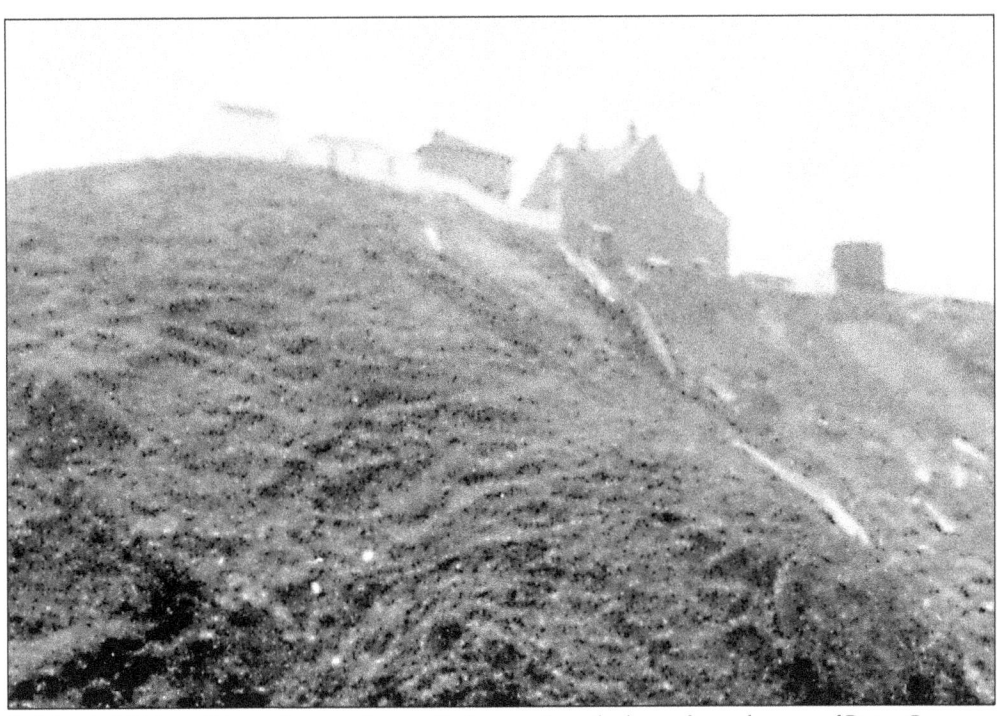

In March 1907, a slide on its east face pulled tons of earth down from the top of Point Sur near the course of the old tramway. Point Sur is made of Franciscan rock that crumbles and easily sloughs off. To compound the problems, the light station builders pushed blasted material from the top of Point Sur over the sides. They gained a little more level space, but left filled areas were unstable. (Courtesy U.S. Coast Guard.)

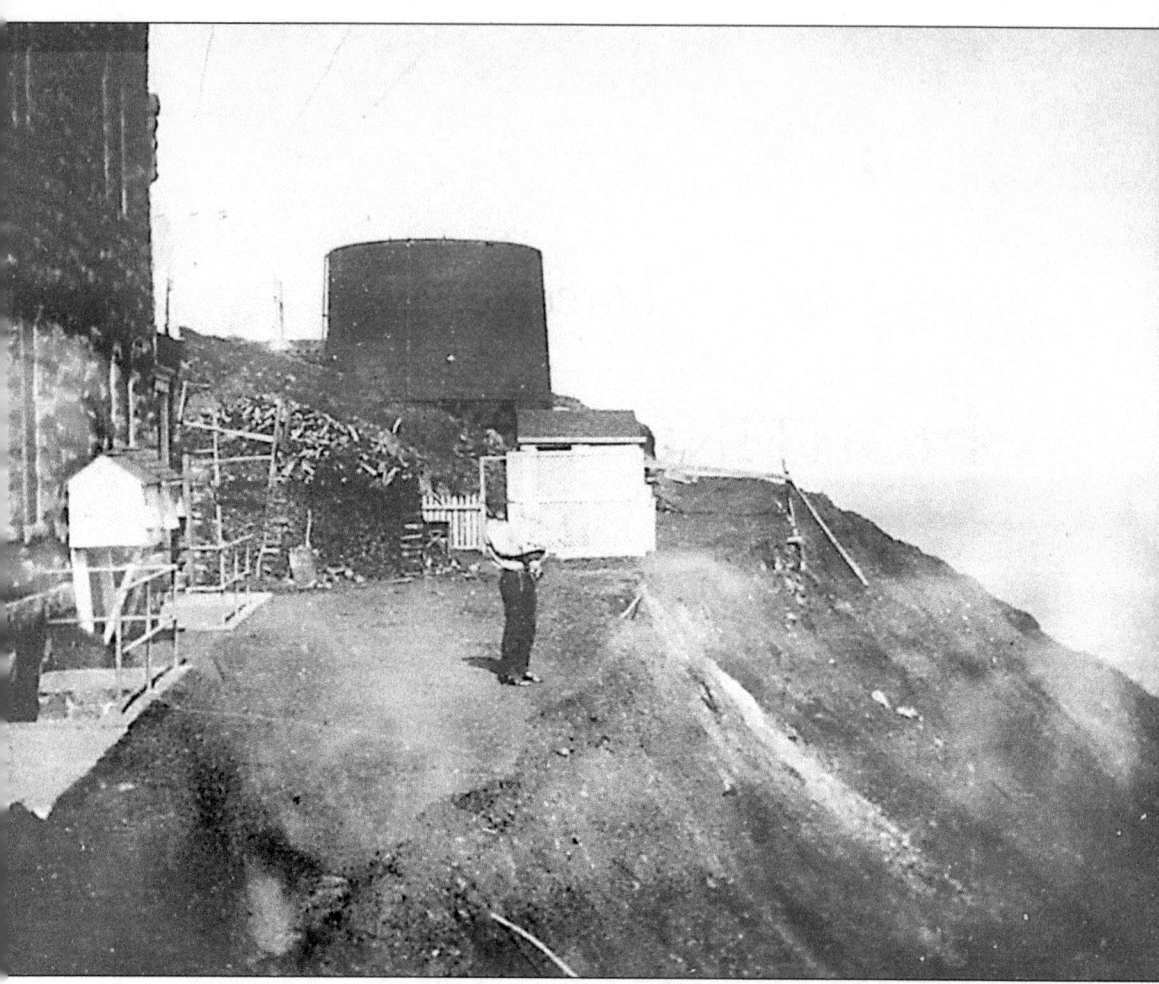

Keeper Newhall sent this message to the Army Corps of Engineers: "There was another landslide at this station yesterday morning which took all the stone wall with it and the ground broke back to within ten feet of the dwelling and drops of[f] to the depth of 20 feet." It must have made a terrific noise when it went. A lightkeeper, center, looks over the edge of the slide. Coolers on the left side of the photograph resemble small houses on stilts. Lacking electricity, and of course refrigeration, the coolers used convection to keep the food "cool." The redwood water tank can be seen behind the "two-station" privy. (Courtesy U.S. Coast Guard.)

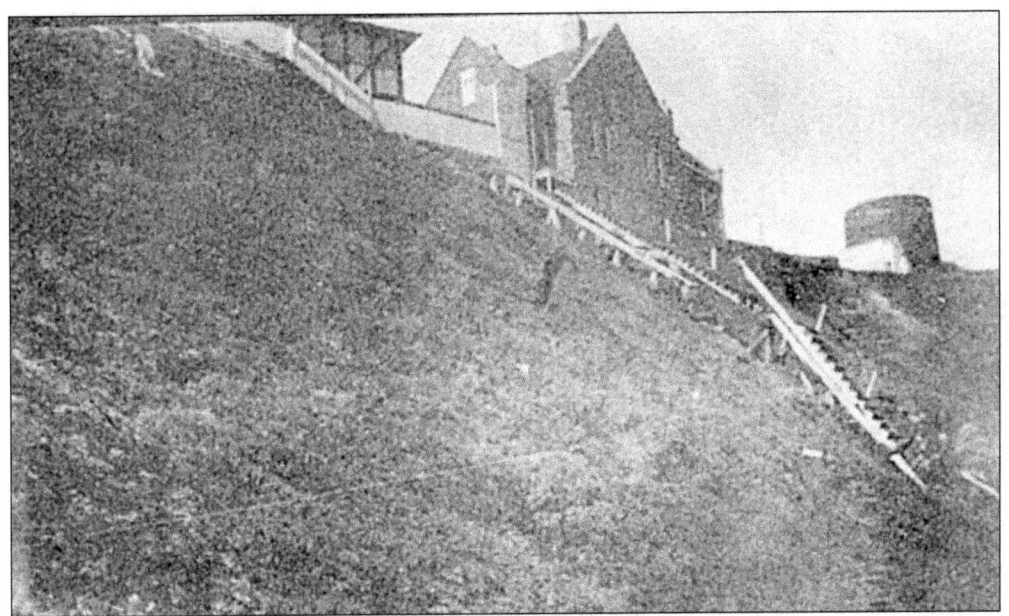

The earth slide wrecked what was left of the incline tramway and its stairs. The tram system had been abandoned in 1900 when a road to the lighthouse was built. The slide also took the "sewer," which was probably the outflow pipe from the privy. (Courtesy U.S. Coast Guard.)

By September 1907, work began on a retaining wall at the top of the slide. A massive concrete wall was built along the old edge-line of the summit. The concrete wall was nearly double (at $6,300) the cost of another proposal which would have used redwood "cribwork" that would be anchored at intervals and filled in behind. (Courtesy U.S. Coast Guard.)

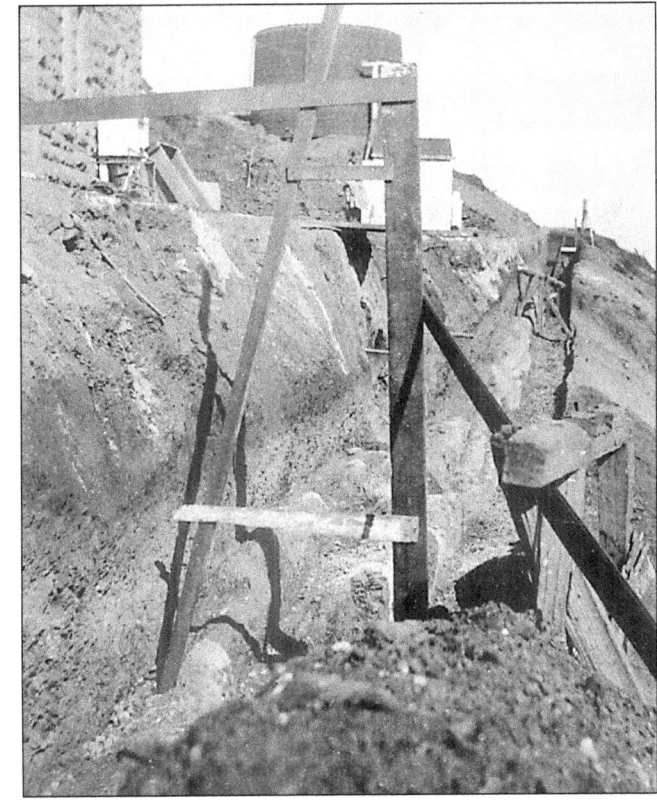

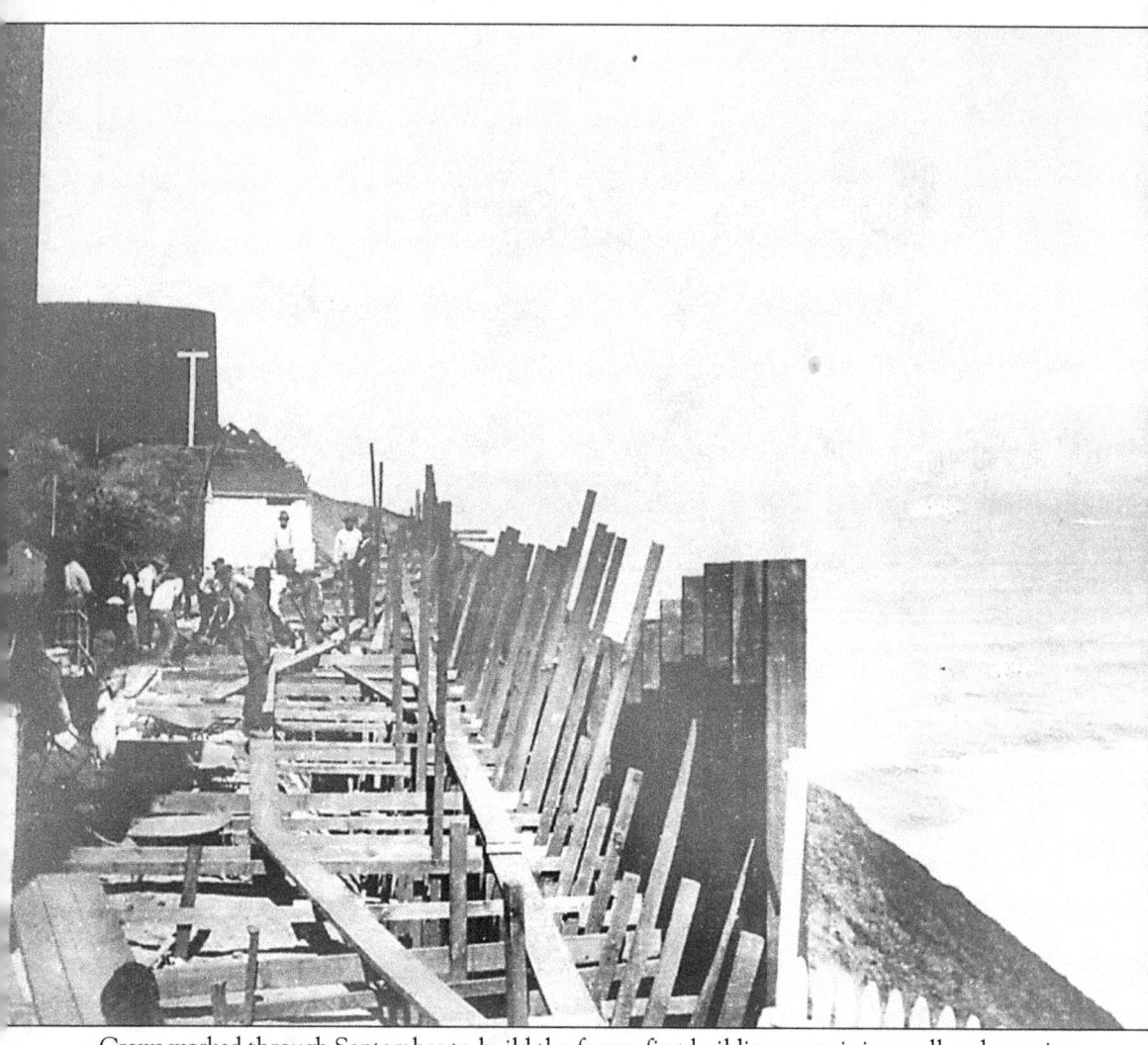
Crews worked through September to build the forms, first building a retaining wall and securing it into the rock. Except for the stone, all supplies had to be brought to Point Sur. During the summer of 1907, 398 barrels of cement were shipped to Point Sur. Hauling and labor costs for excavating, breaking stones, mixing concrete, back-filling, and building accounted for almost half the cost of the wall. (Courtesy U.S. Coast Guard.)

Huge retaining walls consisting of large lumber pieces and metal tie-rods became forms for the concrete that was poured between them. (Courtesy U.S. Coast Guard.)

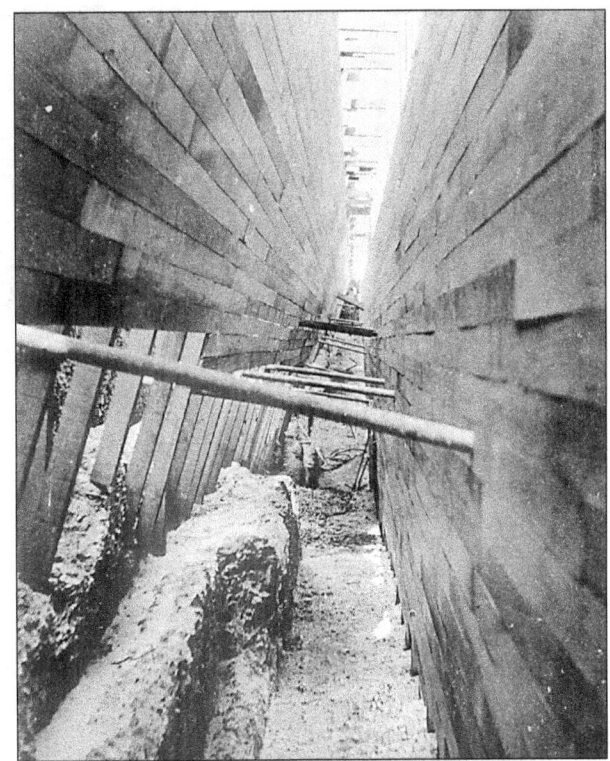

The wooden forms for the retaining walls begin to take shape. The final wall was much larger and took a good deal more concrete than the initial estimate projected. (Courtesy U.S. Coast Guard.)

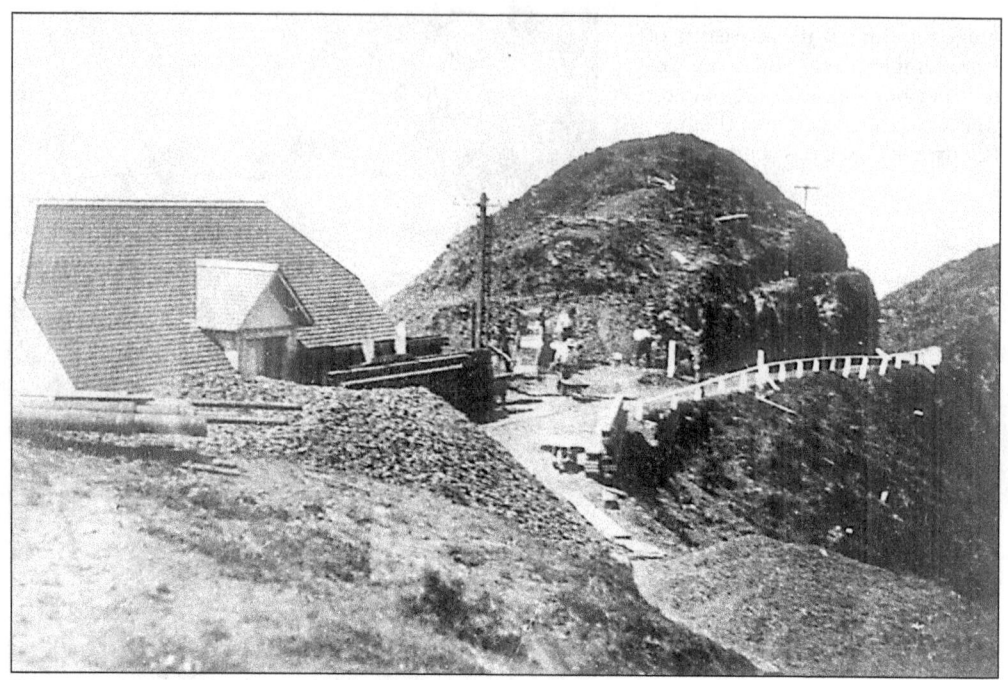

The concrete for the retaining wall was composed of gravel from the rock, mixed with the shipped-in cement. By November 1907, workers were breaking stone for gravel from an area that would eventually accommodate the carpenter-blacksmith shop north of the barn. (Courtesy U.S. Coast Guard.)

Gravel was carried in wheelbarrows to the slide site, while lumber for the project was piled up everywhere room could be found. (Courtesy U.S. Coast Guard.)

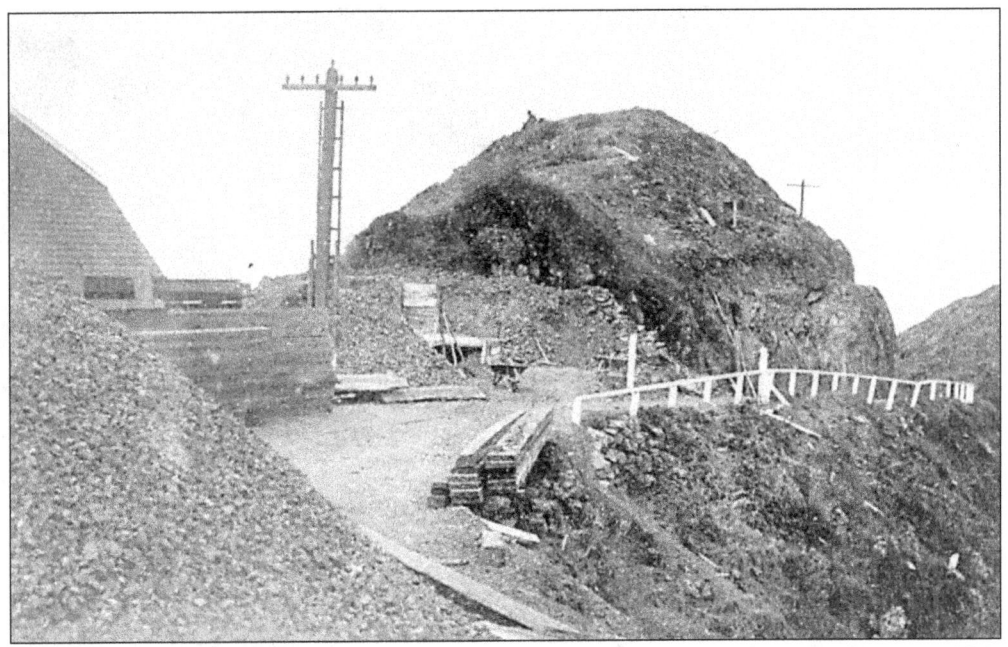

Soon, there was more gravel and less hill in the carpenter-blacksmith shop site. (Courtesy U.S. Coast Guard.)

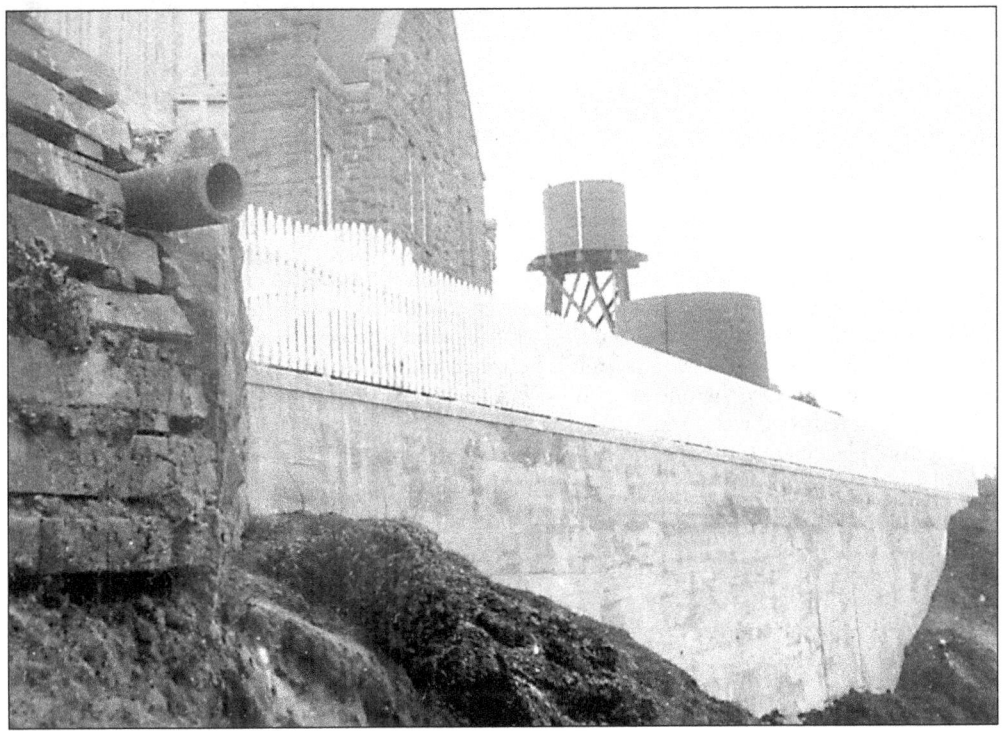

By the end of November 1907, less than two months after starting work, the retaining wall was completed. This massive structure, which used 357 cubic yards of concrete, was 177 feet long, from 7 feet to 21 feet deep, and 18 inches wide. (Courtesy U.S. Coast Guard.)

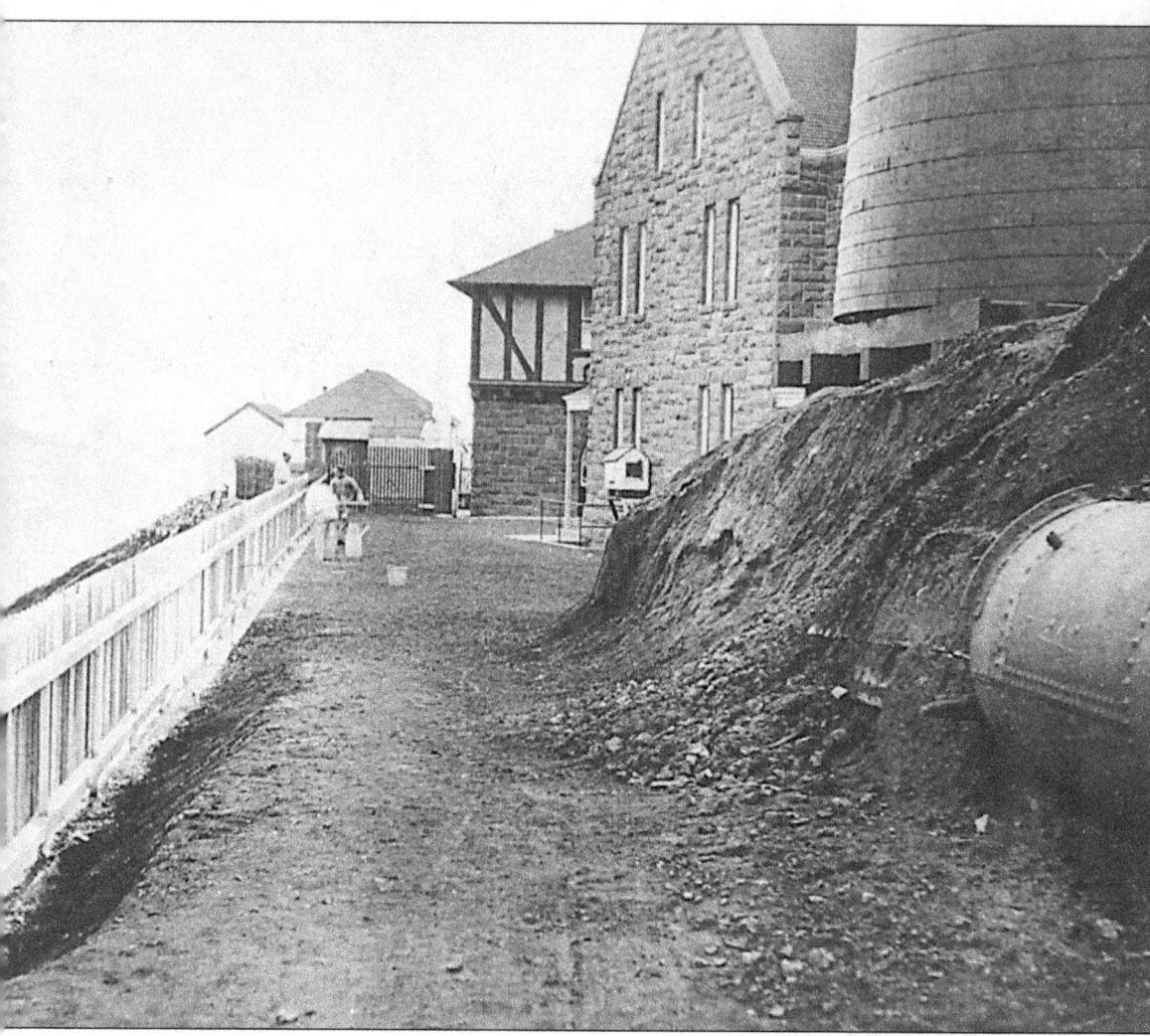

The new retaining wall has held for almost 100 years, and looks much the same today as it did in this November 1907 photograph. From the left, the poultry house is visible behind the construction superintendent's house, which itself is behind a tall picket fence. The half-timbered head keeper's house, formerly the one-story hoist house, is next, and then the massive triplex. The 10,000-gallon redwood water tank sits on wooden decking. A tank lays nearby on the right for some future placement, perhaps the oilhouse down near the lighthouse. (Courtesy U.S. Coast Guard.)

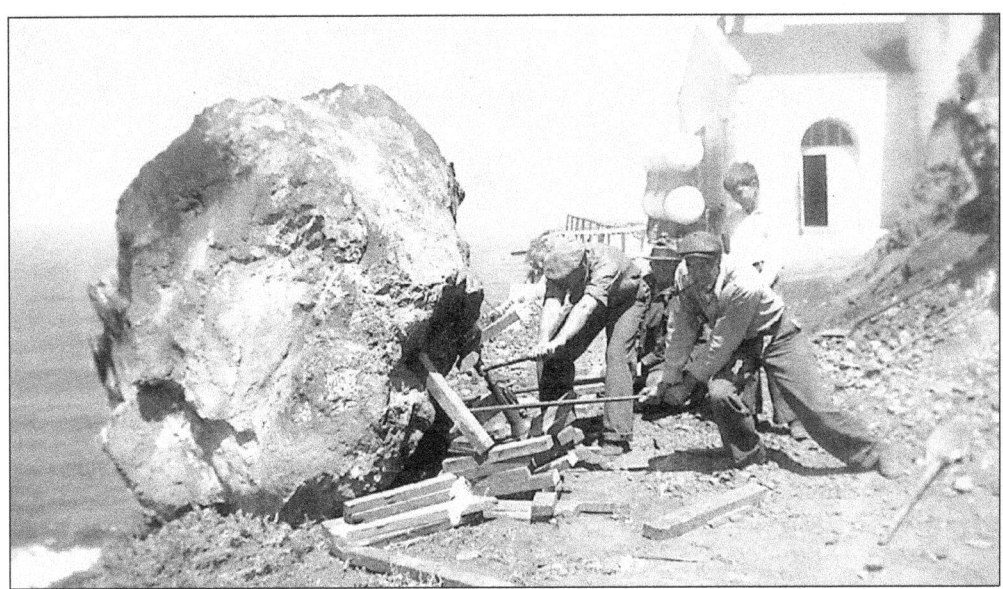
Despite thorough engineering of the site, natural hazards abounded. In 1939, an enormous boulder fell on the road near the lighthouse. (Courtesy Wayne Piland.)

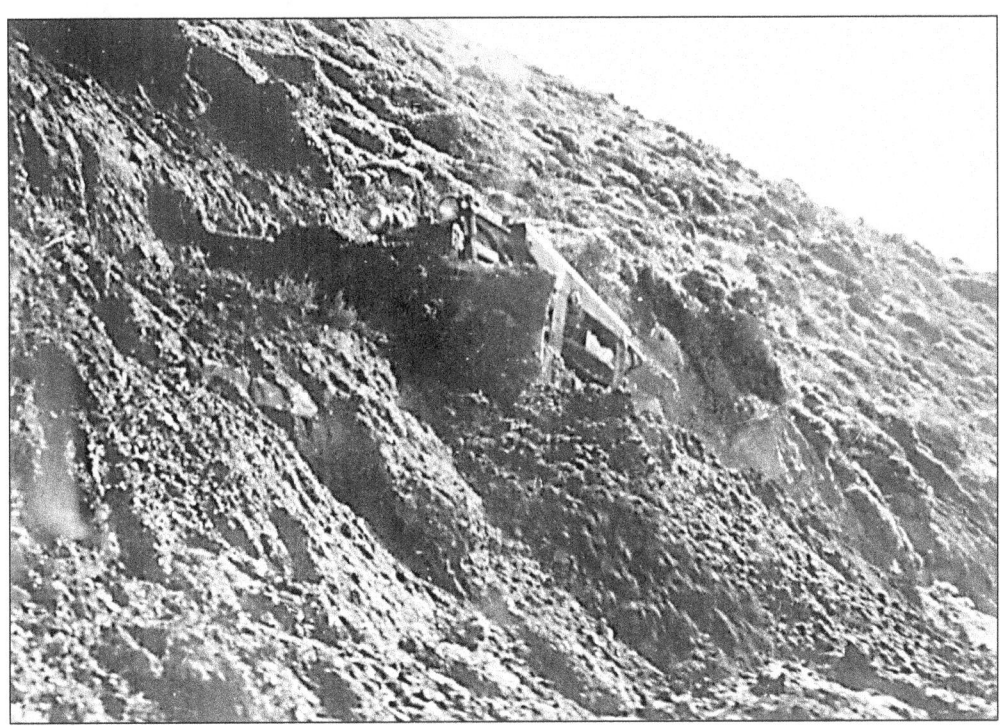
In 1940, a slide on the upper road, just above the fork, required the use of a bulldozer. First the heavy vehicle had to work its way through the newly dislodged and unstable dirt to get to the upper side. One slip and the bulldozer could fall hundreds of feet to the ocean. (Courtesy U.S. Coast Guard.)

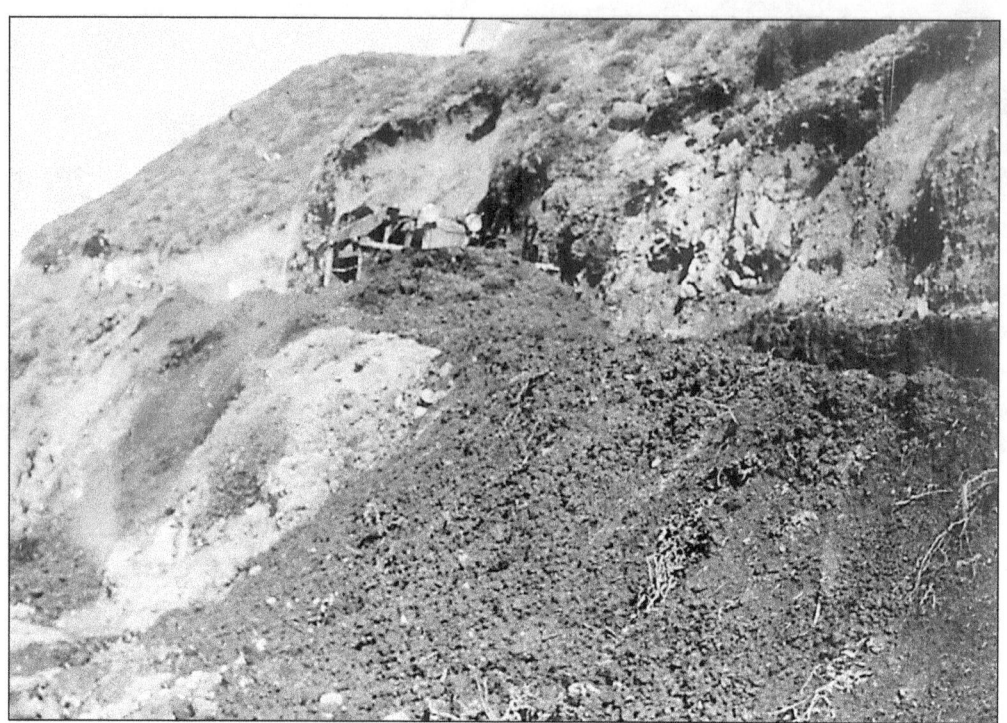

The bulldozer worked from the top of the large slide. Landslides are common in the Big Sur; at times, a large slice of earth can fall away in one piece without warning. (Courtesy U.S. Coast Guard.)

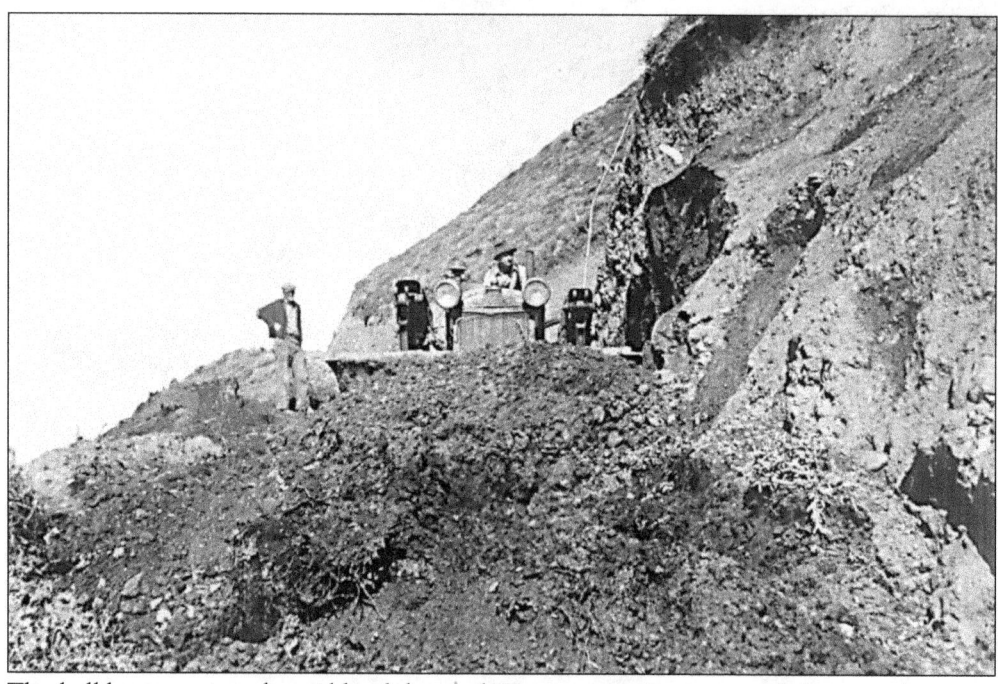

The bulldozer was just the width of the road. Extreme caution was needed to avoid causing landslides or other accidents. (Courtesy U.S. Coast Guard.)

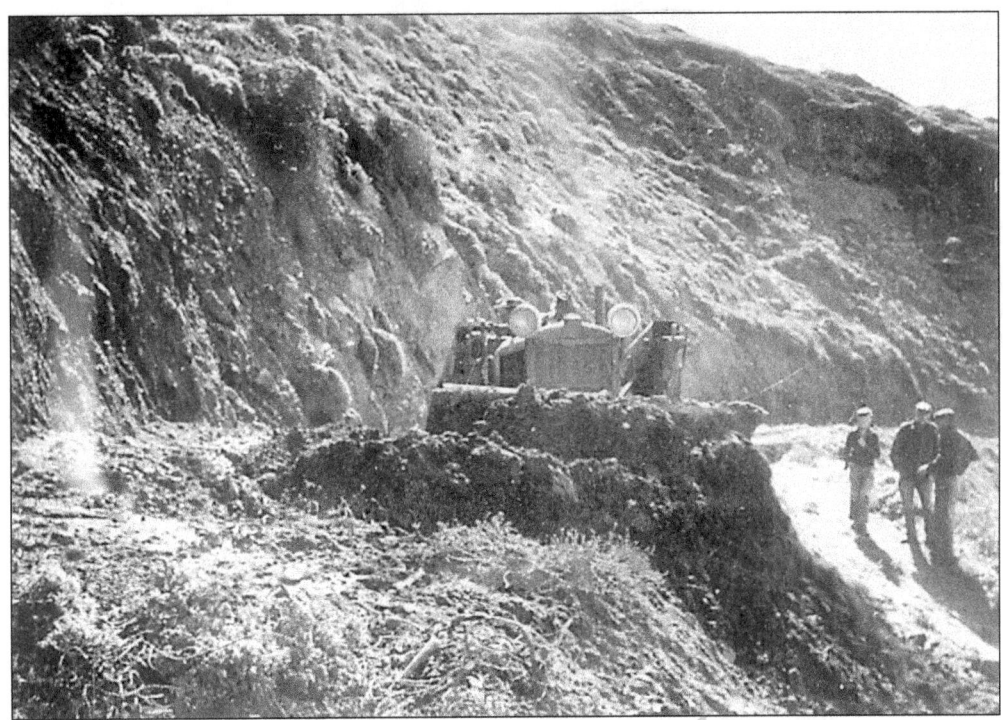
The slide was so large that workers had to tackle it from both sides. (Courtesy U.S. Coast Guard.)

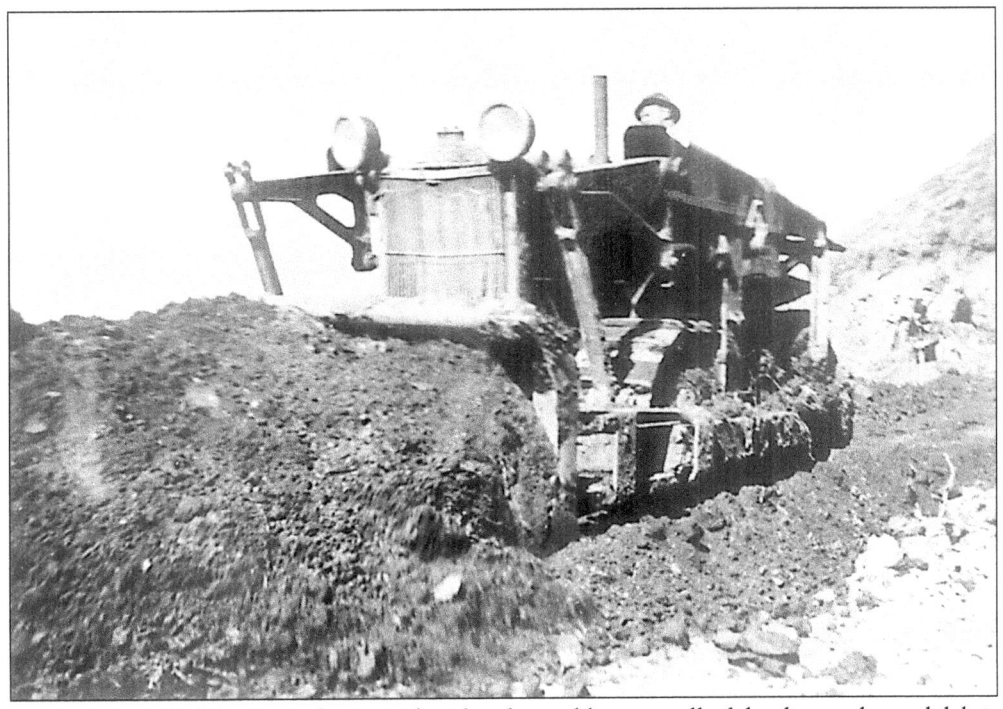
Eventually the bulldozer got the upper hand and was able to get all of the dirt, rocks, and debris over the side. (Courtesy U.S. Coast Guard.)

Again in 1941, dirt and rocks fell onto what is now called "Macon Point" and blocked the road. Instead of using earth-moving machinery alone, this time explosives were also used to move the blockage. (Courtesy Dorothy Delcenio.)

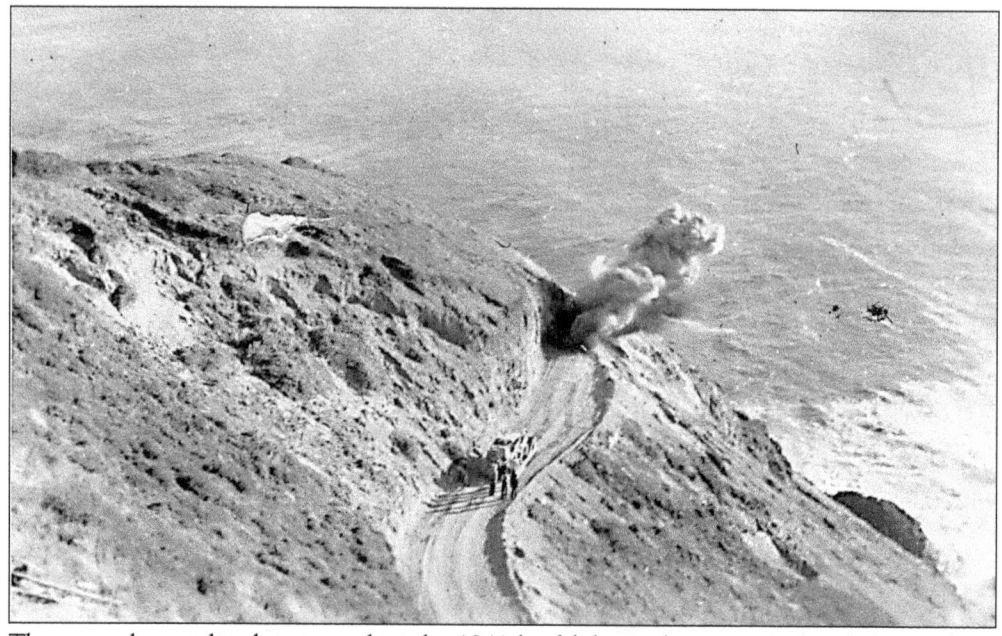
The men who set the charges to clear the 1941 landslide can be seen standing behind a bulldozer while the explosion goes off. (Courtesy of Dorothy Delcenio.)

Four

WATER

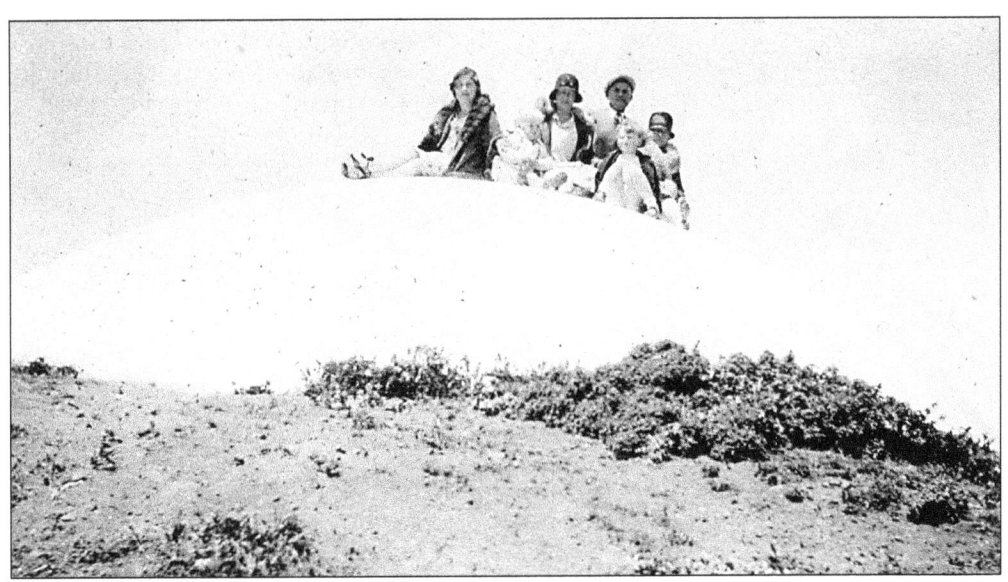

Water was always a concern at Point Sur. Since no water was available on the rock itself, a well was dug in the sand flats near the base of Point Sur, and water was pumped to a cistern located at the top. The cistern was the first structure built at Point Sur and stored 55,000 gallons of water underground in a brick-lined reservoir that measured 18 feet across and 12 feet deep. In this view (c. 1930), a group climbed to the top of the cistern to have their picture taken. (Courtesy Elvina Fraser La Riviere.)

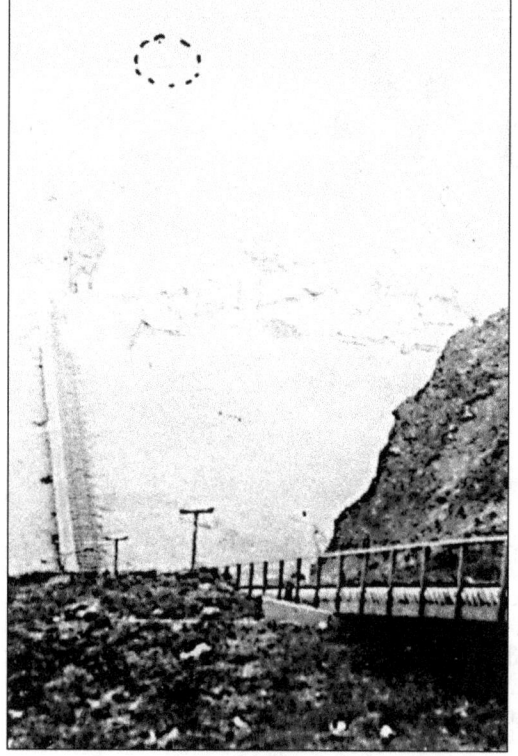

This 1888 map, prepared during the construction of Point Sur, shows the well or pumping station, directly down the hill from the cistern. The pipe from the well to the cistern ran almost parallel to the east hoist railroad. (Courtesy U.S. Archives.)

Interestingly, the pumping station, marked by a dotted line in this detail from an 1889 construction photograph, is located on a direct line from the end of the railroad, not on a line parallel to it. The place shown as the pumping station location in this photograph, is the location of a spring. (Courtesy U.S. Archives.)

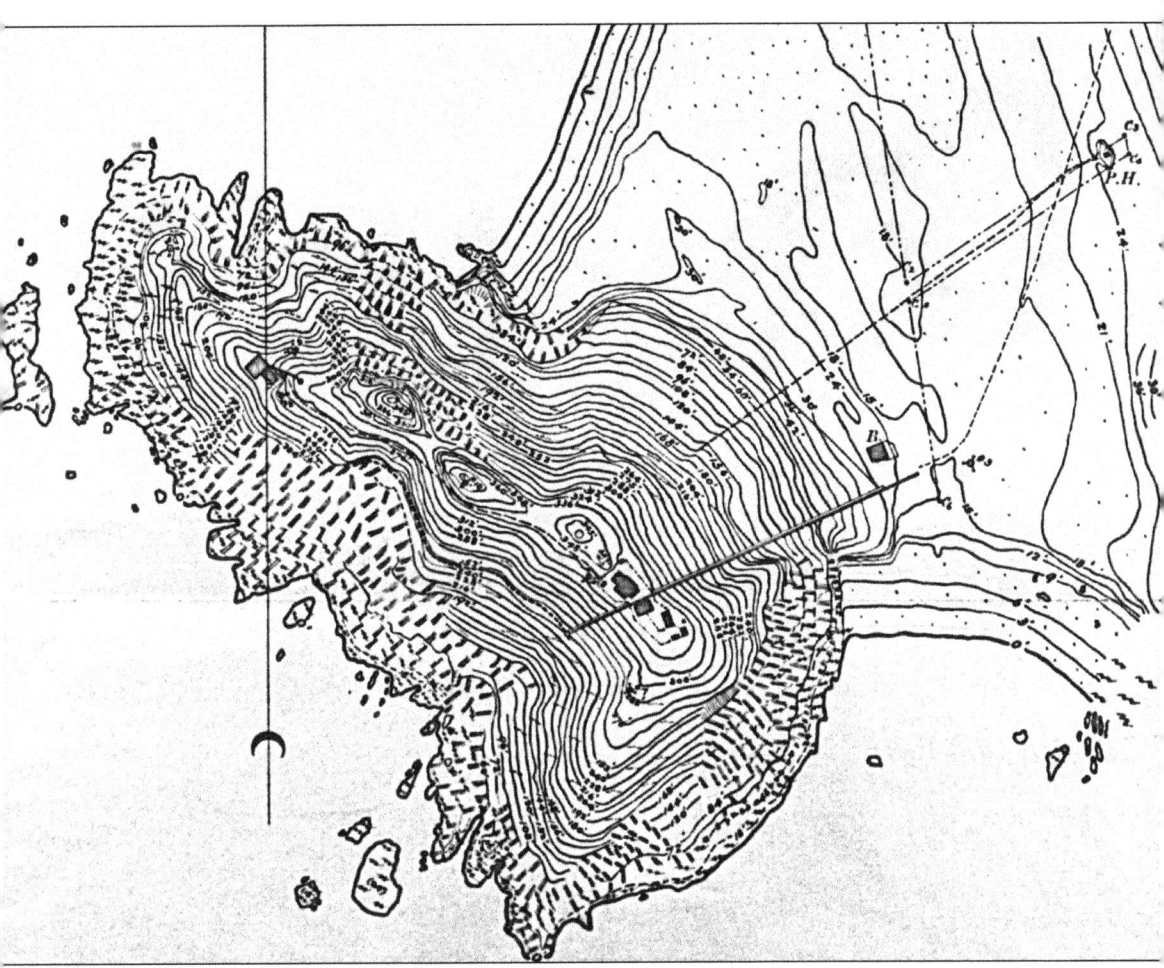

An 1899 map of Point Sur shows the well located in the same place as in the earlier 1888 map. The well and pipes that carried water to the cistern at the top of Point Sur are several yards north of the rail line. Except for the spring, no remains have been found of the original water source or pumping station for Point Sur. It is possible that the spring was too close to the ocean to assure its fresh water purity. Point Sur's property line juts out around the well along the road right-of-way. A barn at the top of Point Sur and the carpenter/blacksmith shop are not on the map. (Courtesy U.S. Archives.)

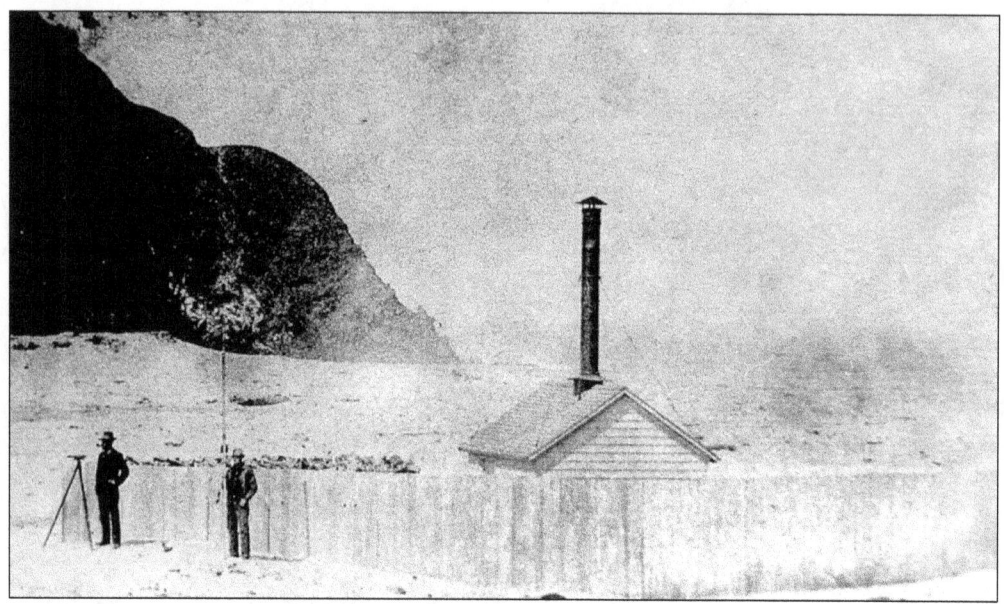

Water from the well on the sand flats was going "bad" as early as in the 1890s. Floods from winter storm tides often surrounded the well. By 1893, a fence was put around the pumping station to keep out ocean water and sand. (Courtesy Herbert Bamber, U.S. Light-House Establishment photo.)

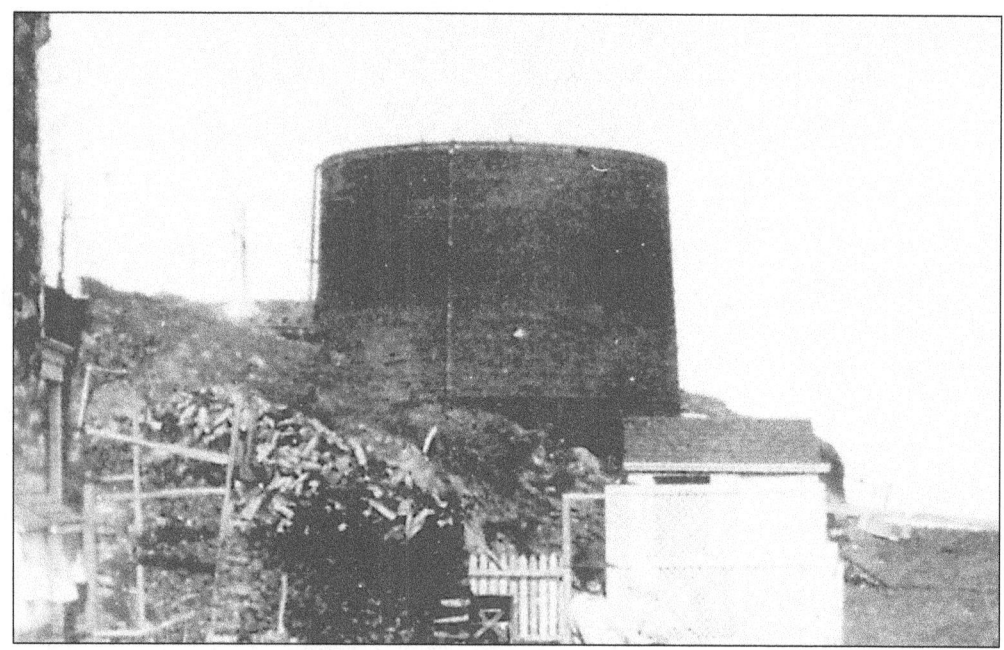

Keepers were instructed to obtain fresh water from the buildings' roofs. A 10,000 gallon storage tank for storing fresh water was constructed behind the keepers' quarters (now called the triplex). Water was to be diverted from the roofs, through the gutters and downspouts, into the new tank. Keepers were instructed to let it rain for several minutes to clean out the system before diverting the water. This detail from an early 1907 photograph shows the water tank on a ridge behind the two-seat privy. On the left is the keepers' food cooler. (Courtesy U.S. Coast Guard.)

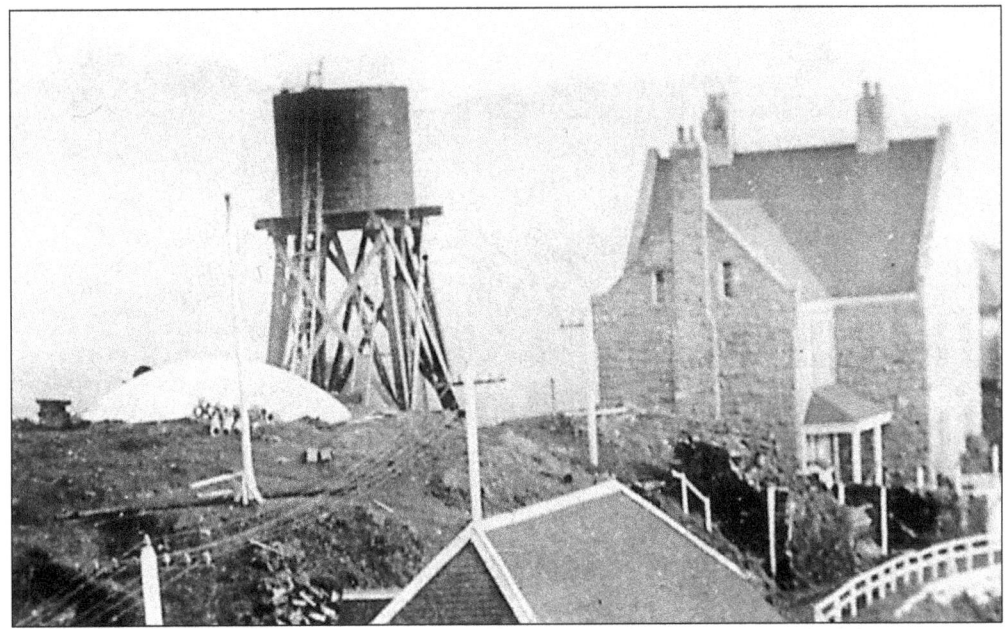

In 1907 flush toilets were installed at Point Sur. In the assistant keepers' quarters (in the triplex), they were installed on the third floor. An elevated water tank had to be built higher than the toilets so there was enough water pressure to flush the new toilets. This 1907 photograph shows the new elevated 18,000-gallon tank, the cistern on the left, and the quarters on the right. (Courtesy U.S. Coast Guard.)

In this c. 1910 photograph, the elevated water tank is visible built between the cistern and the ground-mounted redwood water tank. (Courtesy U.S. Coast Guard.)

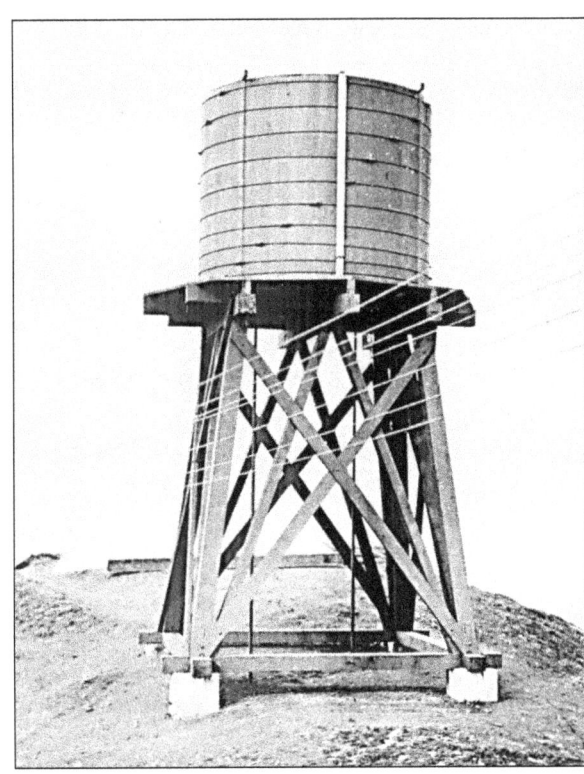

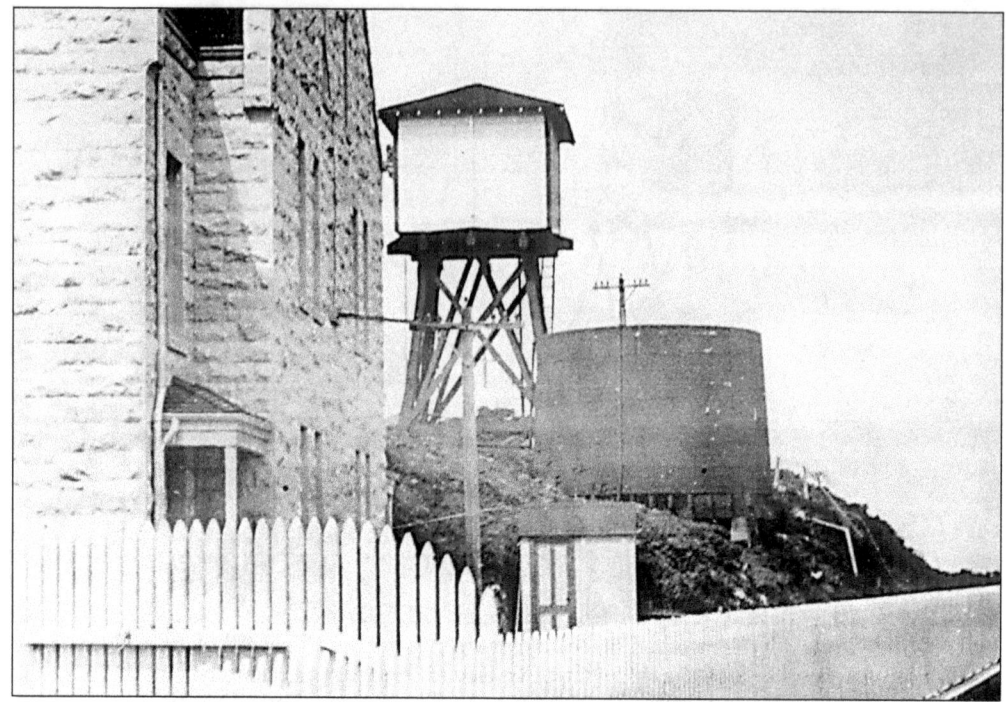

The round elevated water tank was encased in a boxy enclosure sometime before 1920. This 1924 photograph shows the elevated water tank, the ground-mounted redwood tank, and the old privy building, now probably having some other use, was moved several feet west. The privy is in the space where a garage would be built in 1925. (Courtesy U.S. Coast Guard.)

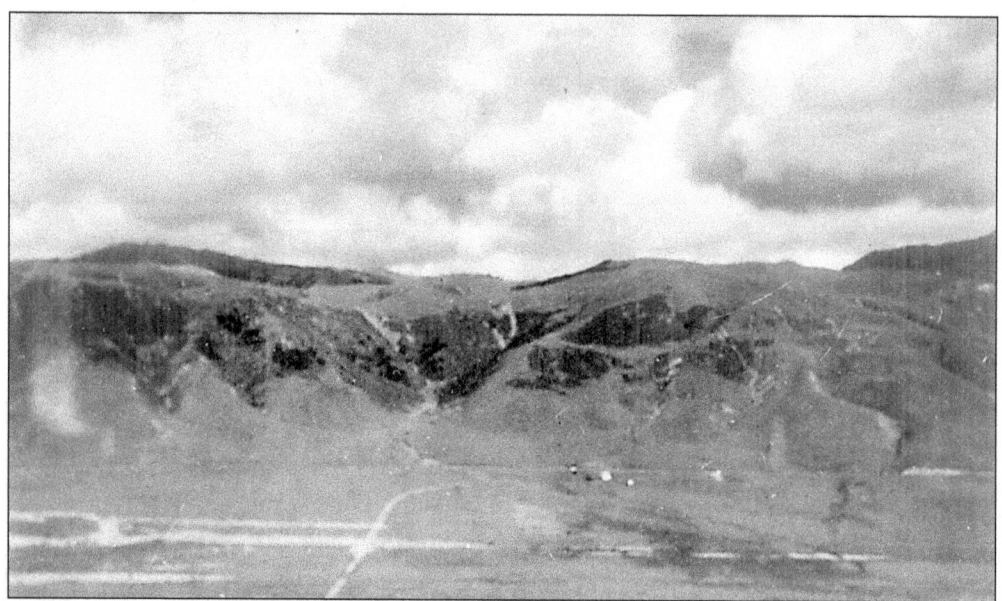

A spring high in the hills on the El Sur Ranch was envisioned as a fresh-water source for the lightstation. Negotiations began for this water in the late 1890s with the owner of the El Sur Ranch, whose lands are east of Point Sur. In this c. 1935 photograph of the hills, the spring is located above the canyon in the center of the picture. (Courtesy U.S. Coast Guard.)

It took almost 20 years before negotiations with the rancher were complete and the Lighthouse Service had secured the spring and a right-of-way for pipes to take the water to Point Sur. Because the spring, as shown in this *c.* 1915 photograph, is located higher than the cistern at the top of the rock, water could flow by gravity into the cistern. (Courtesy U.S. Coast Guard.)

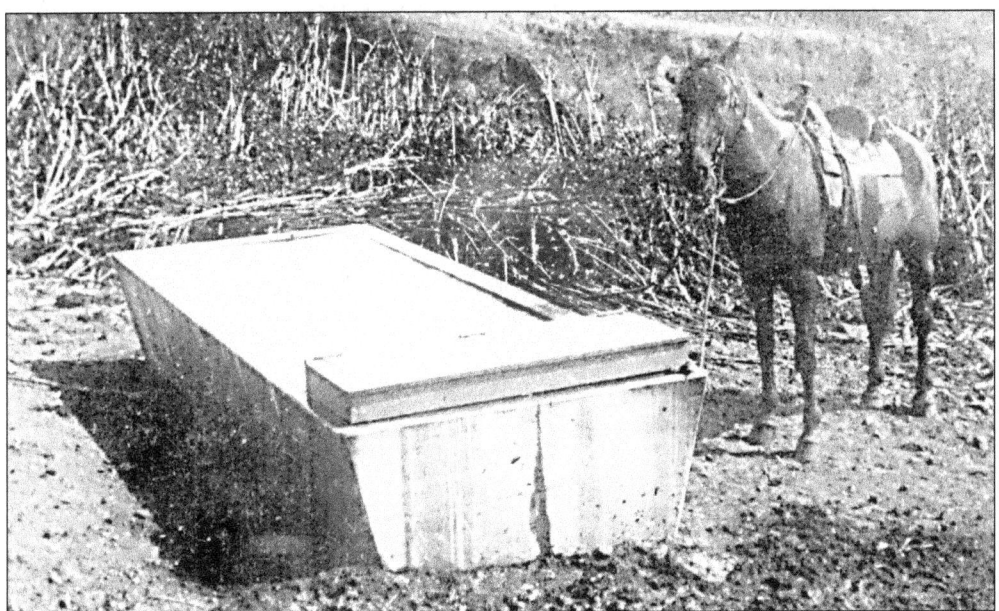

The ranch was not going to give up all rights to the water, however. The eventual agreement gave the rancher's cattle first claim on the water. This *c.* 1915 photograph shows one of four concrete water troughs along the pipeline to the lightstation that had to be filled before the remainder of the water was allowed to flow to Point Sur. The mechanism inside the troughs was similar to the float system inside toilet tanks. It controlled the level in the troughs and once full, allowed water to flow through the pipe supplying the lightstation. (Courtesy U.S. Coast Guard.)

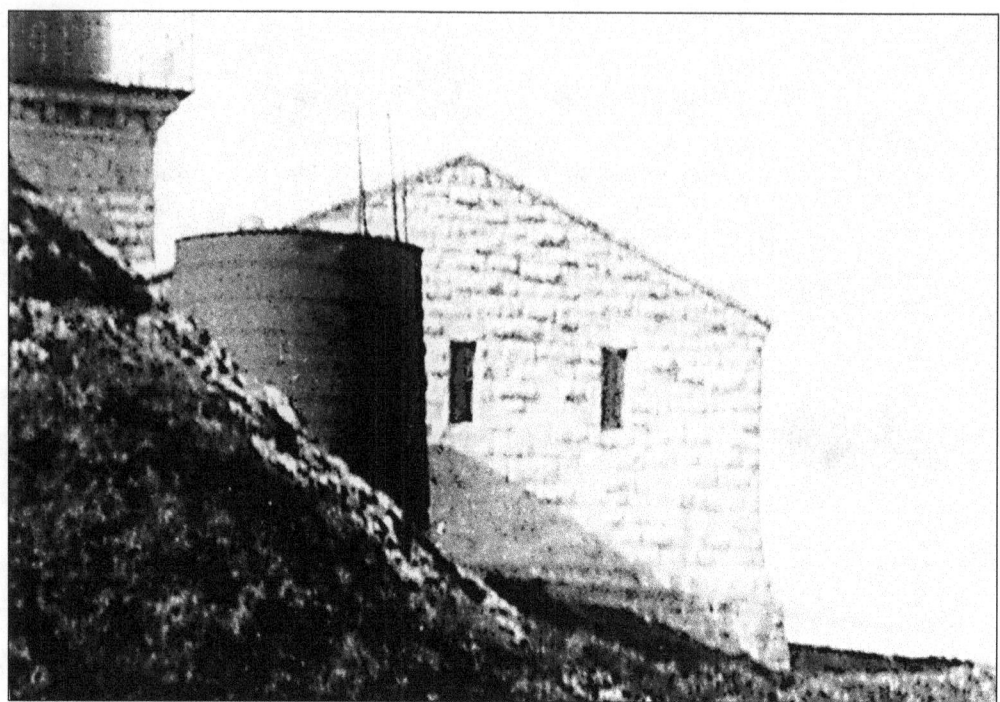

Water wasn't needed just for the lightkeepers and their families. The fog signal was steam driven from 1889 until 1910 and required a lot of water. The original water tank at the lighthouse was placed on the ground, level with the southwest side of the lighthouse. Sometime before 1910, it was moved to the east side of the lighthouse, as shown in this detail from a 1925 photograph. (Courtesy U.S. Coast Guard.)

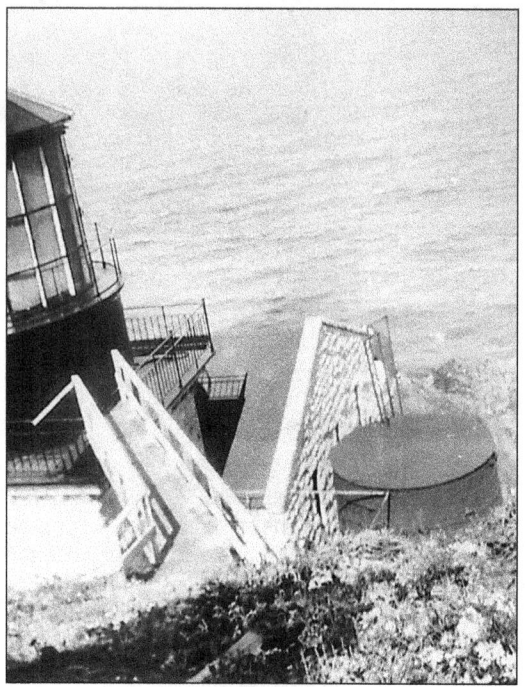

The east-side water tank, shown in this undated photograph, was installed after the steam fog signal was replaced. Water was needed to cool the machinery that made the compressed air, and then later, for the bathroom installed inside the lighthouse in 1930. (Courtesy U.S. Coast Guard.)

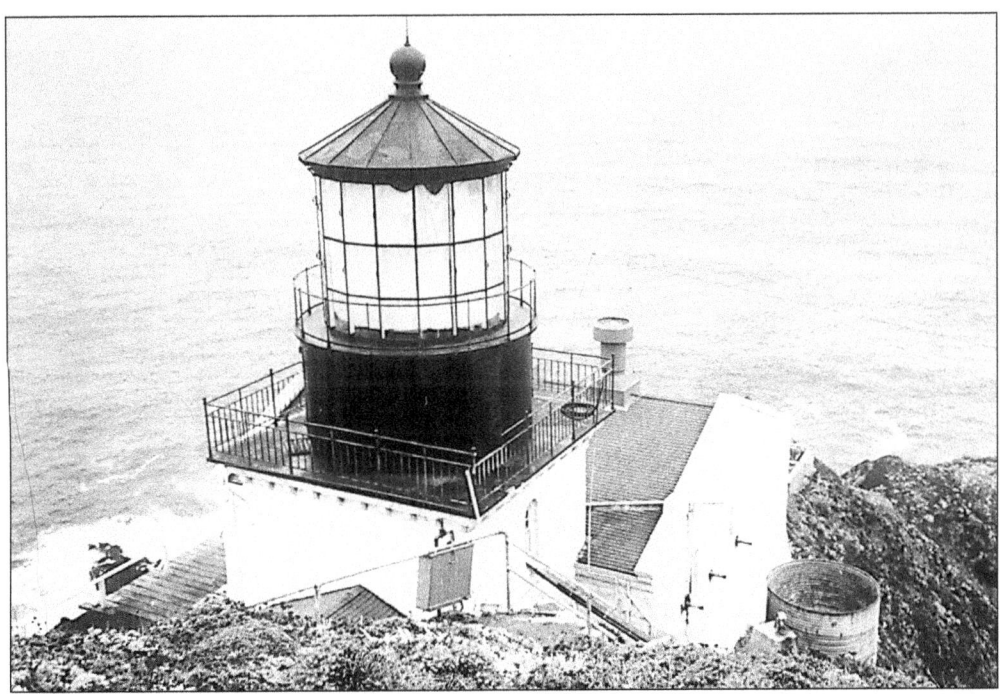

After it was no longer needed, the water tank was left to deteriorate in place as seen in this undated photograph. (Courtesy U.S. Coast Guard.)

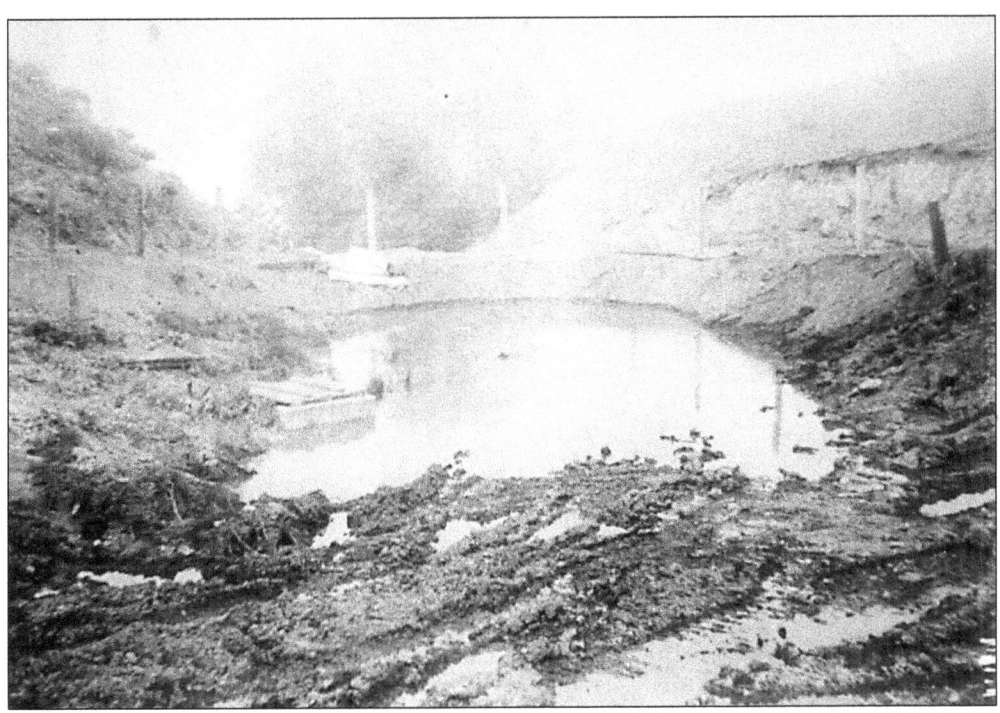

Keepers were still making inspections on the spring in the hills, as shown in this 1962 photograph. Their job was to hike the several miles into the hills, view the water levels, and clear the spring, sometimes of rattlesnakes. (Courtesy U.S. Coast Guard.)

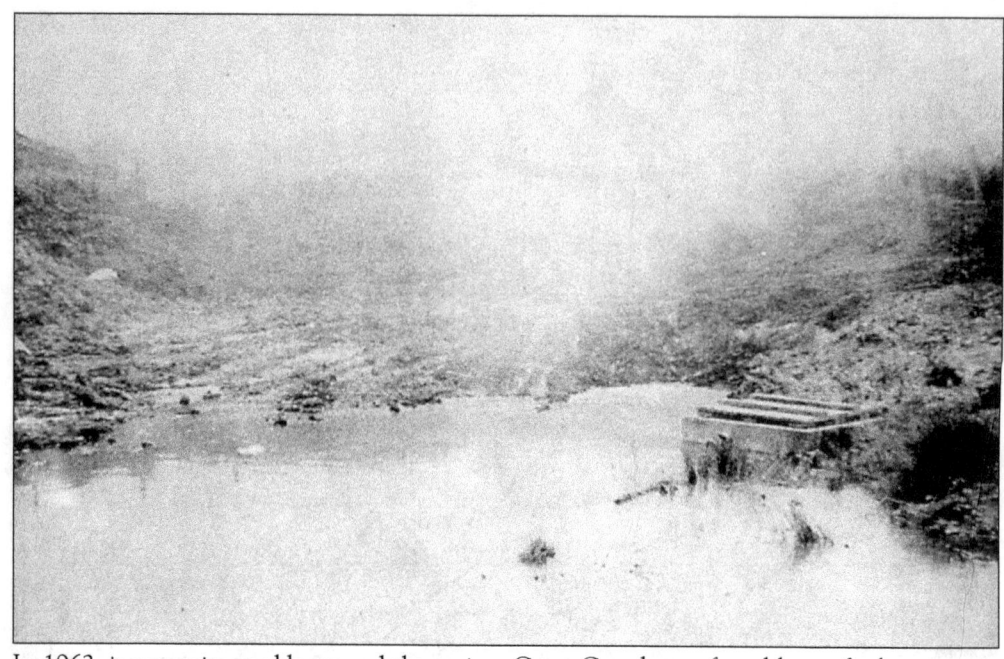

In 1962, it was quite muddy around the spring. Coast Guardsmen found large, fresh mountain lion tracks next to the spring. (Courtesy U.S. Coast Guard.)

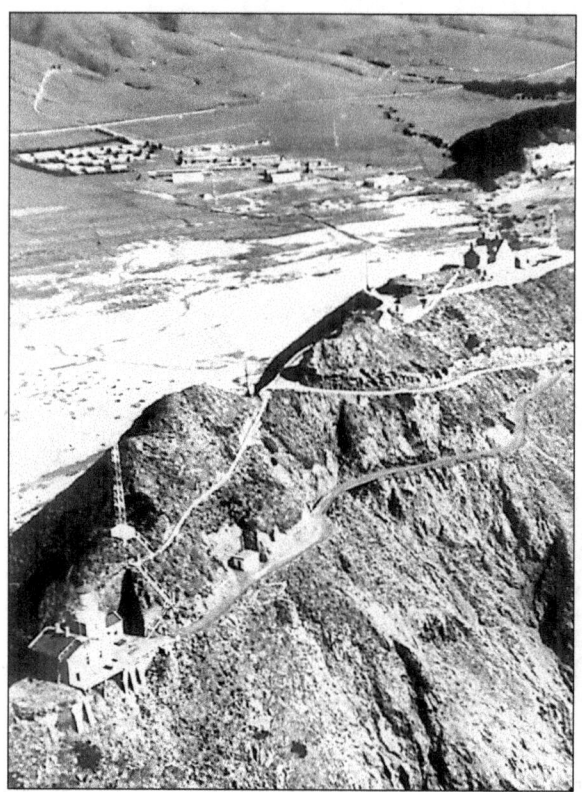

In 1958, a small naval facility was built near Point Sur. Water for the lightstation then was available from the Navy's water supply. By the early 1970s, pipes from the spring in the hills were diverted to the Navy tanks. In this 1969 aerial view, the naval facility is visible beyond Point Sur and the water tanks are located at the end of the short road in the upper left. (Courtesy U.S. Coast Guard.)

Five

THE LIGHTHOUSE

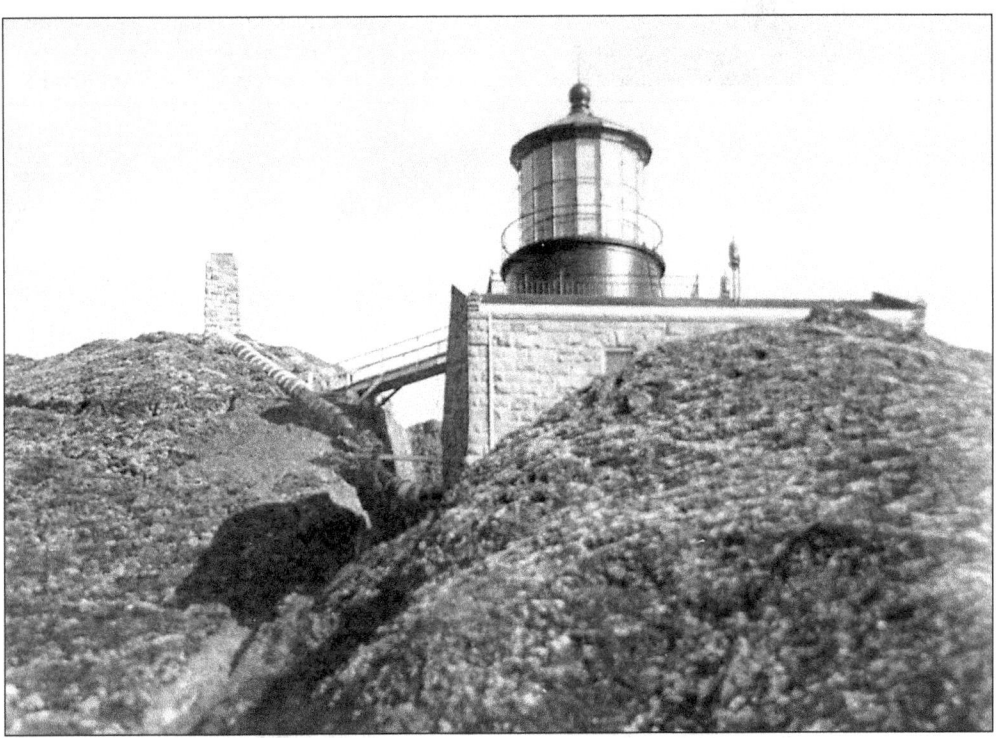

This 1893 photograph is one of the earliest images of the lighthouse on Point Sur. A terra cotta pipe can be seen funneling smoke from the steam boilers in the fog signal room, away from the lantern room to the smokestack on the leeward side of the lighthouse. If smoke were allowed to rise straight up from the boilers, the prevailing northwest winds would blow it onto the storm panes of the lantern room. (Courtesy Herbert Bamberg, U.S. Light-House Establishment photo.)

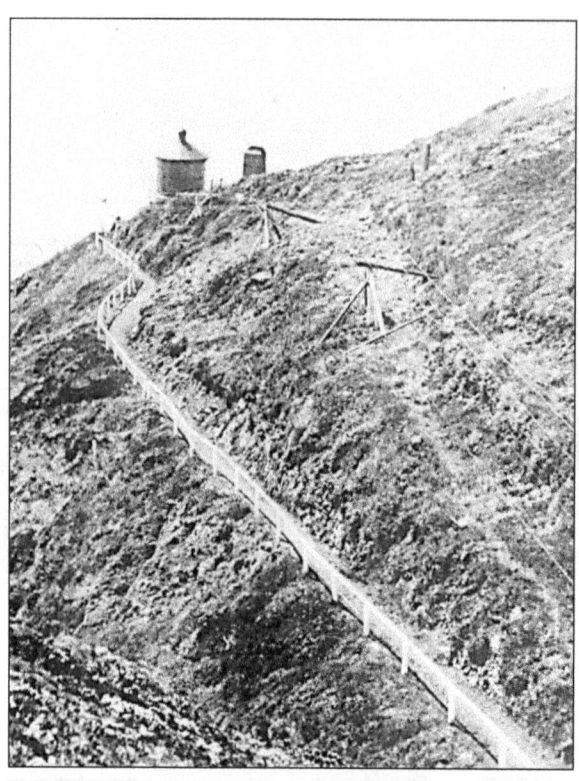

The smokestack can be seen above the trail in 1907. Telephone lines that linked the keeper's quarters with the lighthouse can also be seen paralleling the trail. (Courtesy U.S. Coast Guard.)

The steam-driven fog signal is visible on the roof in this 1907 photograph. The system used whistles that sounded like ship's horns, and had two sets of boilers and whistles, a primary and a backup. The fog signal's signature was a 5-second sound, every 20 seconds. (Courtesy U.S. Coast Guard.)

Redwood and oak fueled the boilers, which used over 100 cords of wood in an average year. Wood can be seen stacked up next to the oil room on the southwest side of the lighthouse in this 1907 photograph. It took 42 minutes to fire up the boilers and get steam to the 12-inch fog whistles. (Courtesy U.S. Coast Guard.)

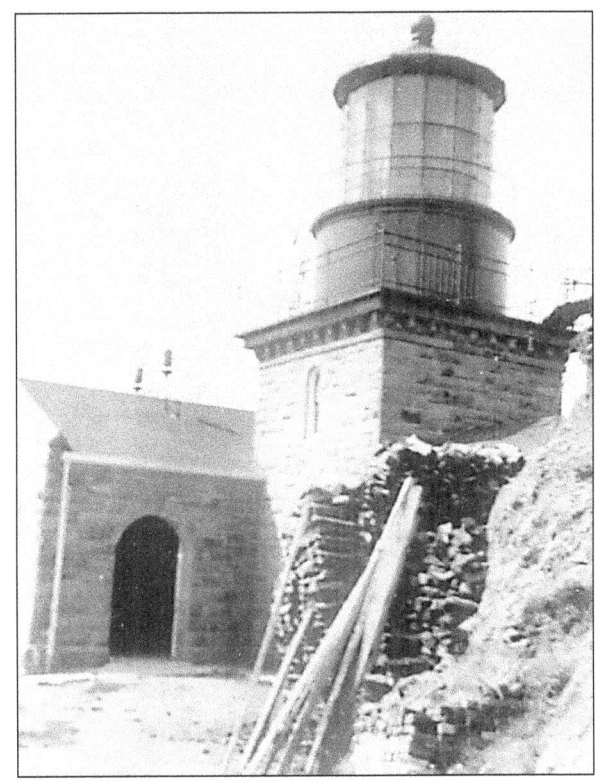

Wood was cut locally and delivered in wagons pulled by mules. A rail line took wood to the lighthouse until 1900 when the road was built in its place. An area on the north side of the lighthouse was leveled to provide a turn-around space for the wagons. In this 1907 photograph, the mules and wagons have turned around already. The lighthouse privy, perched on the edge of a cliff, is on the left. Note the little girl standing on top of the woodpile. (Courtesy U.S. Lighthouse Society.)

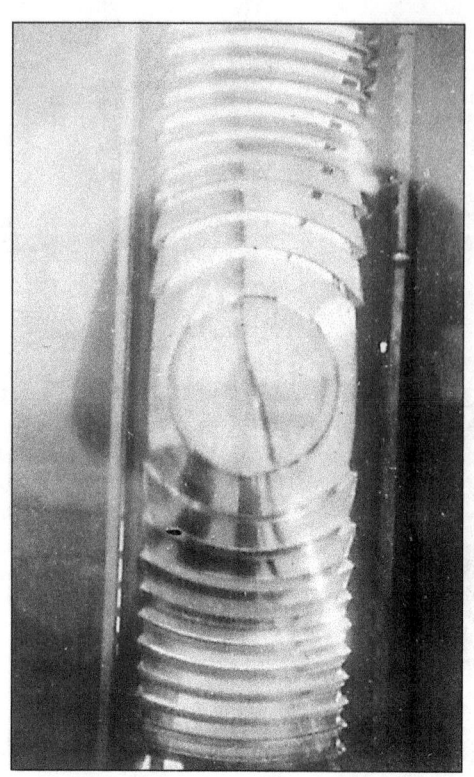

This *c.* 1910 photograph shows just one panel of Point Sur's 16-panel Fresnel lens. Point Sur was a major point of navigation, and so it was equipped with a first-order Fresnel lens, the largest made. At over six feet in diameter and almost nine feet high, its light could be seen to the horizon, which for the Point Sur light, at 270 feet high, is 23 miles. (Courtesy U.S. Coast Guard.)

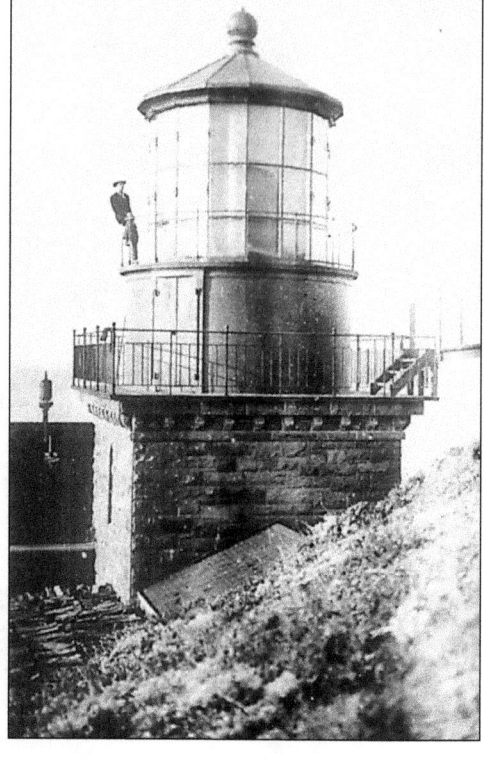

A lightkeeper relaxed against the lighthouse's gallery railing in 1910. Wood was piled up below him to fuel the steam-driven fog whistle on the roof behind him. To protect the light source inside the Fresnel lens from the sun, a curtain was drawn inside the lantern room. (Courtesy U.S. Coast Guard.)

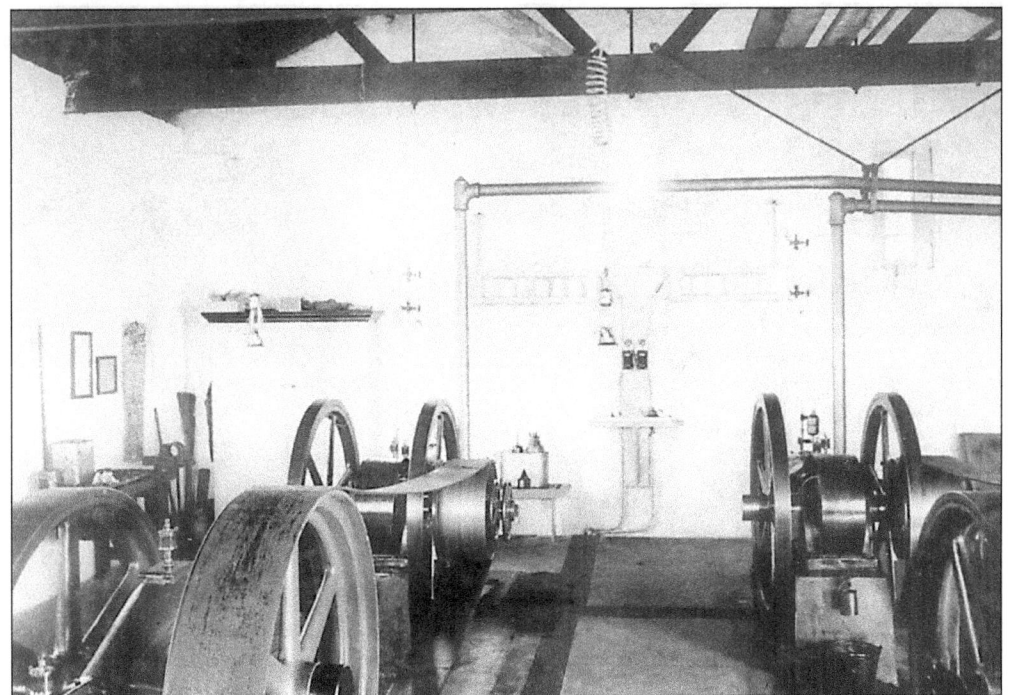

Changes in the fog signal in 1910, from steam to compressed air, meant that the fog signal could be sounded almost instantaneously instead of waiting for boilers to get up steam. The new first-class compressed air siren fog signal is visible in this rare interior 1914 photograph taken in the fog-signal room. (Courtesy U.S. Coast Guard.)

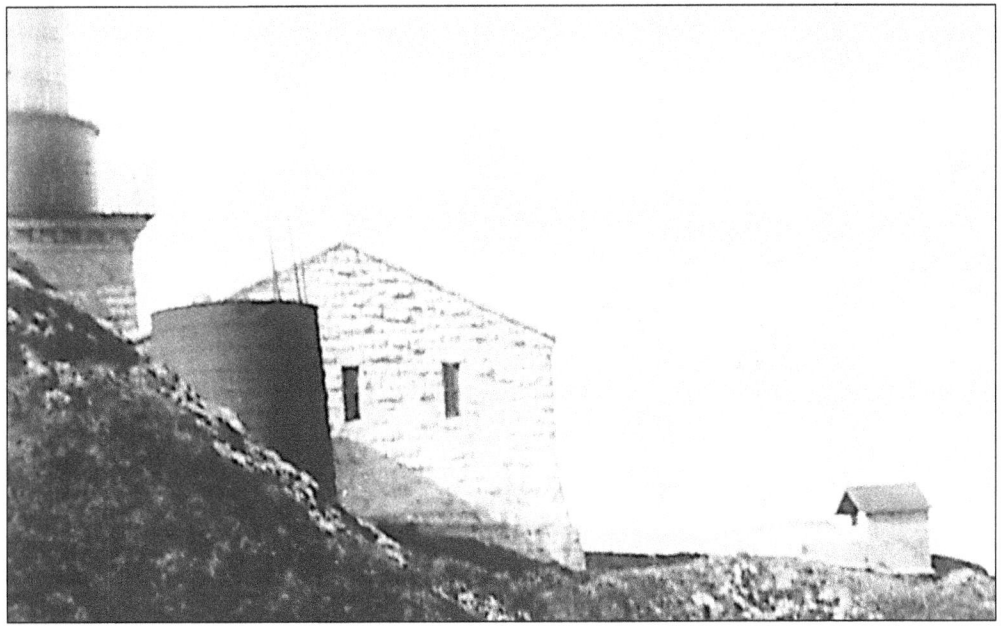

A small brick fuel tank house also was built in 1910, visible on the far right in this *c.* 1925 photograph. It held 120 gallons of fuel and was linked by pipes to the new oil house 300 feet away. (Courtesy U.S. Coast Guard.)

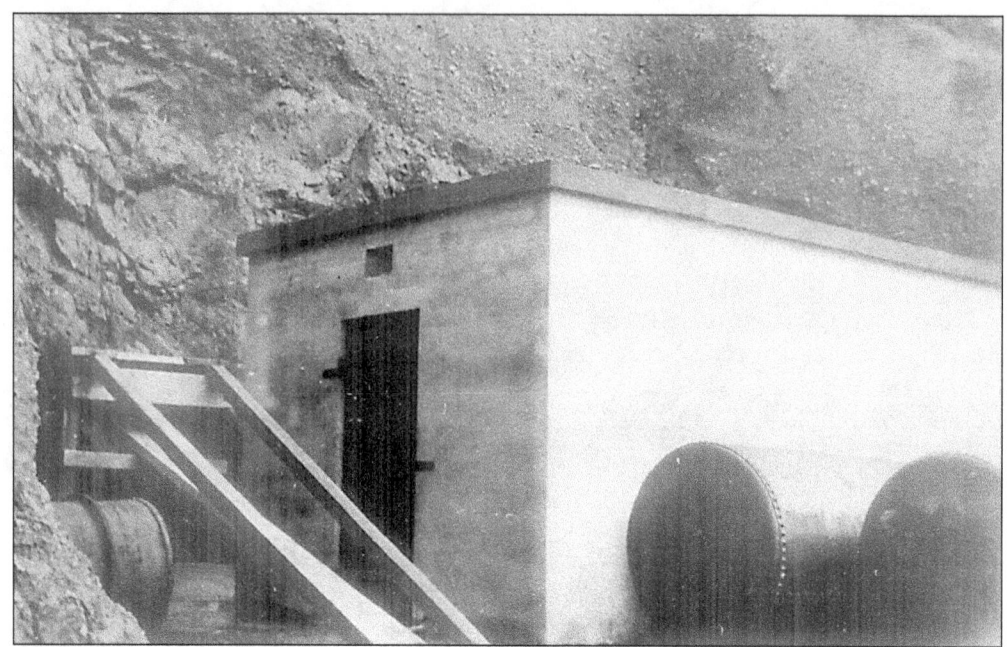
The oil house was placed in an area blasted out of the rock, just south of the lighthouse. Oil tanks seen here waiting for installation were placed inside. (Courtesy U.S. Coast Guard.)

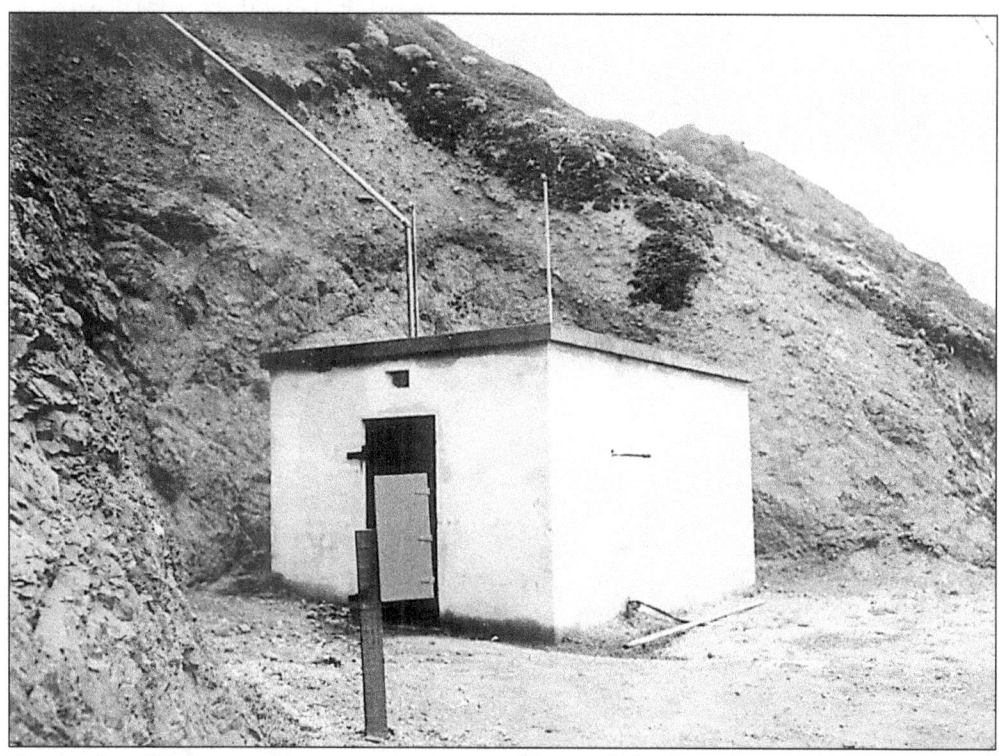
Eventually, oil was poured into pipes at the top of the south landing almost 1,000 feet away; oil flowed down into tanks inside the oil house. Those pipes are visible in this post-1974 photograph. (Courtesy U.S. Coast Guard.)

In 1914, Assistant Keeper Clyde Church stood on the gallery for this photograph. The new fog signal is clearly visible on the roof behind him. The compressed-air signals kept the original signature of a 5-second blast every 20 seconds. (Courtesy Elsie Church Goff.)

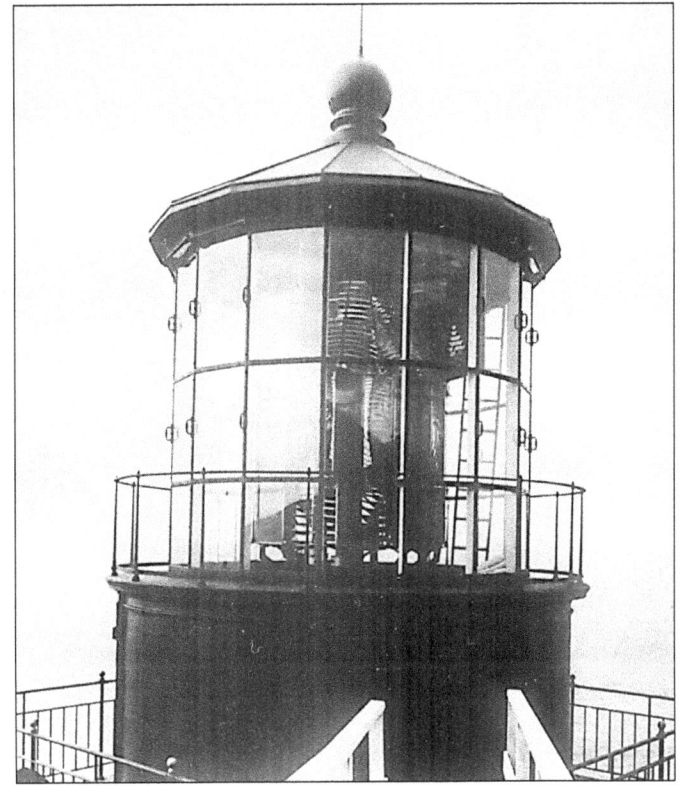

Another 1914 photograph of the lantern room shows a rare view with the Fresnel lens uncovered. A ladder is propped inside so the keeper can wash the storm panes. Brass handles are attached to the outside so he can hold on in the high winds when washing the outside of the panes. (Courtesy U.S. Coast Guard.)

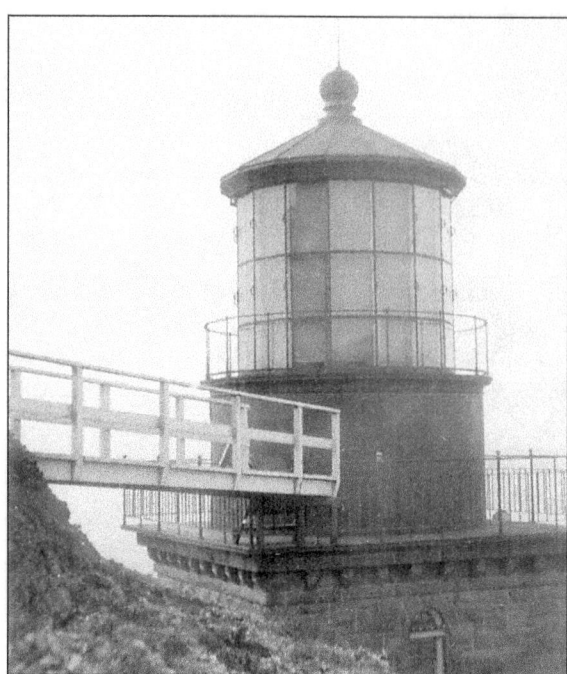

This bridge was the light keeper's primary access to the lighthouse from the quarters above. The only other access to the lighthouse was by the road from below. The stairs from the trail to the base of the lighthouse were not built until the 1940s. (Courtesy U.S. Coast Guard.)

The curtains are closed in the lantern room in this 1920 view of the lighthouse. The compressed-air fog sirens are on the fog-signal room roof on the left and the walkway from trail to gallery comes in from the right. The top of the water tank is just visible under the walkway. (Courtesy U.S. Coast Guard.)

By the time this photograph was taken in 1924, the lighthouse had been painted or whitewashed. The water tank is no longer visible, as it was either moved or removed. All of the other details remain the same as the previous photograph. (Courtesy U.S. Coast Guard.)

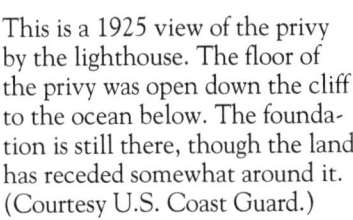

This is a 1925 view of the privy by the lighthouse. The floor of the privy was open down the cliff to the ocean below. The foundation is still there, though the land has receded somewhat around it. (Courtesy U.S. Coast Guard.)

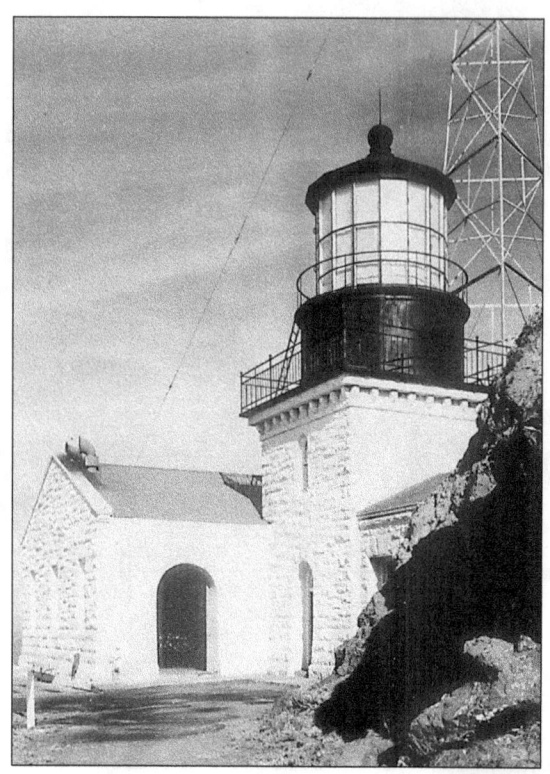

A radio beacon tower was built on the hill behind the lighthouse in 1926, and it can be seen in this 1933 photograph. (Courtesy U.S. Coast Guard.)

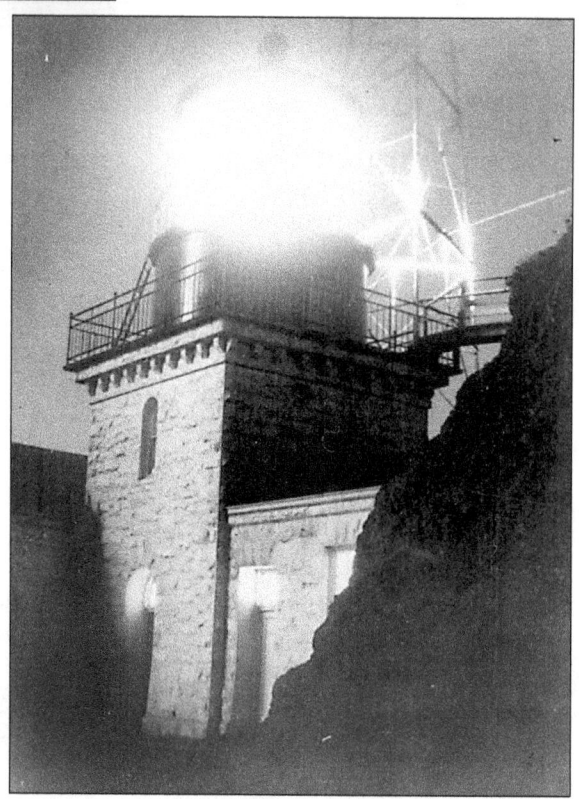

This is a rare nighttime photograph taken in 1933 or 1934. (Courtesy Harry Russell Miller.)

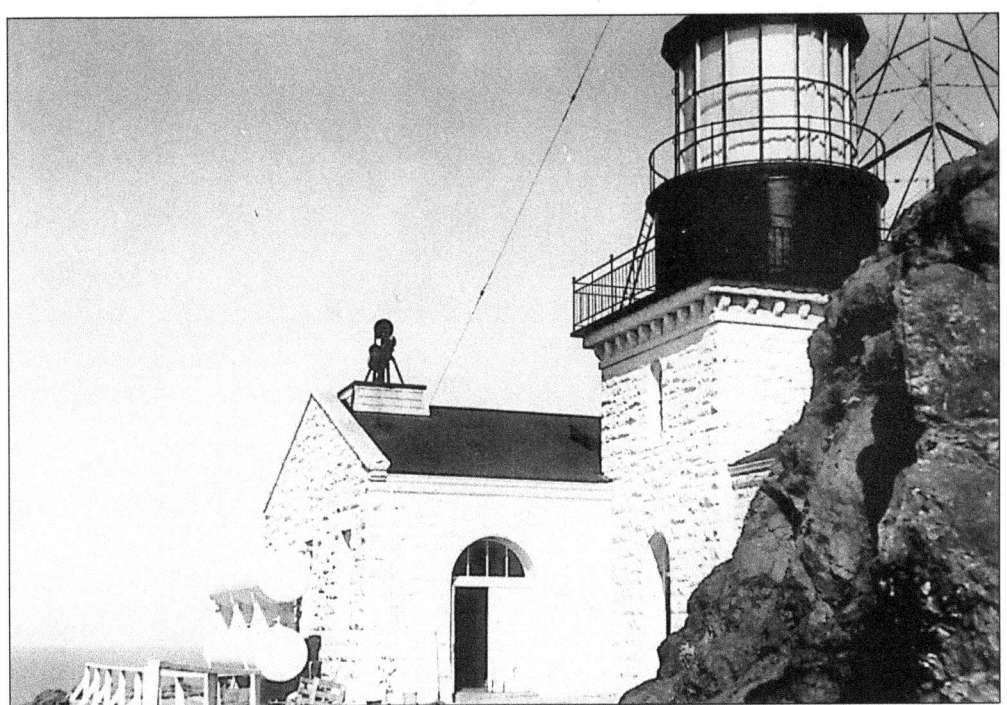

In 1935, a new diaphone fog signal was installed. Air receiver tanks, placed on the deck west of the fog signal room, gave the extra capacity to the diaphones. In this c. 1939 photograph, the new horns are visible on the roof. (Courtesy U.S. Coast Guard.)

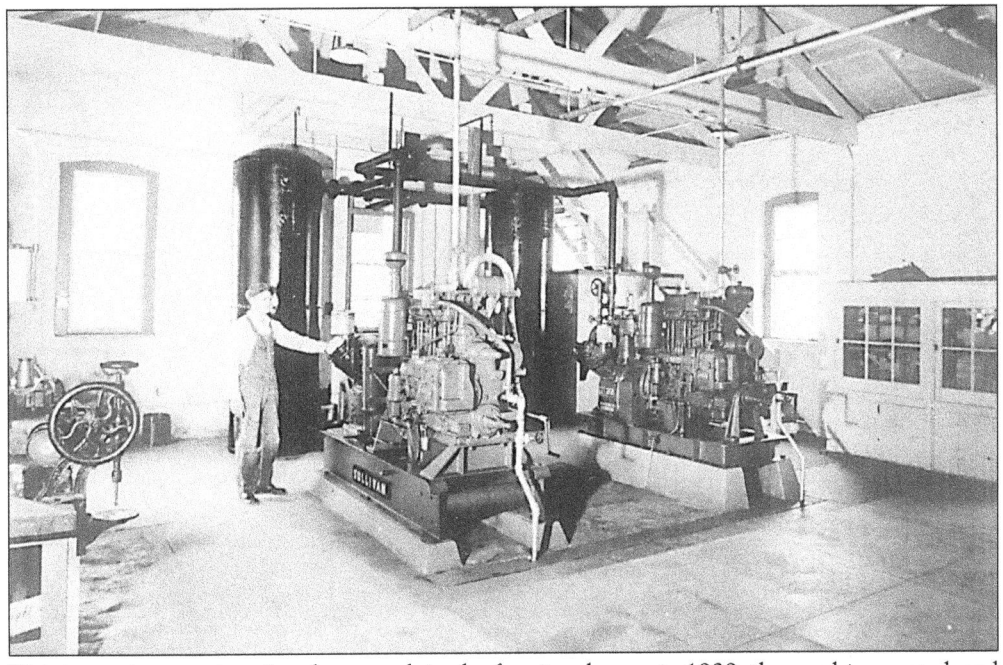

This is another rare interior photograph in the fog-signal room in 1939; the machinery produced compressed air for the diaphones. Other upright tanks are against the far wall. (Courtesy U.S. Coast Guard.)

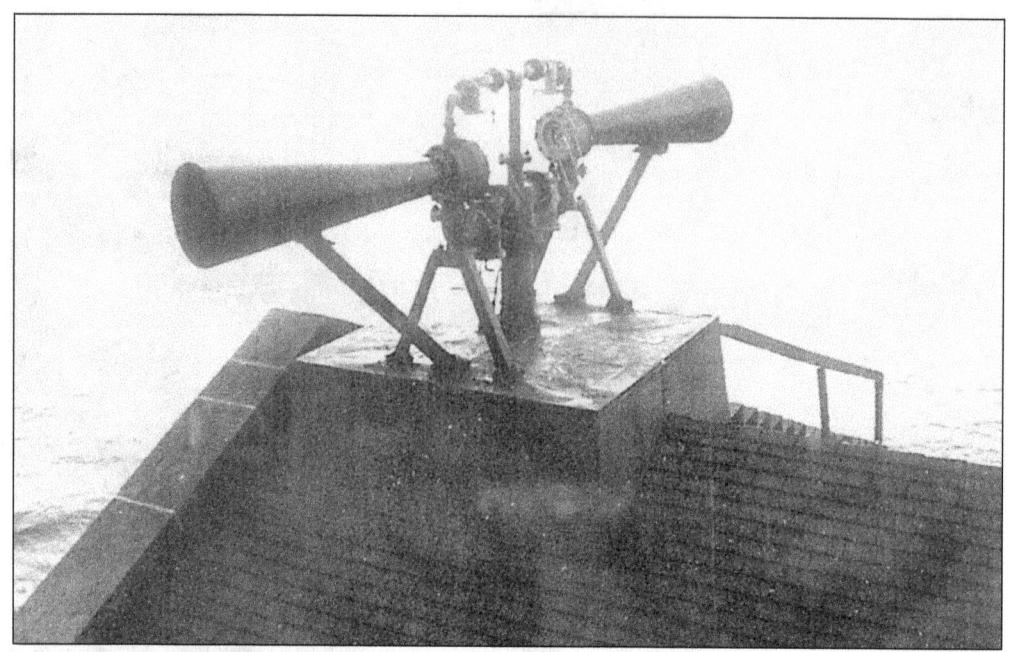

Diaphone horns, visible in this 1957 photograph, were in place on top of the fog-signal room from 1935 to 1960. The diaphone produced a two-tone, or "bee-oh," sound. (Courtesy U.S. Coast Guard.)

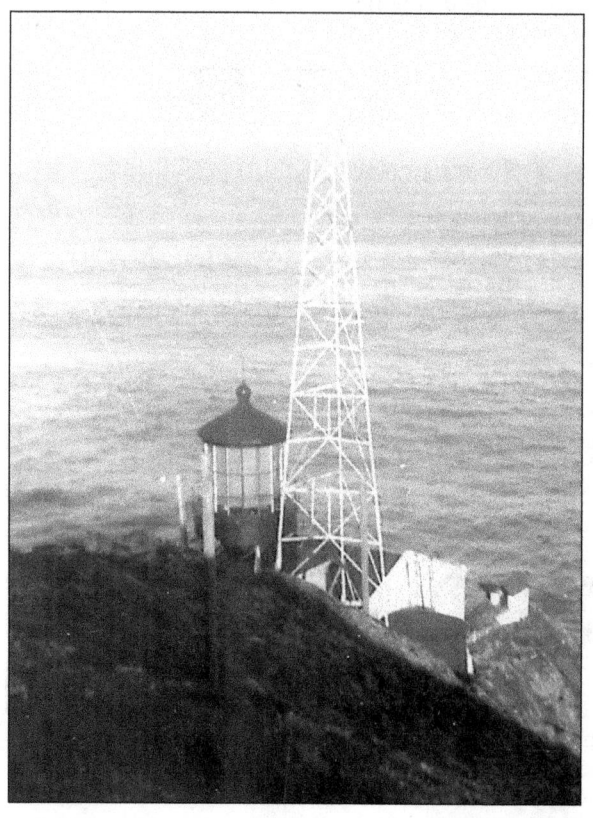

In this undated photograph from the mid-1930s, the radio beacon, water tank, and fuel tank house are all clearly visible. (Courtesy the George Henderson family.)

In this image taken in the same 1930s time period, the walkway to the gallery was still in place. A ladder to aid in cleaning the Fresnel lens is visible to the right of the lens. (Courtesy the George Henderson family.)

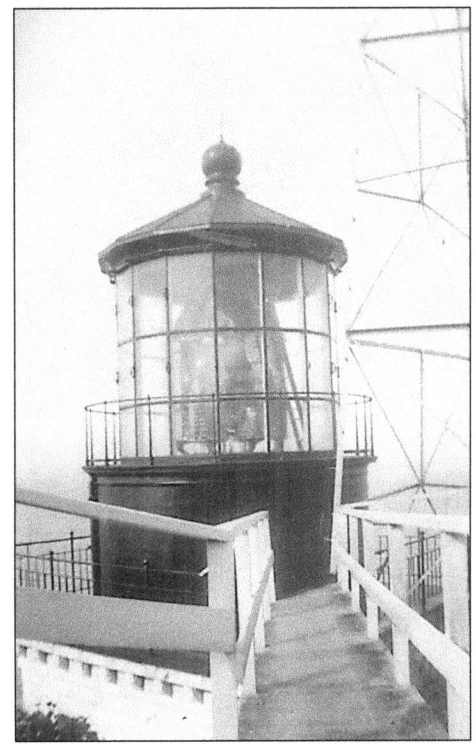

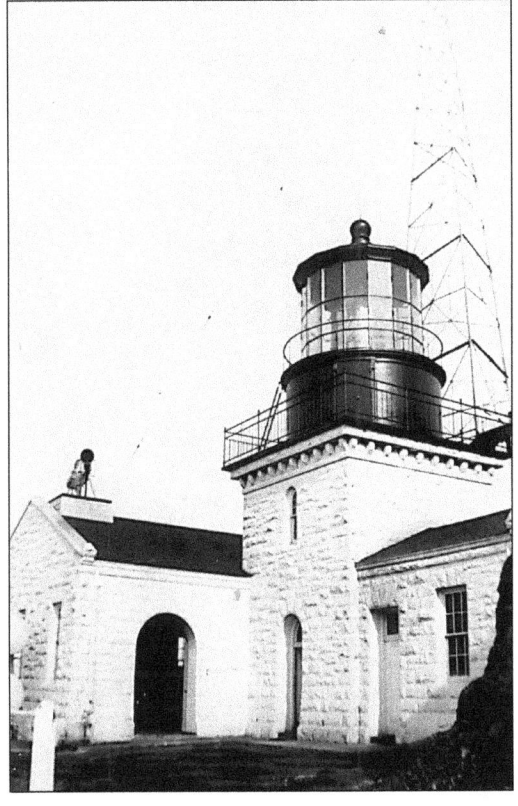

Another ladder, shown in this mid-1930s photograph, was placed outside the caisson to aid keepers climbing from the gallery to the catwalk to wash the windows of the lantern room. (Courtesy the George Henderson family.)

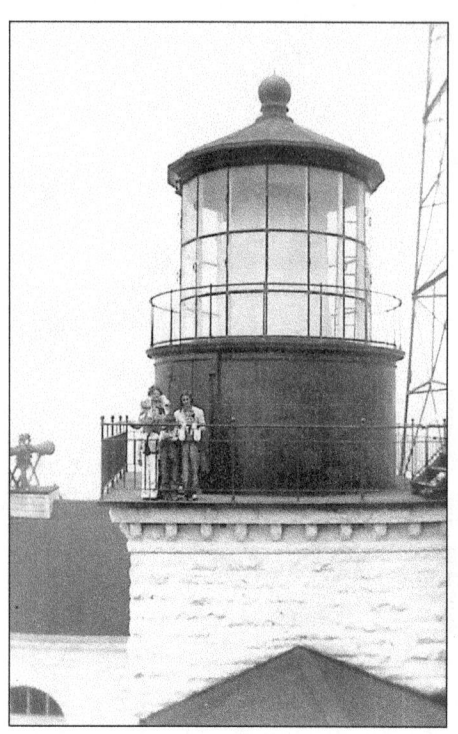

An unidentified group posed on the lighthouse tower in the late 1930s, and a curtain draped the Fresnel lens. Lightkeeper Wayne Piland noted on the photograph, "I should have drawn the curtain." He must have been referring to the second curtain that was hung just inside the storm panes. (Courtesy Wayne Piland.)

Sometime after the early 1940s, the lighthouse was returned to its natural gray stone color. An unidentified man is coming down the stairs at the far right. The stairs were built after 1939 and the walkway from the trail removed. (Courtesy U.S. Coast Guard.)

The trail to the lighthouse, seen here on the left, was still dirt in this 1957 photograph. The early telephone system wires and poles had been removed, and the diaphone horns can be seen next to the lantern room. The radio beacon dominates the north end of Point Sur. (Courtesy U.S. Coast Guard.)

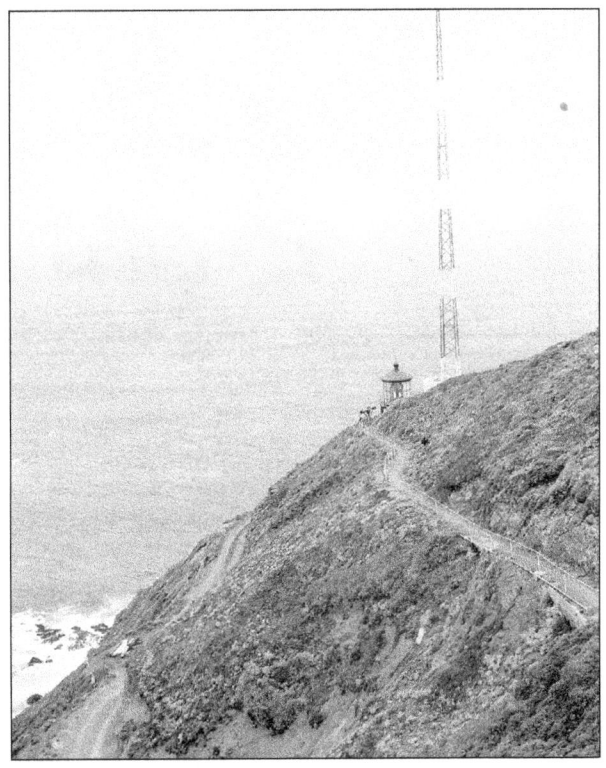

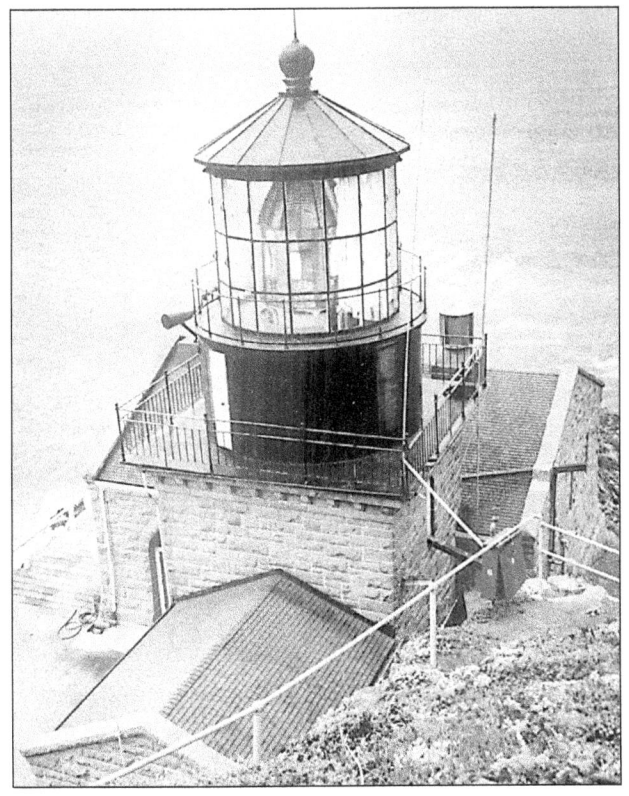

The lighthouse is little changed in this 1957 photograph. The Fresnel lens is peeking out from the curtains and the diaphone is still providing the fog signal. Antennas have been moved around and added as electronics become more important to navigation. (Courtesy U.S. Coast Guard.)

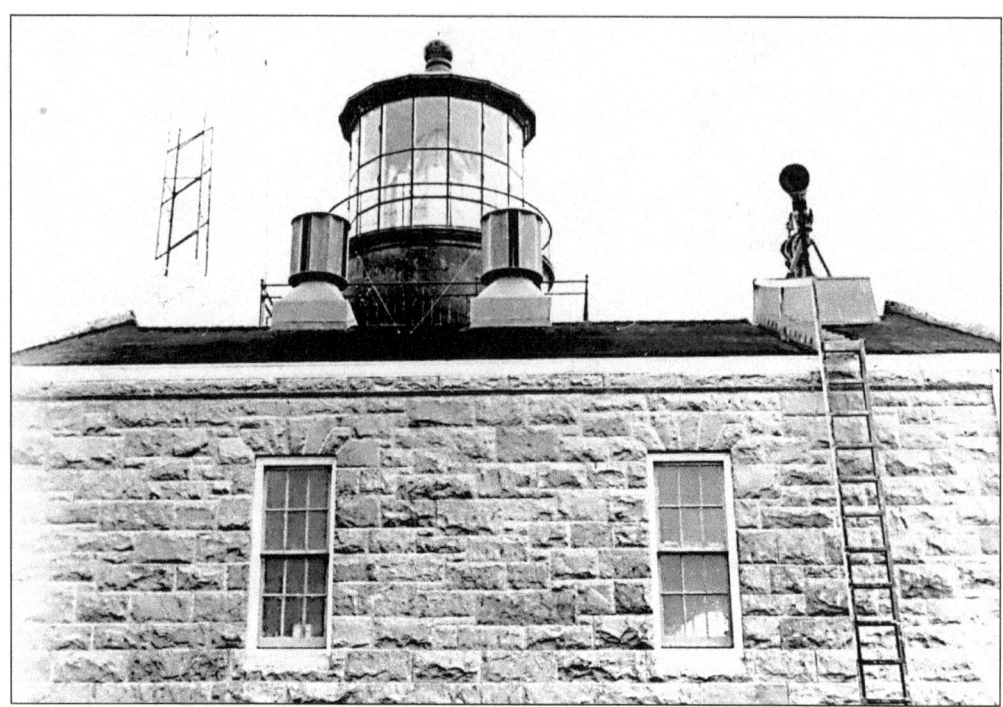

This 1957 photograph shows a rare north view of the fog-signal room and lighthouse. A ladder leads up to the twin diaphone fog signals on the roof, where two ventilators were also located. The Fresnel lens in the tower and the radio beacon behind can be seen as well. (Courtesy U.S. Coast Guard.)

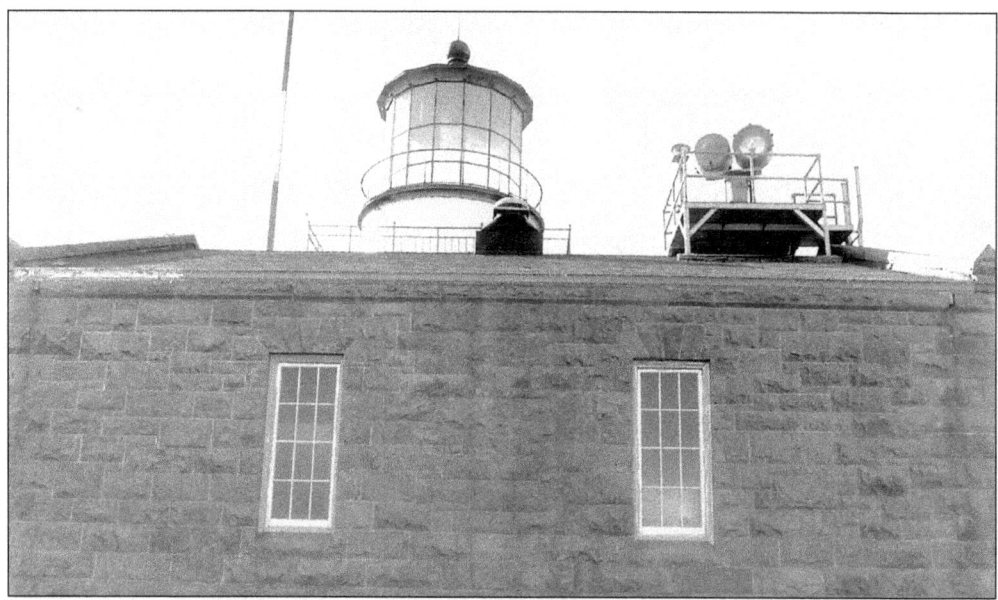

In the same view from the north, probably taken in 1980, the Fresnel lens is gone and an aerobeacon light on the fog-signal room roof is now providing the aid to navigation. The fog signal was permanently removed in 1976, and the Fresnel lens was removed to the Monterey Maritime Museum in 1978. (Courtesy U.S. Coast Guard.)

By 1977, the fog signal had been removed from the roof, but the Fresnel lens was still in place and operational. The lens can be seen in the tower, draped by a curtain. Draped curtains could protect the Fresnel lens, or curtains could be pulled around the inside of the storm panes in the tower. (Courtesy U.S. Coast Guard.)

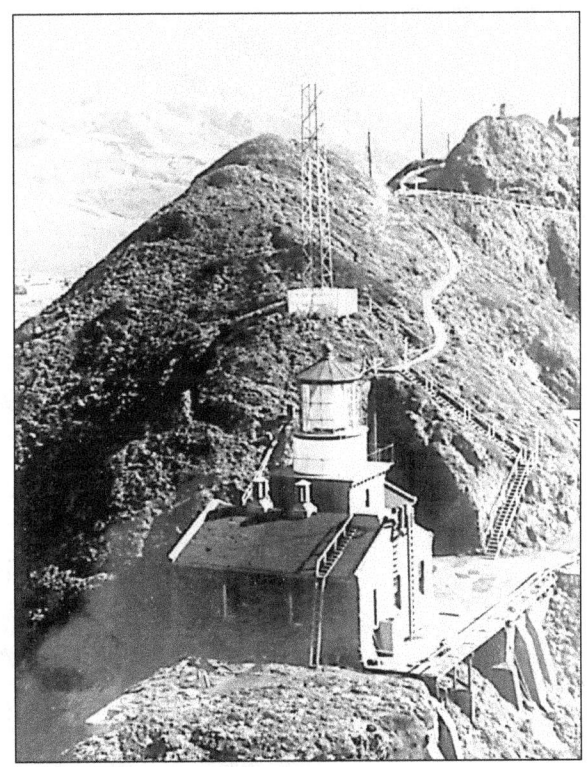

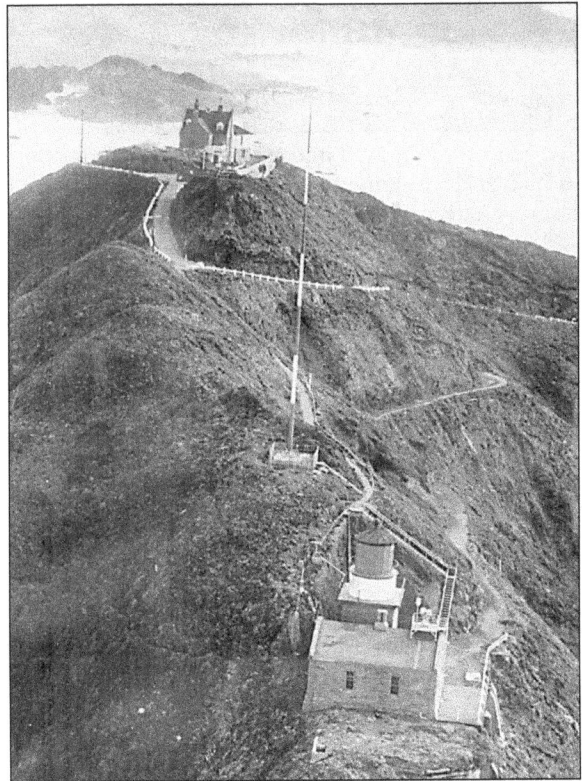

This undated aerial view was probably taken before the Fresnel lens was removed. The lantern room and its lens were protected by plywood after the lens was no longer needed. In 1972, the lighthouse was automated by installing an aero-beacon outside the tower. Resident Coast Guard personnel were no longer needed and the other station buildings were abandoned. Note that the caisson has been painted white. (Courtesy U.S. Coast Guard.)

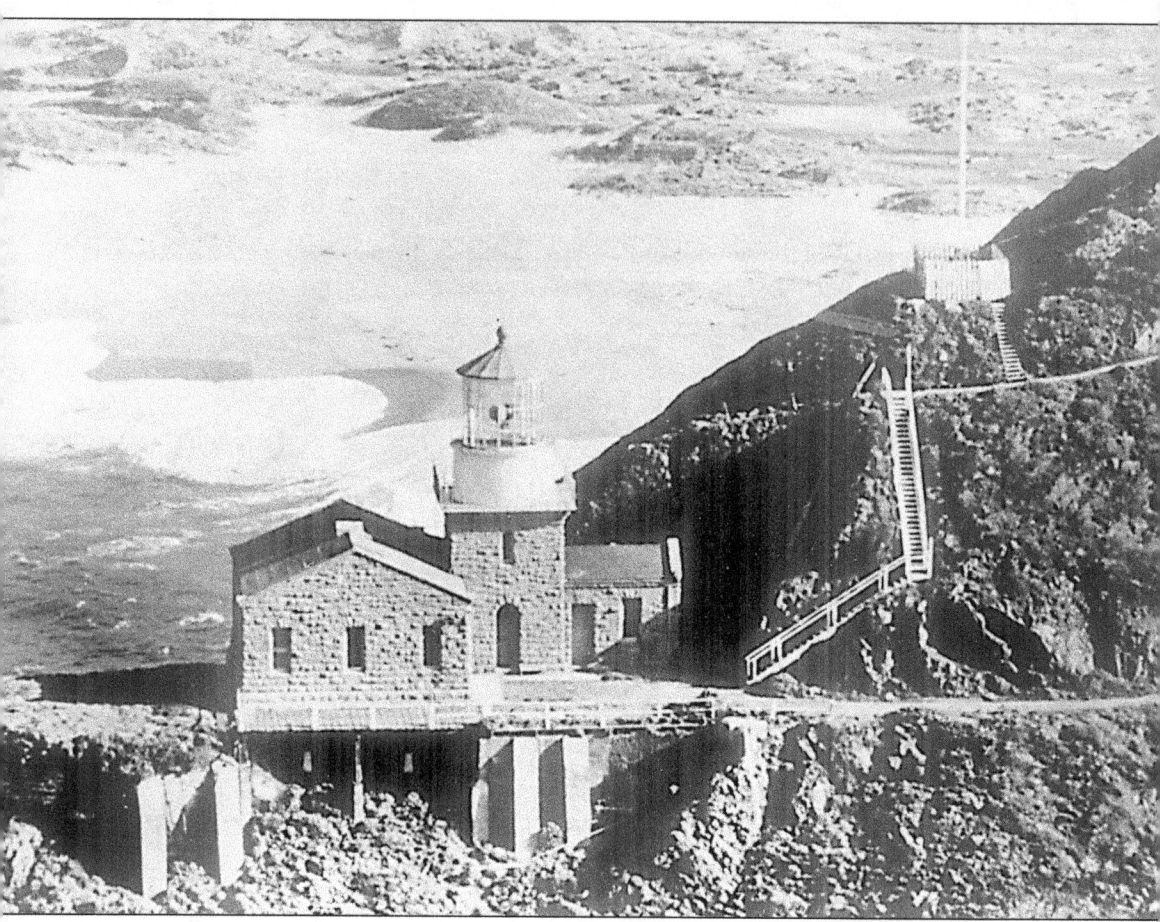
After the Fresnel lens was removed, the aero-beacon was moved into the lantern room sometime after mid-1980. Usually, the modern optic is left outside the lantern room, but the wind at Point Sur was so severe that it interfered with the beacon's rotation. (Courtesy U.S. Coast Guard.)

Six
ROAD BUILDING

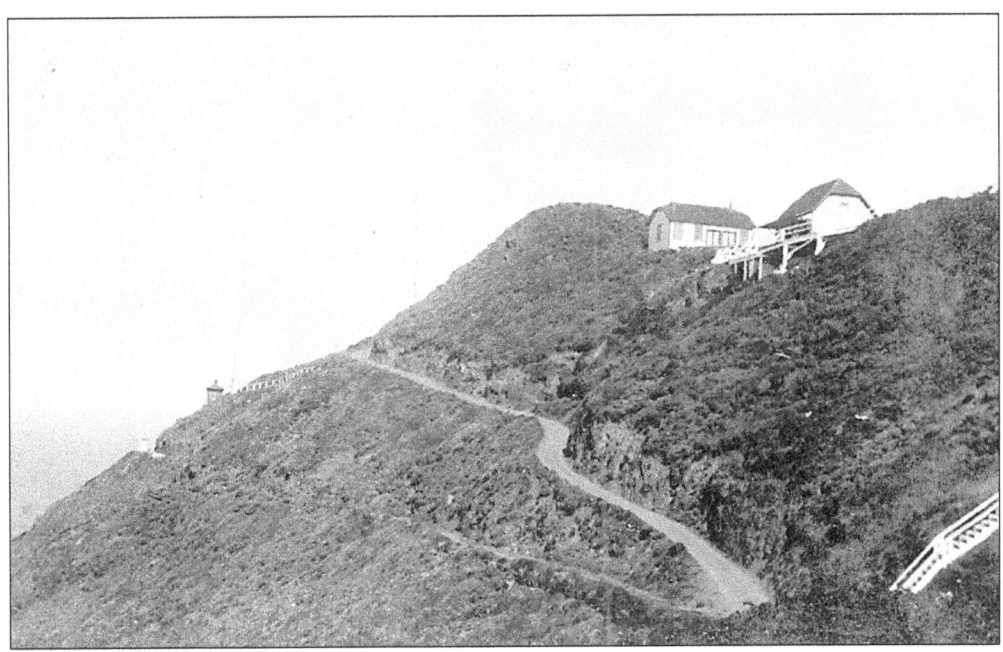

Roads at Point Sur were carved into the rock, and most of the road surfaces were unpaved until the 1980s. Since rubble was often pushed over the side when construction occurred, parts of the roads often rested on fill, making them unstable. In this c. 1929 view, the road to the top of Point Sur is in the middle. The road to the lighthouse, which is below the other road, is quite narrow. (Courtesy Ruth Coursey.)

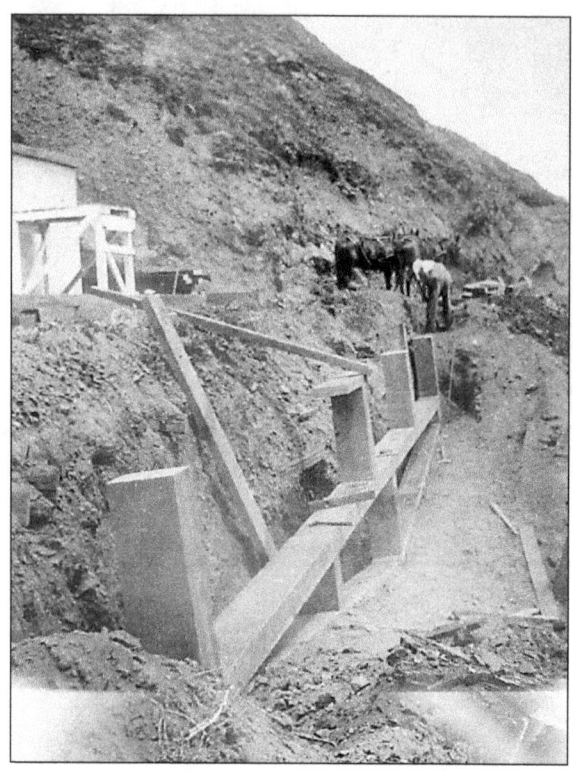

In a series of three photographs from 1918, the Lighthouse Service documented the building of a retaining wall next the oil house along the lighthouse road. This photograph looks south at the construction by the oilhouse. The road to the lighthouse was built over the old 1889 railbed. Keeping the roads at Point Sur passable required constant maintenance. (Courtesy U.S. Coast Guard.)

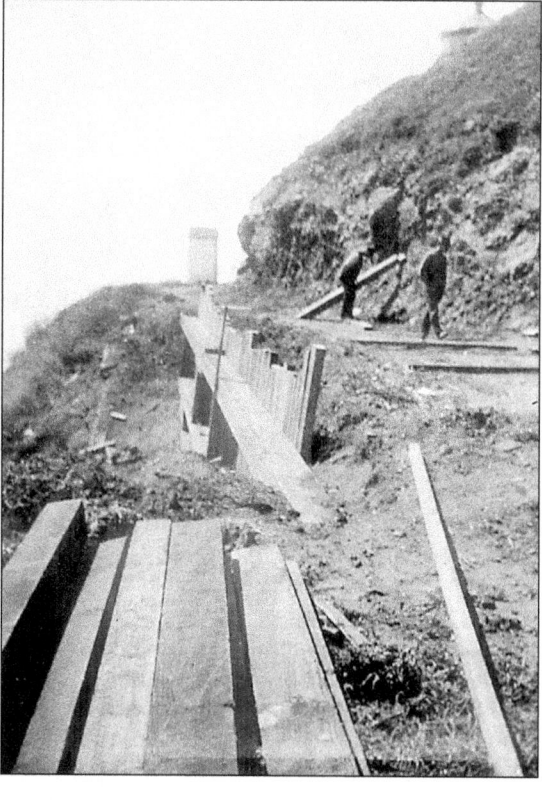

This view looks toward the lighthouse as the retaining wall was beginning to take shape. The lighthouse privy is visible at the bend in the road, just before the road gets to the lighthouse. The cliff to the left drops off more than 200 feet to the ocean. (Courtesy U.S. Coast Guard.)

Work on the retaining was is nearly complete as a "sidewalk superintendent" checks up in this photograph looking towards the lighthouse. The completed wall still keeps the oil house secure from erosion after over 80 years. (Courtesy U.S. Coast Guard.)

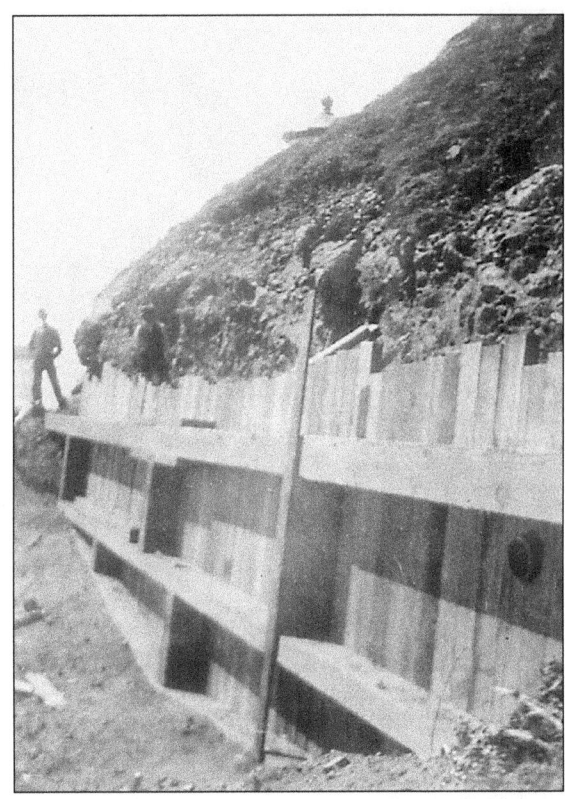

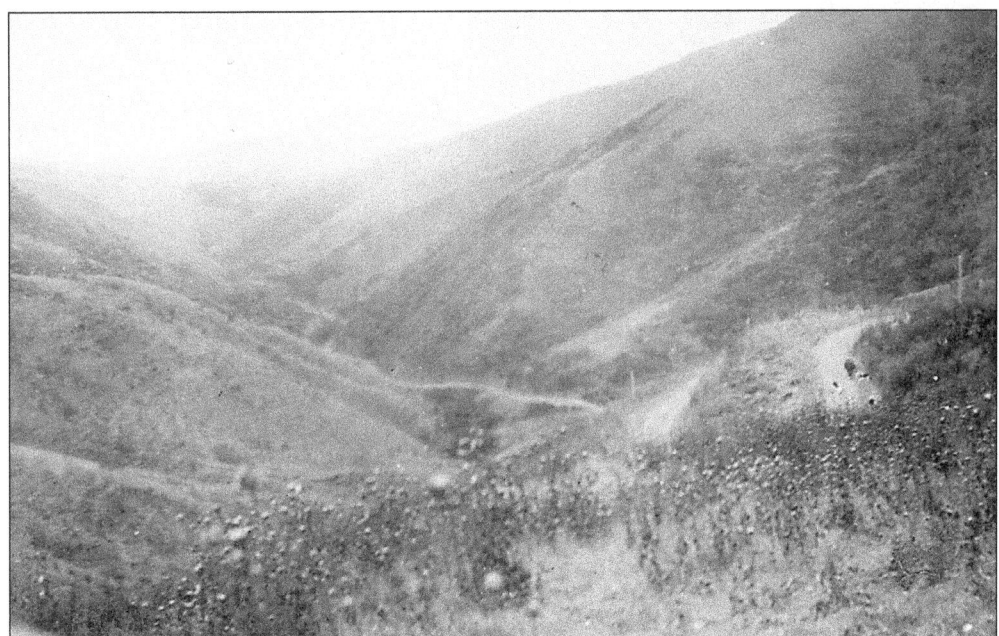

Before the 1930s, the "Old County Road" was the only way for the lightkeepers to get to Monterey, 26 miles north. This c. 1929 view shows how the road wound up and down through the hills and clung to cliffs hundreds of feet above the surf. In wet weather, the trip might take all day, or not be possible at all. (Courtesy Ruth Coursey.)

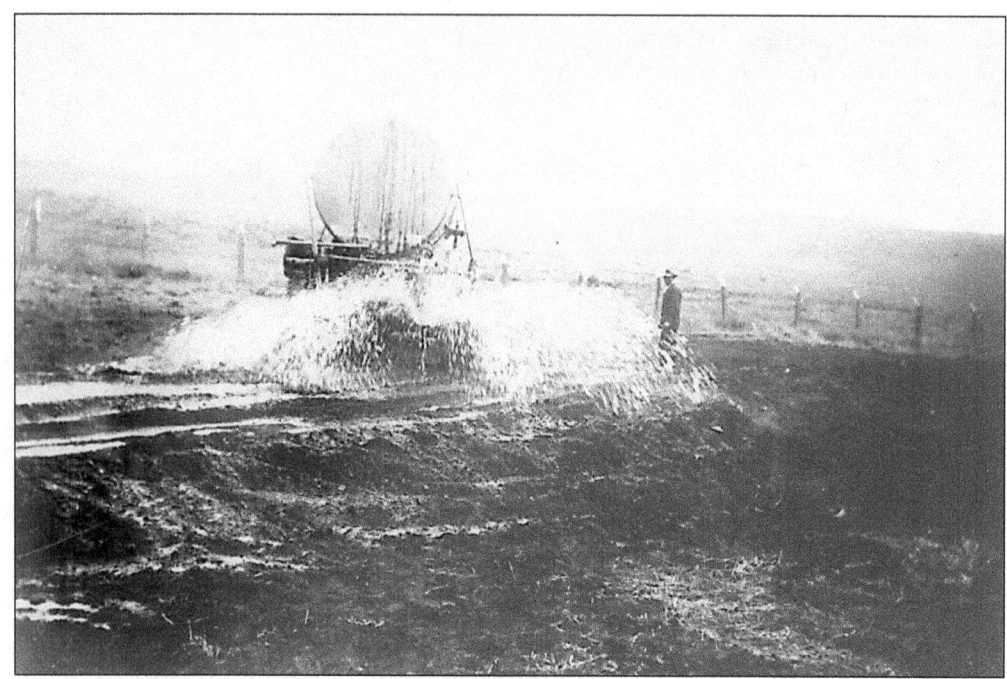

In 1932, Highway 1 inched its way south. The relatively flat land near Point Sur was easier to build on than the sheer rock cliffs along much of the route. The biggest problems along this stretch were the wet weather in winter and the dry conditions in summer. In this photograph, a water truck sprays the roadway in an effort to keep the dust down. (Courtesy U.S. Coast Guard.)

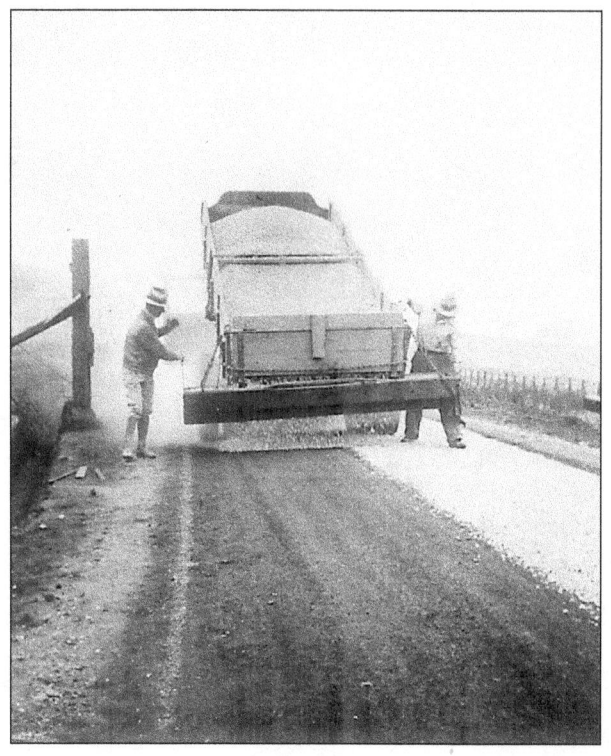

Finally, Highway 1 was paved, as seen in this photograph is taken just opposite Point Sur. Note False Point Sur, just visible in the right of the photograph. False Point Sur is a land mass just to the south of Point Sur that has a similar form to Point Sur, though smaller. Convicts were often part of the road-building labor force. (Courtesy U.S. Coast Guard.)

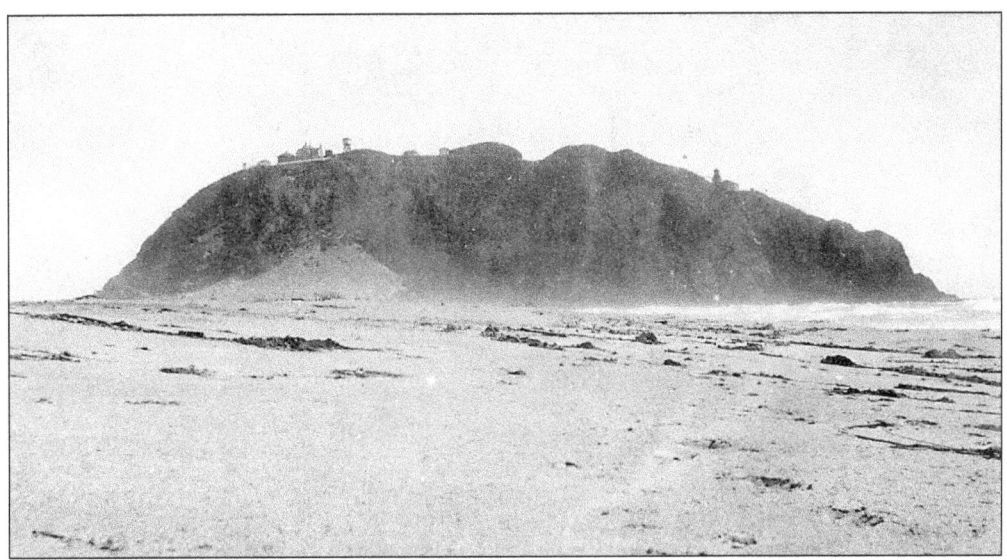

Once the highway was finished and it passed by Point Sur less than a mile away, the Lighthouse Service decided to upgrade the road across the sand flats to Point Sur itself. This c. 1929 photograph shows the sand flats, which posed the formidable challenges of blowing sand, seasonal flooding, and a soft surface. (Courtesy Ruth Coursey.)

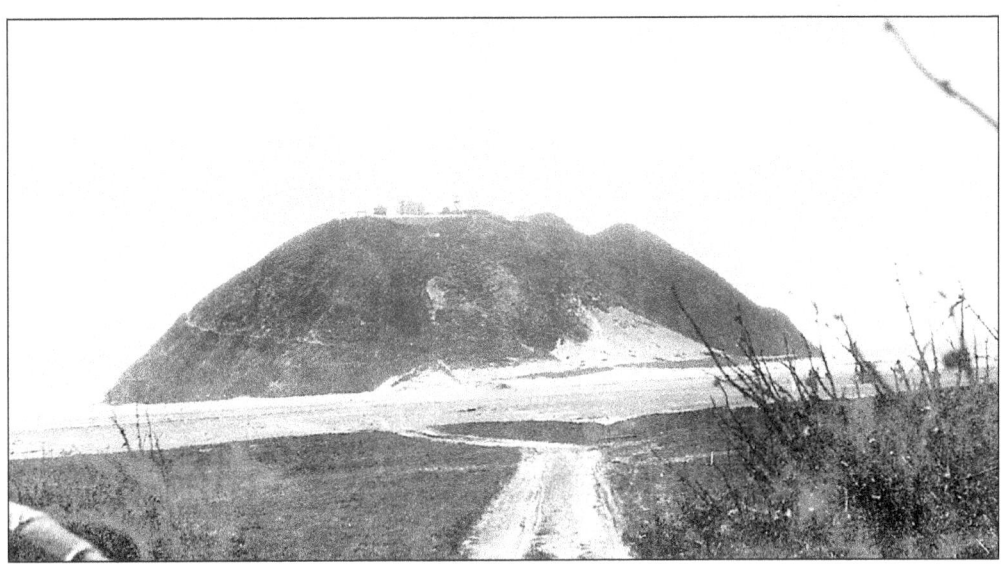

In 1933, the road from Point Sur across the sand flats to the new highway was built. Previously the passage across the sand had changed according to the needs of the lightkeepers. For example, a corduroy road was used by horse-drawn wagons, but when cars arrived, they sometimes needed the help of chains to get across. (Courtesy Ruth Coursey.)

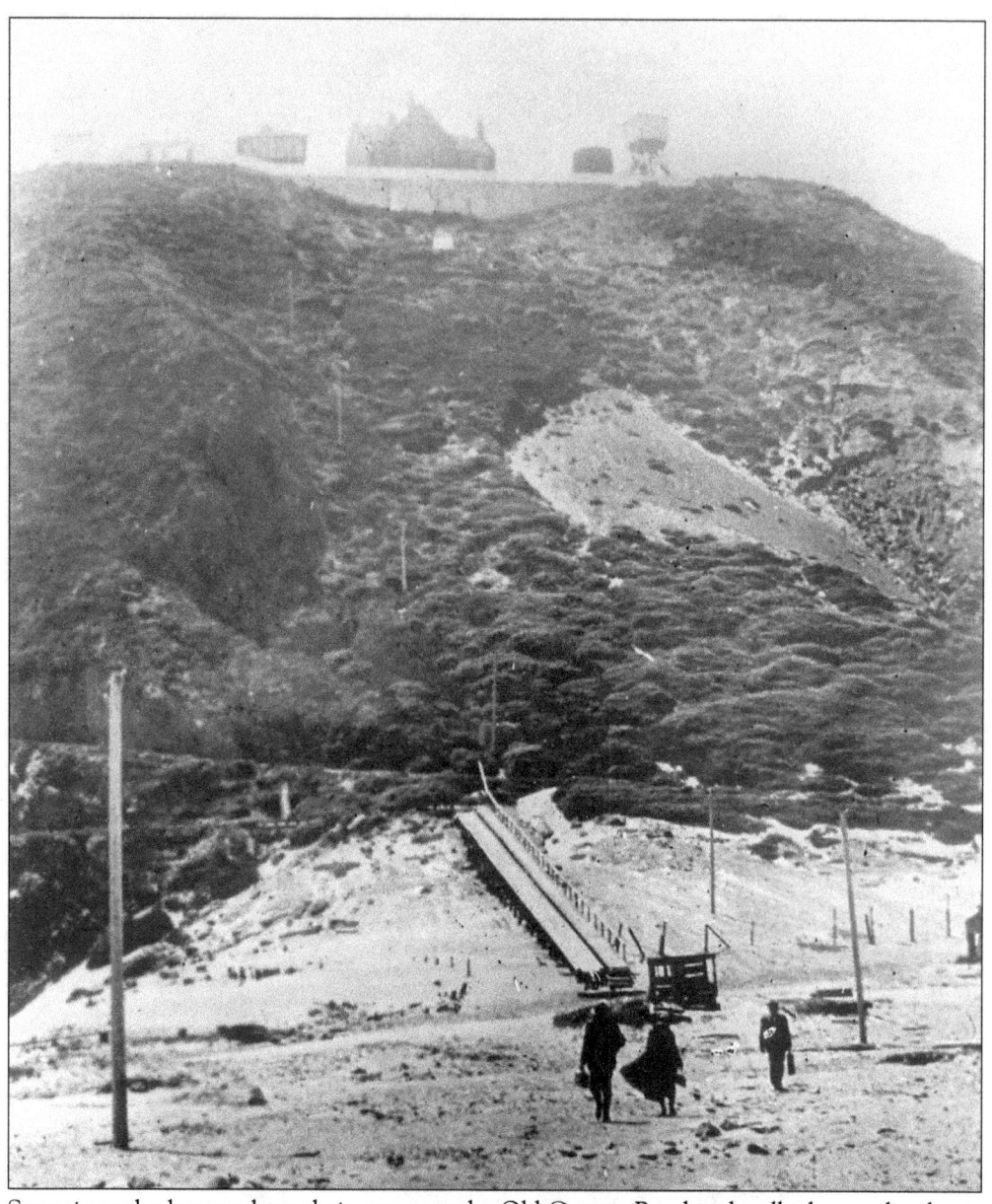
Sometimes the keepers kept their cars near the Old County Road and walked several miles to the lightstation. These hearty travelers in the early 1930s still have over a half-mile to hike to get to the top of Point Sur from the sand dunes below. Remains of the abandoned hoist railway can be seen at the base of the hill. (Courtesy Monterey County Free Libraries, Salinas.)

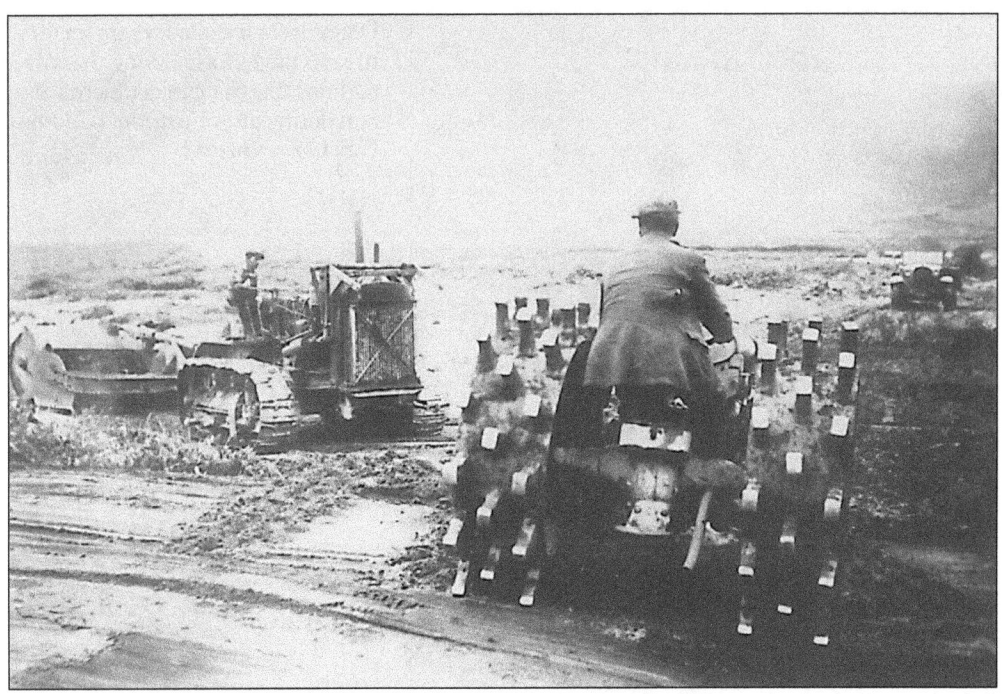

The road is being graded and leveled in this c. 1933 photograph. The tracked vehicle on the left is towing a roller to compress the roadway. (Courtesy U.S. Coast Guard.)

The road was packed down and straight. It was still dirt, however, and weather would always take its toll on the roadway as it crossed the sand flats. High winds blew sand across the road, while rain and storm tides covered the road with water. The keepers' vehicles caused ruts and potholes. (Courtesy U.S. Coast Guard.)

Drains were installed where small streams might form during the winter rains. Big Sur can get inches of rain during just one storm. (Courtesy U.S. Coast Guard.)

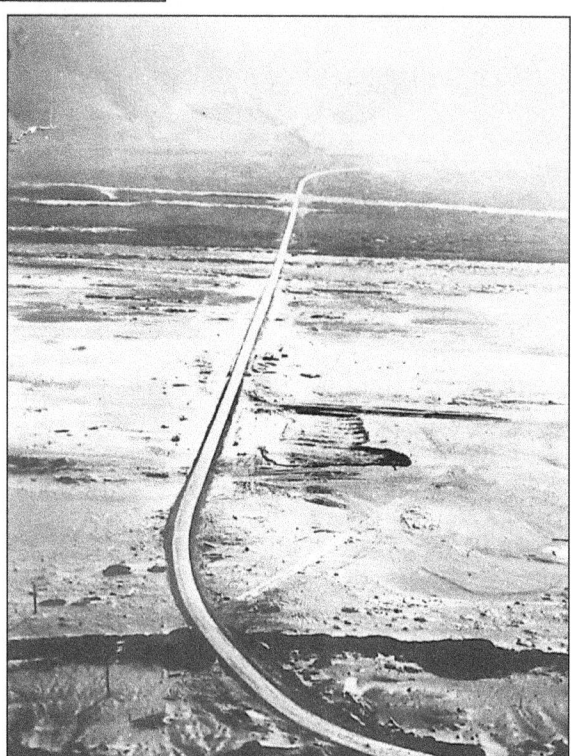

The finished road went straight from the rock to a turn near the highway where the school was placed. The road today follows this route, but the school is gone. (Courtesy U.S. Coast Guard.)

A fence was built along the north or windward side of the new road to protect part of the .75 mile of roadway from blowing sand in the open flat area. Sand built up gradually behind the fence, forming a dune and protecting the roadway. (Courtesy U.S. Coast Guard.)

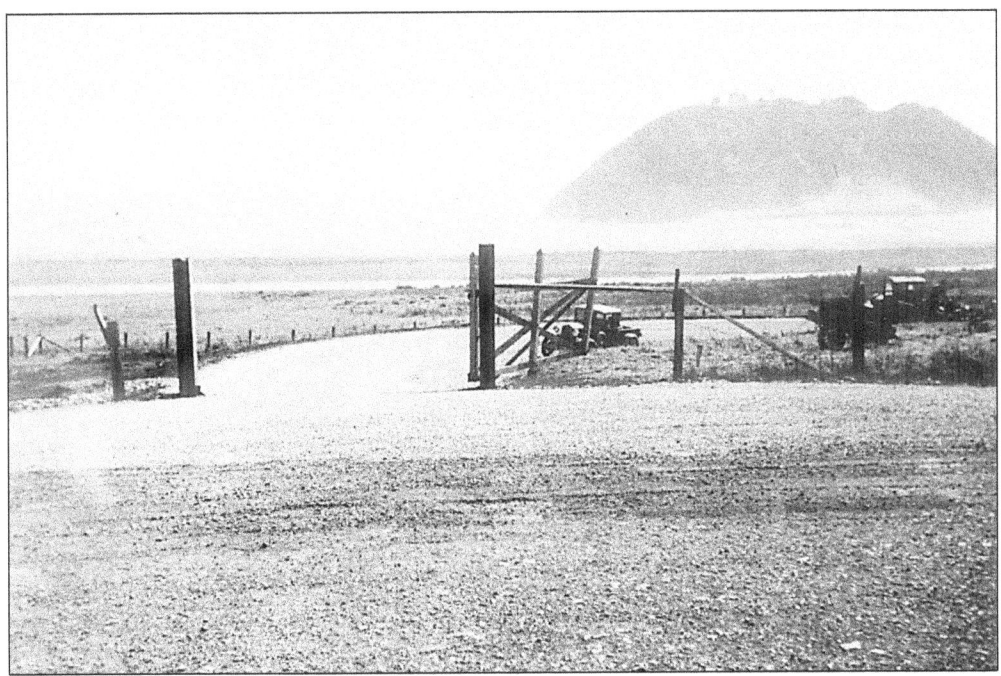

The Highway 1 entrance to Point Sur seen in this 1933 photograph did not look much different than it does today. Cars and trucks are lined up to enter the Carmel-San Simeon Highway. (Courtesy U.S. Coast Guard.)

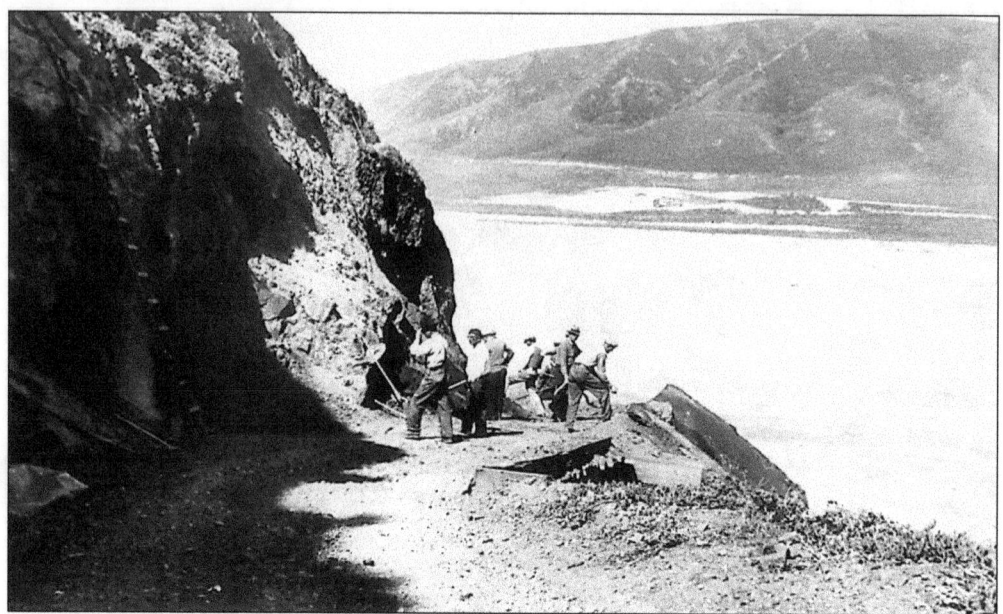

In 1936, the road around the rock to the lighthouse and the keepers' quarters at the top was widened. Supplies had been delivered by ship until an accident in 1933, in which two sailors drowned. This incident led to a re-assessment of the re-supply system. With the new highway in place to Big Sur in 1932, supplies soon began arriving by truck. (Courtesy U.S. Coast Guard.)

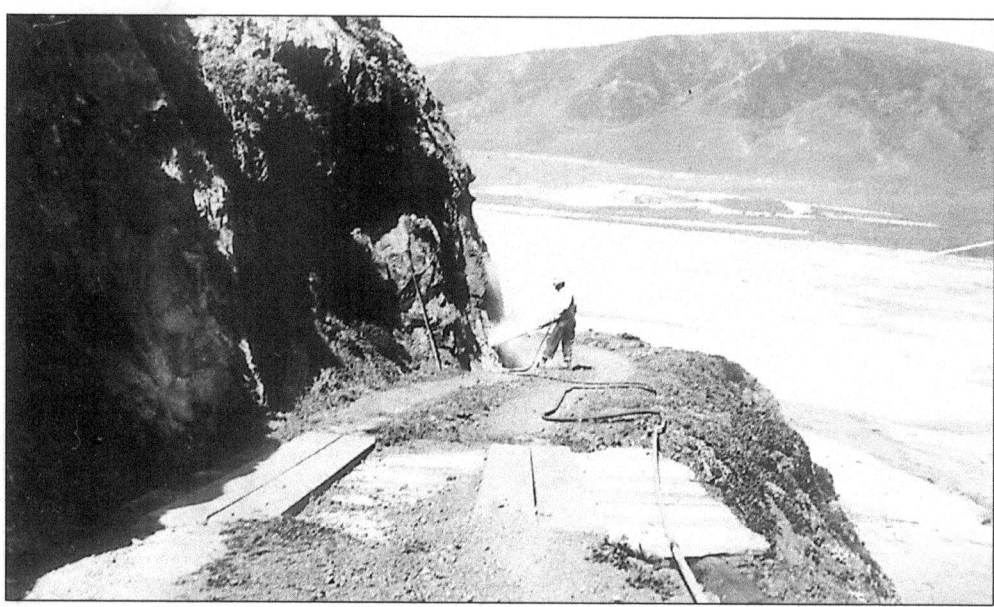

The worker in this photograph uses a pneumatic or hydraulic drill to cut the rock. The boards probably covered a new culvert, which drained water from the inside of the road to the outside to prevent erosion. (Courtesy U.S. Coast Guard.)

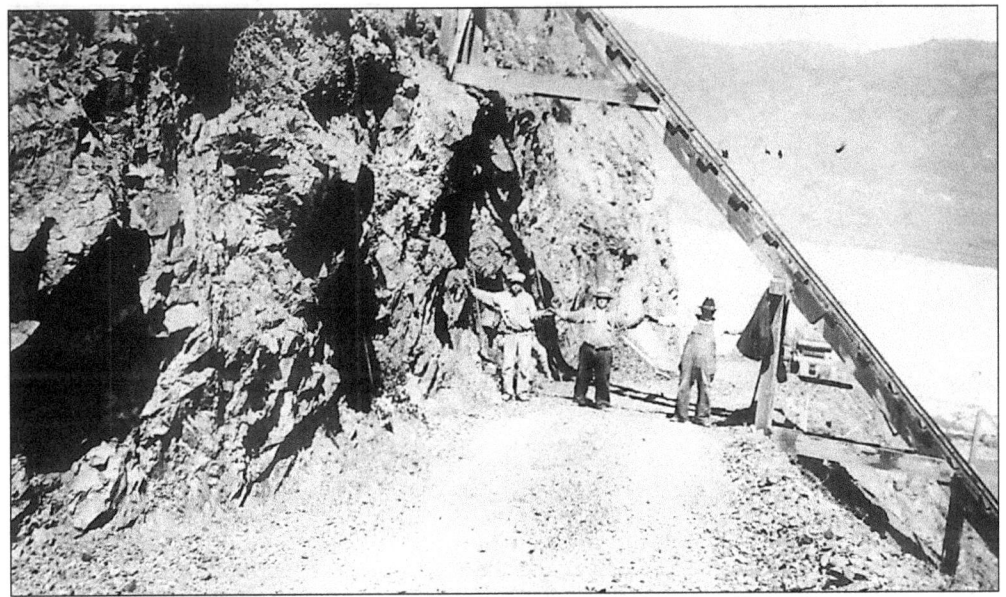

After the road was widened, workers posed in 1936 to show how much wider the road had now become. (Courtesy U.S. Coast Guard.)

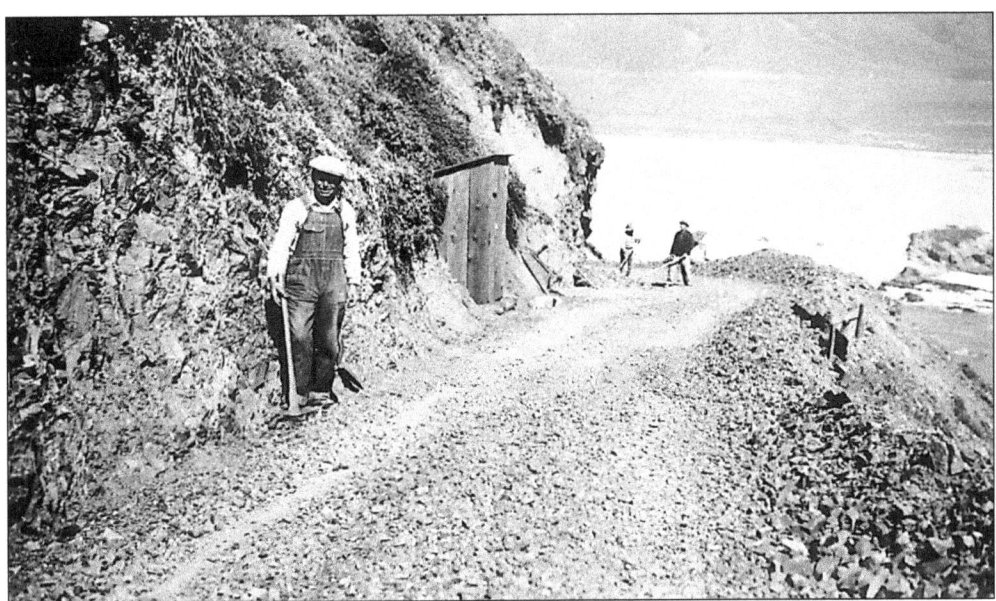

In 1936, workers continued up along the road using picks and shovels as their primary tools. A wheelbarrow was upended and placed almost on top of a culvert, next to the small building that looks like an outhouse. (Courtesy U.S. Coast Guard.)

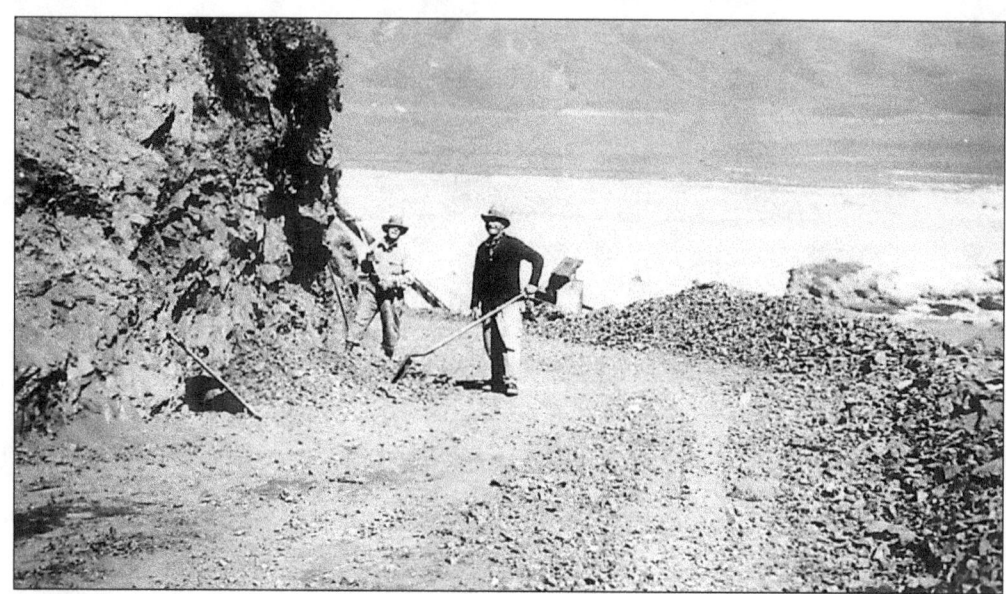
The old tramway is visible behind these two workers who seem to be moving rocks from the inside of the road to the outside. (Courtesy U.S. Coast Guard.)

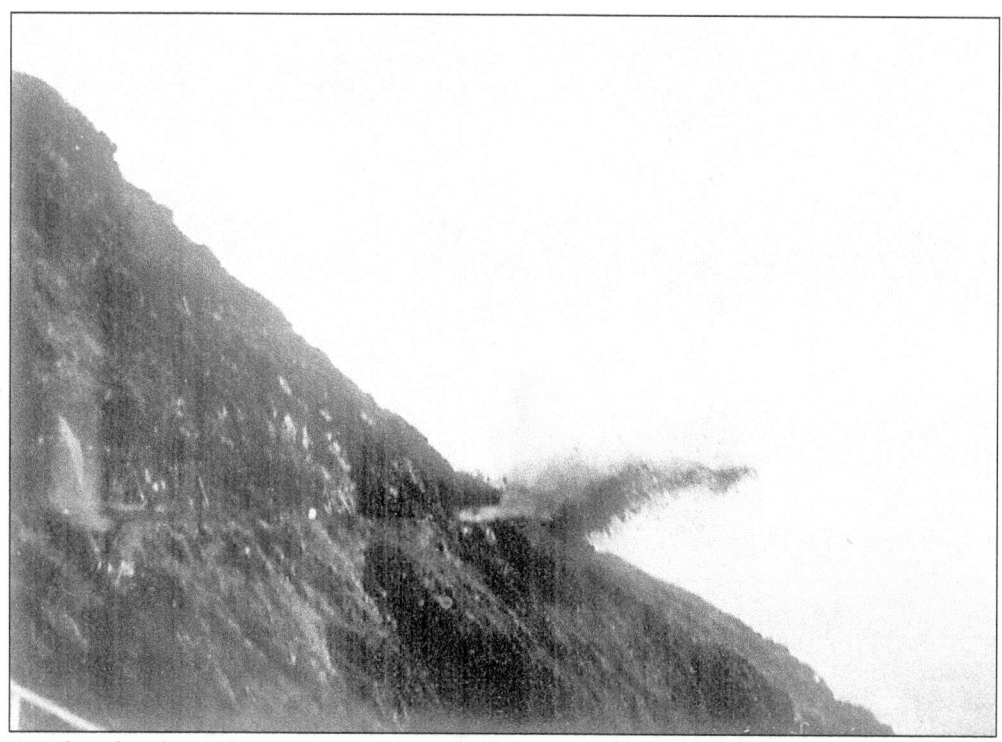
Another handy tool in the road-builders' bag of tricks was dynamite. (Courtesy U.S. Coast Guard.)

Working their way up from what is now called Macon Point, these road builders approach the stairs (visible in the upper left corner) that go from the quarters down to the fork in the road. (Courtesy U.S. Coast Guard.)

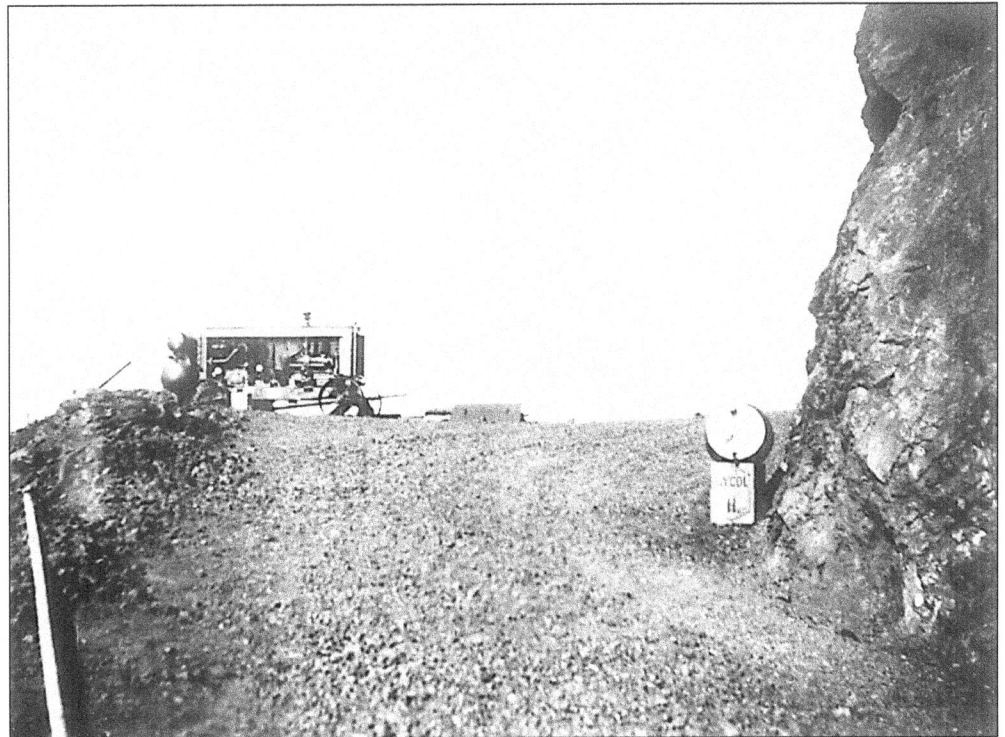

This photograph from the same series shows the road as it approached the hairpin turn just before the top. The trail to the lighthouse goes off to the left behind the equipment sitting at the outside of the hairpin turn in the road. (Courtesy U.S. Coast Guard.)

Looking down at the hairpin turn, the compressor sits at the head of the trail to the lighthouse. (Courtesy U.S. Coast Guard.)

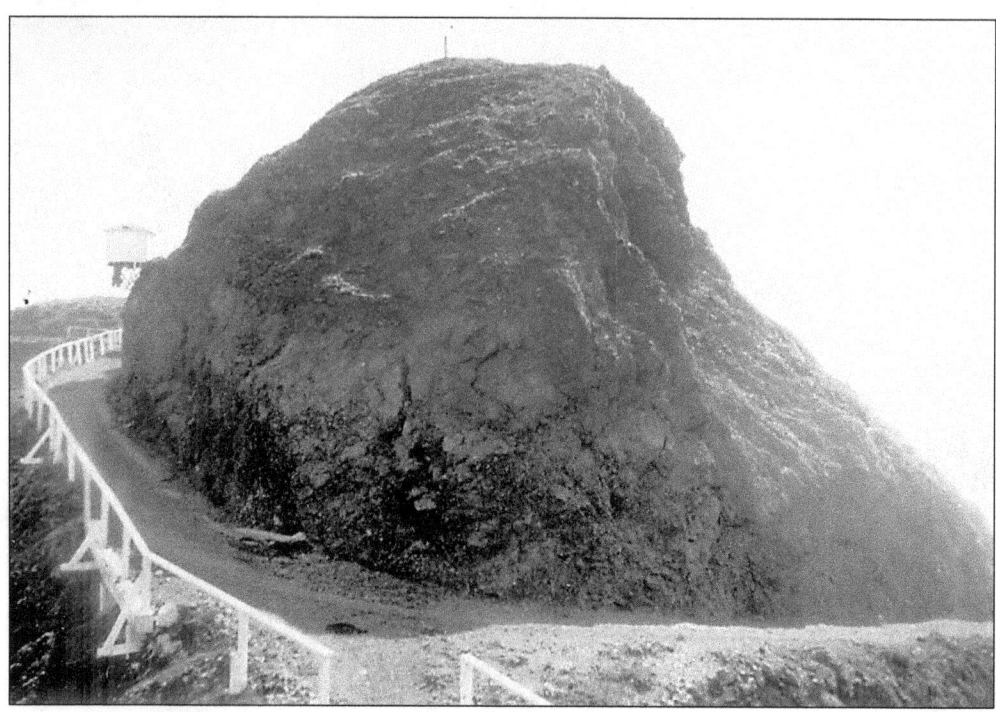
Before widening, this turn and the road on either side were very narrow. This photograph was taken in 1935. (Courtesy U.S. Coast Guard.)

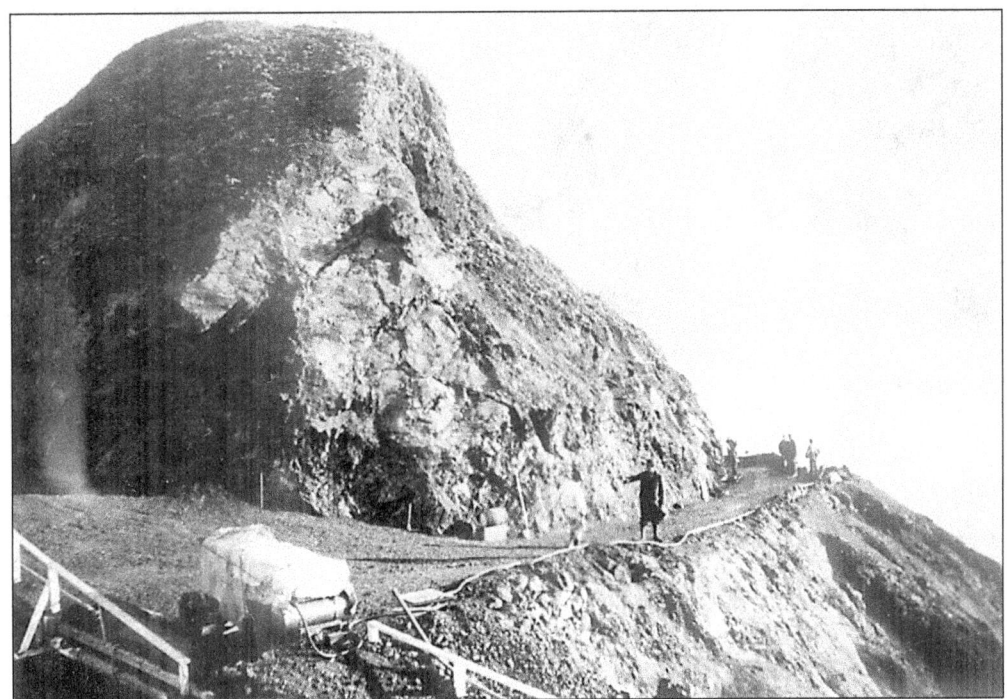
In this later photograph, the left side of the turn appears to be complete, while the right side is still quite narrow. (Courtesy U.S. Coast Guard.)

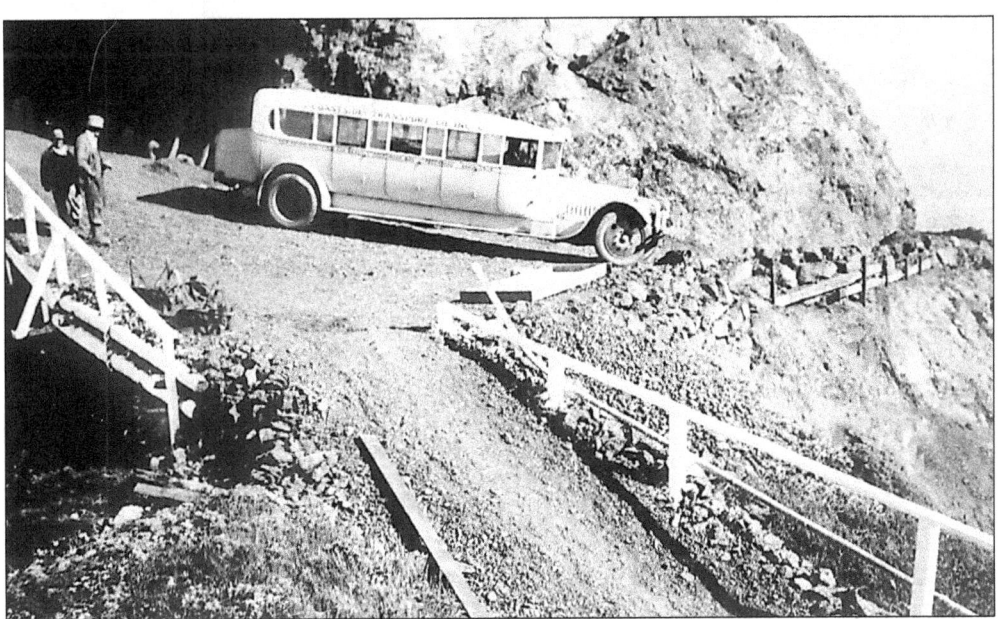
Even this bus could make the turn from the top of Point Sur by late 1936. (Courtesy U.S. Coast Guard.)

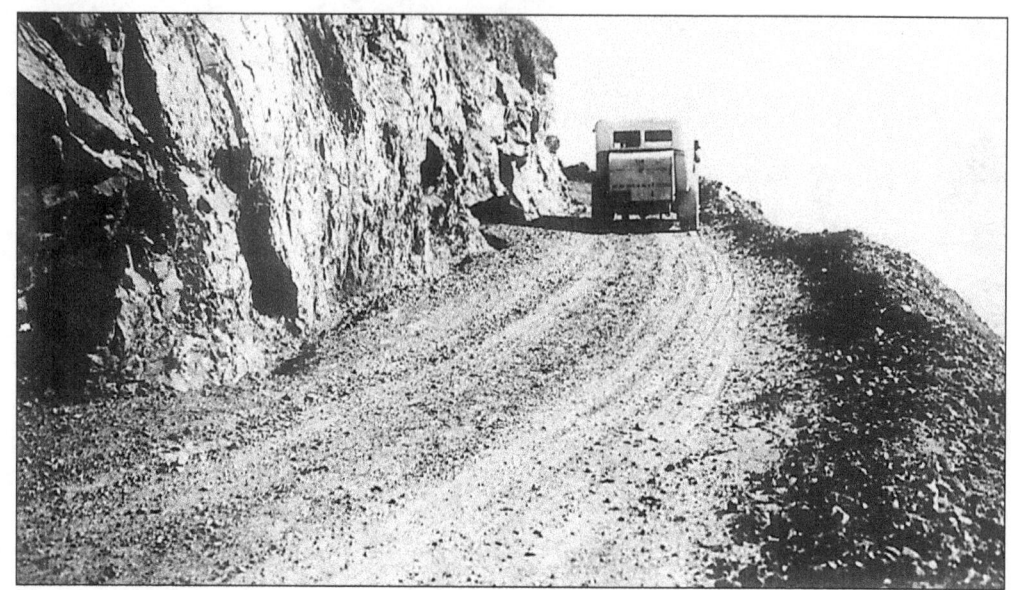

There was now plenty of room along the one-lane road for the bus. (Courtesy U.S. Coast Guard.)

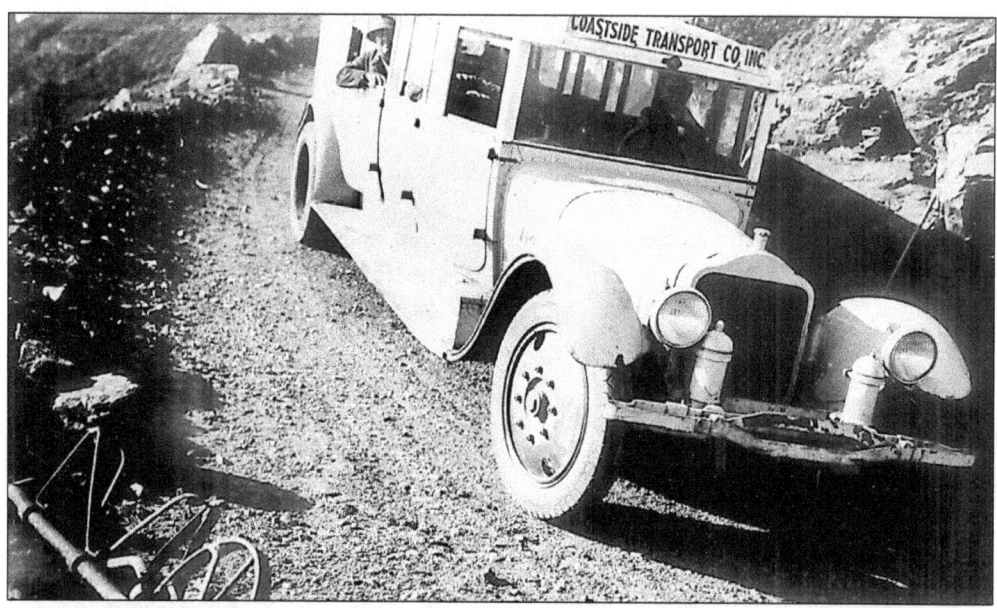

Lightstations were open to the public until the latter half of the 20th century. Anyone could visit, and lightkeepers were expected to be polite hosts. Point Sur was a regular stop for the Coastside Transport. (Courtesy U.S. Coast Guard.)

Seven
1945 AND LATER

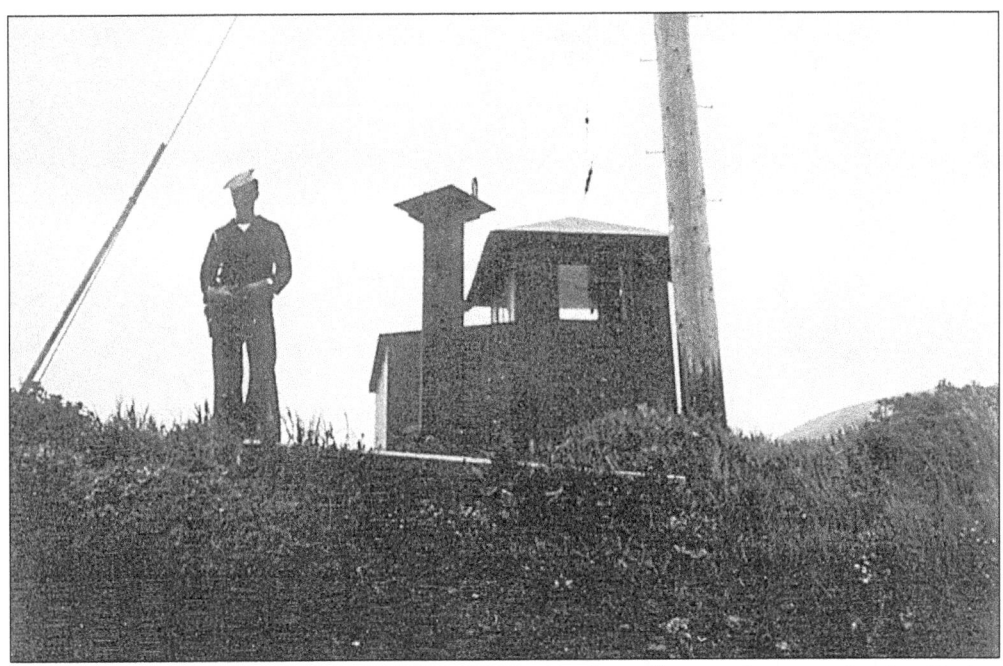

In this 1945 Coast Guard photograph, a sailor on watch is silhouetted against the sky. During World War II, the military moved several men to Point Sur to serve as lookouts. On December 7, 1941, two Coast Guardsmen were taken to Point Sur and left to guard the lighthouse until relieved. (The lightkeepers and their families were there, but unarmed.) The guards were relieved six weeks later in the middle of the night by an Army patrol who were almost shot when they arrived unannounced. (Courtesy U.S. Coast Guard.)

The building that housed the construction manager when Point Sur was built in 1889 was still in use in early 1945. Over the years it served many purposes, from coal storage to schoolroom. By the time this photograph was taken during World War II, it was a mess hall and shower room for the men stationed at Point Sur and living in the barracks building just west of it. (Courtesy U.S. Coast Guard.)

This undated photograph is of the barracks built in 1943 at the very south end of Point Sur, south of the head keeper's house and west of the mess hall and shower. They referred to the barracks as the "bunkhouse." It was torn down sometime after 1959, probably after the Point Sur Naval Facility was built nearby in 1958. (Courtesy U.S. Coast Guard.)

In a rare World War II-era photograph, a sailor can be seen walking from the barracks, just visible behind the head keeper's house, to the mess hall. After the start of World War II, naval personnel, who served as both lightkeepers and coast watchers, augmented the Coast Guard keepers. (Courtesy U.S. Coast Guard.)

In a similar photograph taken in the 1950s, the new concrete block mess hall and shower, built in the spring of 1945 to replace the 1889 building, can be seen. After the war it housed electronic equipment, research equipment and even the teenage son of a keeper in the 1960s who needed "space." Today it is the State Park Visitors' Center. (Courtesy U.S. Coast Guard.)

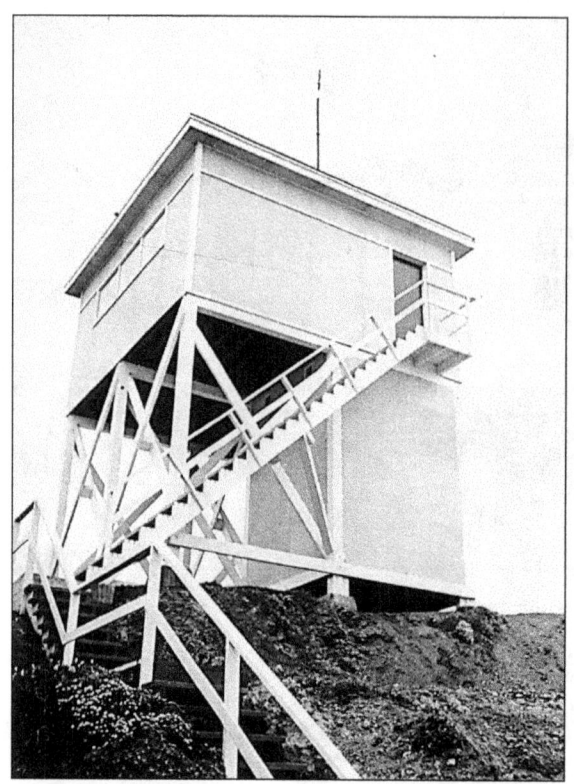

A RACON (Radar Transponder, stands for RAdar and beaCON) tower was built in the mid 1940s to hold navigation equipment and later to hold equipment for early missile research. It was built near the place where the water tower (which was dismantled after 1939) had stood since 1907. (Courtesy U.S. Coast Guard.)

A shed was built near the pump house to keep flammable products safely away from other structures. Room for additional structures was difficult to find on "the rock" so they were tucked in anywhere there was flat space. (Courtesy U.S. Coast Guard.)

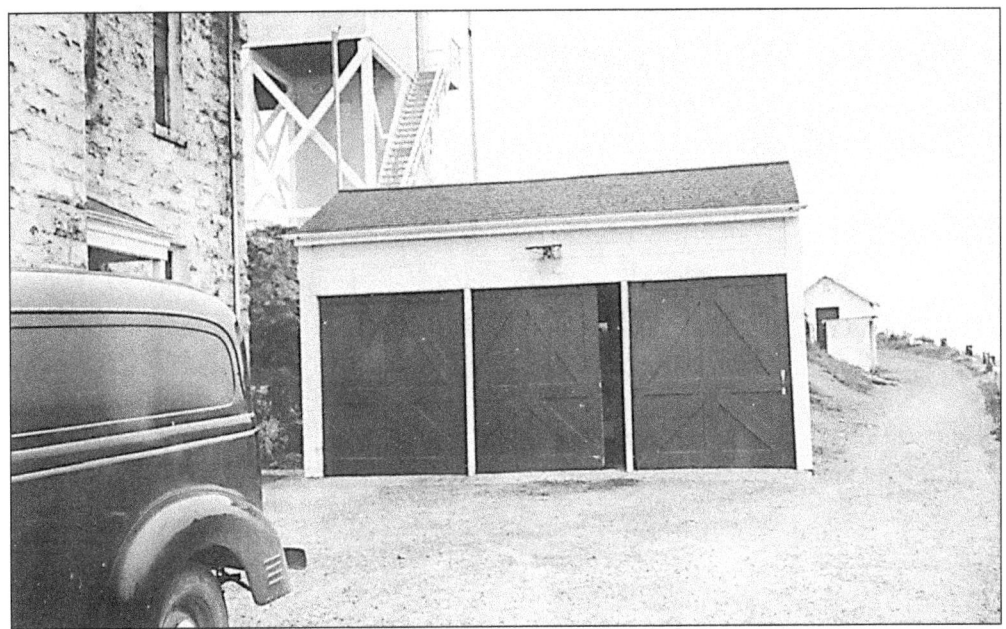

The garage, built in 1925, has reconfigured doors in this 1940s photograph. The large open doorway has been braced with two uprights. Recent restoration of the garage to 1920s-era architecture confirms that bracing was a good idea. (Courtesy U.S. Coast Guard.)

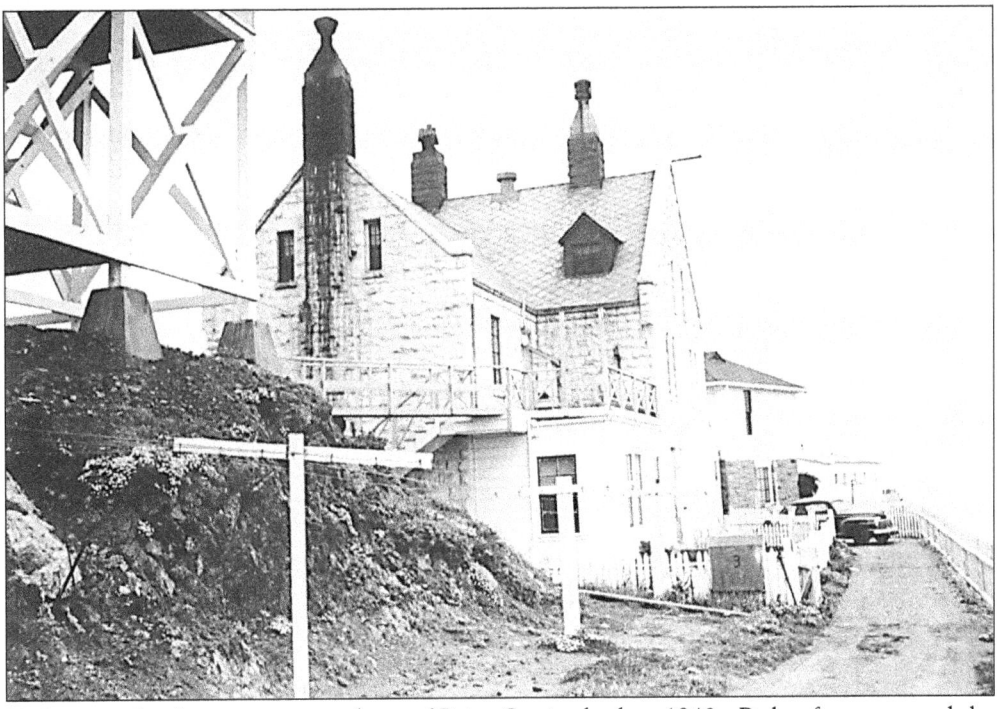

Unfortunately, there was poor upkeep of Point Sur in the late 1940s. Picket fences around the gardens of the triplex were allowed to fall apart. Note the walkway from the second floor apartment across to the small hill holding the RACON tower. The "bunkhouse" is visible in the background. (Courtesy U.S. Coast Guard.)

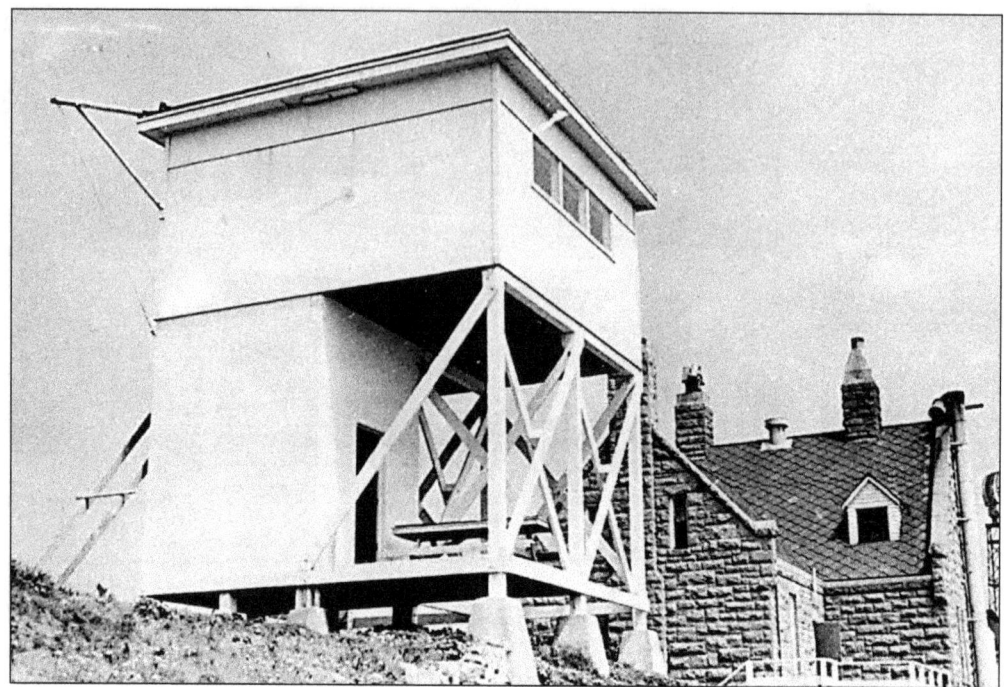

Point Sur's harsh environment takes its toll on every building. Winds over 65 miles per hour are common, a wind-measuring equipment often blows out when the winds are higher. A brace to hold up the stairs can be seen behind the tower in this undated photograph. The tower was removed in 1959 and offered for free to anyone who would remove it, but there were no takers so it was dismantled and burned for firewood. (Courtesy U.S. Coast Guard.)

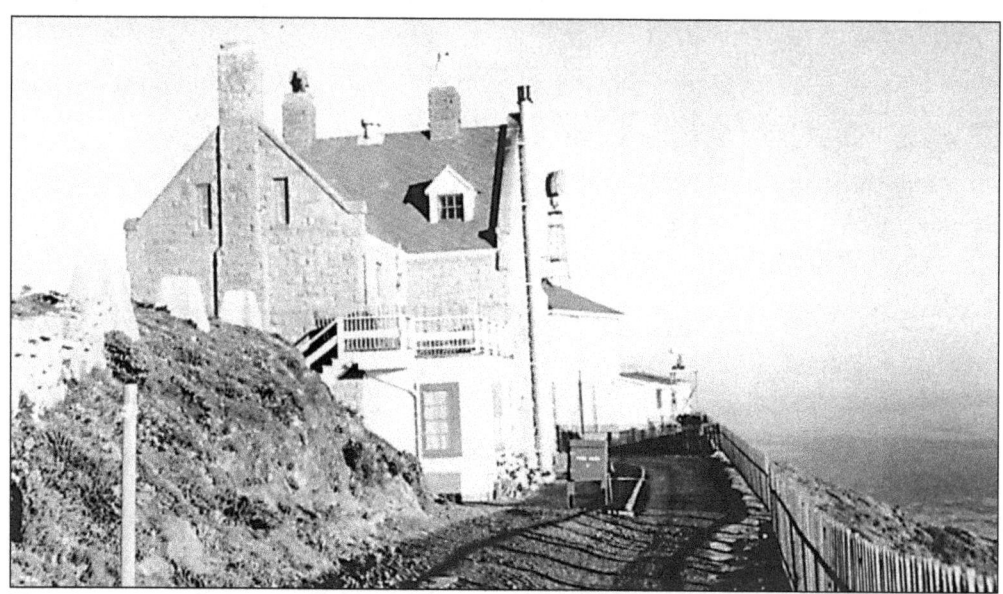

This view captured after 1959 shows a more ship-shape lightstation. In 1959, the RACON tower was removed and other improvements were made to the buildings and surroundings. The porch on the front of the triplex was enclosed in 1939 for more kitchen and bathroom space. The second-story apartment has a deck on the roof of this addition. (Courtesy U.S. Coast Guard.)

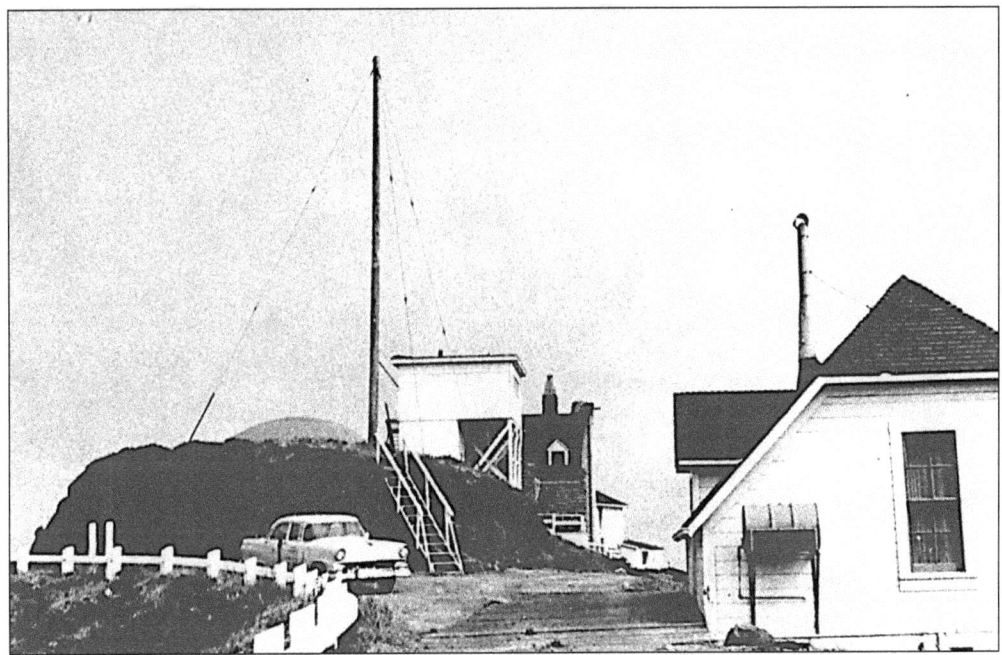

In this scene looking toward the cistern and RACON tower, another antenna braced with guy wires is seen on the hill. The barn, located on the right, has a chimney sprouting through the roof and a small fire-fighting station standing next to it. The car is a mid-1950s model Ford. (Courtesy U.S. Coast Guard.)

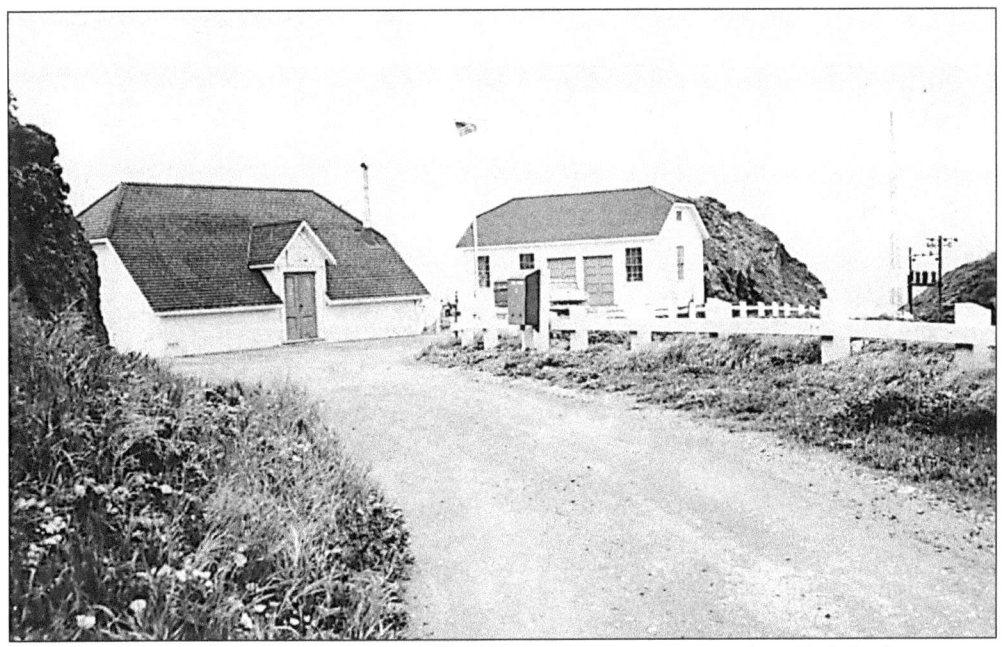

By the 1950s, when this photograph was taken, the barn was commonly called the "recreation center" and its original purpose forgotten. Upstairs, in the old hayloft, the station's television set and a pool table provided some entertainment for the single sailors stationed at Point Sur. The old carpenter-blacksmith shop was used only for storage. (Courtesy U.S. Coast Guard.)

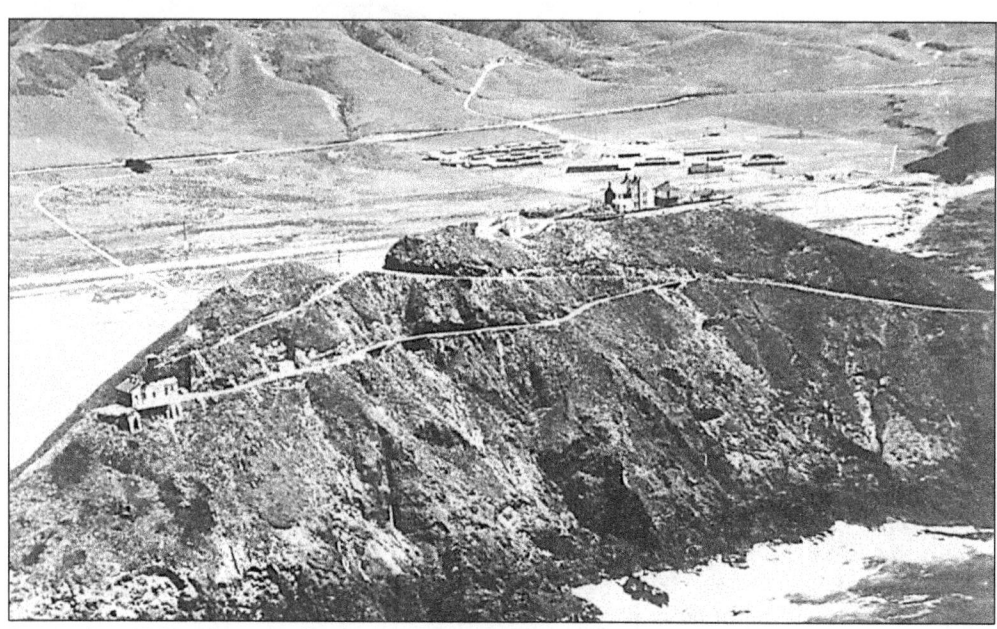

This undated photograph, probably from the 1960s, was taken approaching Point Sur from the southeast. The land east of the rock was still mostly sand. (Courtesy U.S. Coast Guard.)

In another 1960s photograph, this time taken from the northwest of Point Sur, the Big Sur Naval Facility, built in 1958, is visible behind the keepers' houses on the top of the rock. The bunkhouse is still in place, but the RACON tower is gone. (Courtesy U.S. Coast Guard.)

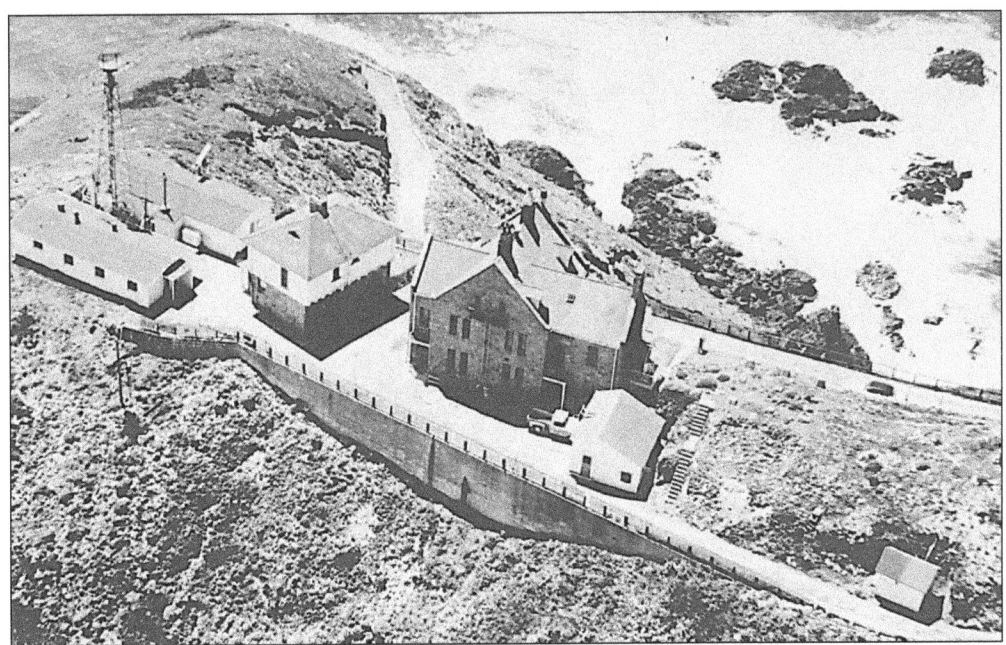

A close-up of the housing area at the top of Point Sur in the 1960s shows, from left to right, the mess hall, the bunkhouse, the head keeper's house, the triplex, the garage, and the pumphouse at the extreme right. (Courtesy U.S. Coast Guard.)

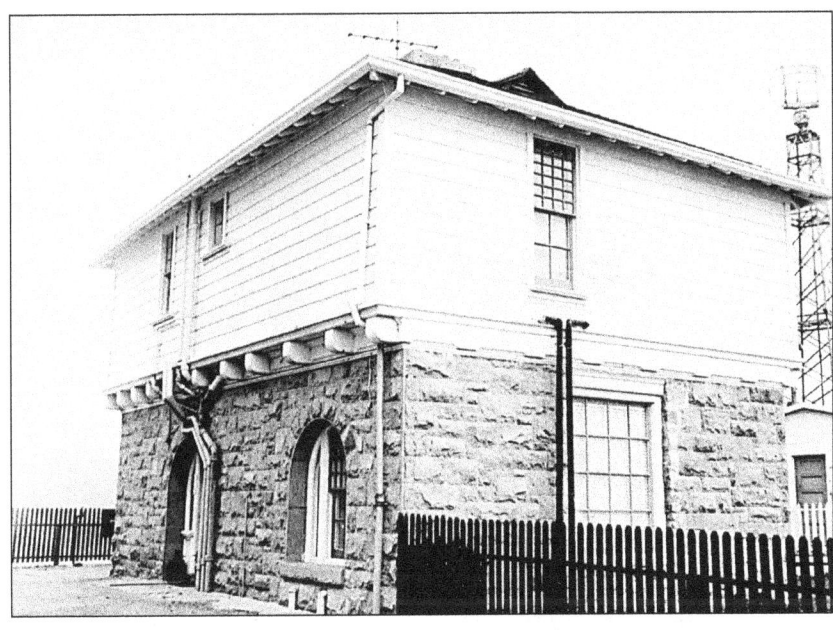

The head keeper's house in the 1950s was adorned with a TV antenna. The steam pipes climbing the wall next to the window brought heat from a boiler in the basement of the triplex since 1949. The large, multi-light window was not part of the original building but was cut into the stone sometime after 1939. Aluminum storm windows were added to all the residences sometime after this photograph was taken. Today, this window is one pane of glass, with a storm pane. (Courtesy U.S. Coast Guard.)

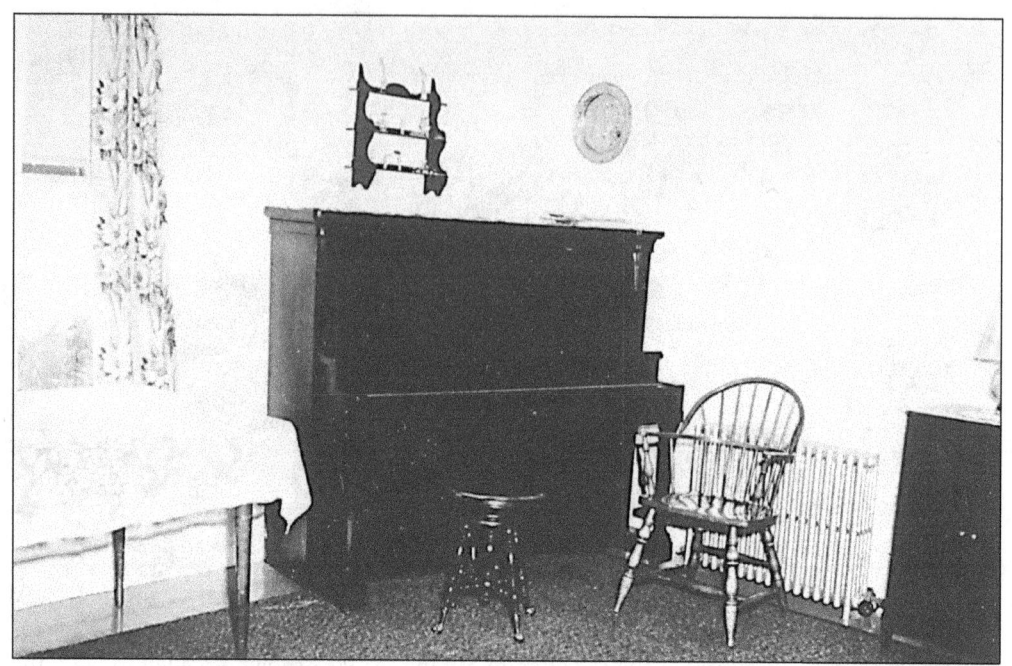
One of a series of very rare interior photographs taken in the early 1950s, this view shows the inside of the head keeper's house. The living room had a large ocean view window, seen here to the left of the piano. (Courtesy U.S. Coast Guard.)

Looking the other way in the room, one can see classic middle-American, 1950s décor. Note the record player on the left and a collection of tea cups on the mantle. (Courtesy U.S. Coast Guard.)

Taking a peek in the head keeper's kitchen, one can see a coffee maker sitting on the counter and a can opener mounted on the wall at the far right. But the government binoculars on the windowsill by the curtains are a clue that this is no ordinary kitchen. The binoculars were used to see who was at the gate on the highway, almost a mile away. The kitchen had been remodeled while the keeper's wife was in Monterey having a baby. (Courtesy U.S. Coast Guard.)

In the dormitory apartment in the triplex, the kitchen was ship-shape for the official photographer. A radio, sugar canister, and box of Tide detergent sit on the counter. (Courtesy U.S. Coast Guard.)

Four to six young enlisted Coast Guardsmen shared the dormitory kitchen. They kept binoculars on the windowsill too. (Courtesy U.S. Coast Guard.)

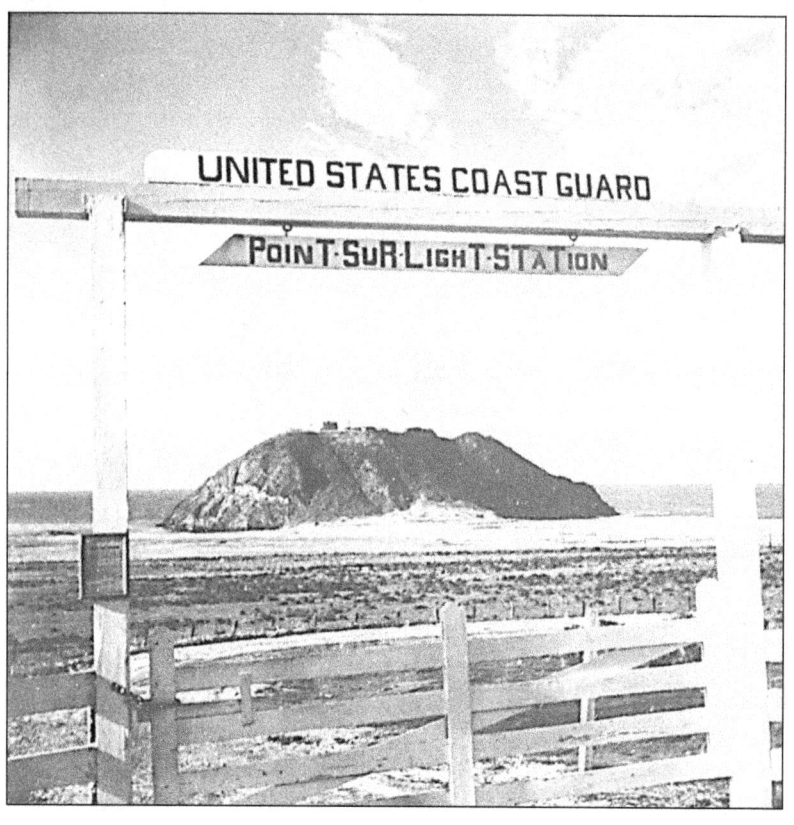

Sometime during the 1950s or 1960s, Point Sur visitors were able to pass through this western-style ranch gate along Highway One. (Courtesy U.S. Coast Guard.)

Eight
THE PEOPLE OF POINT SUR

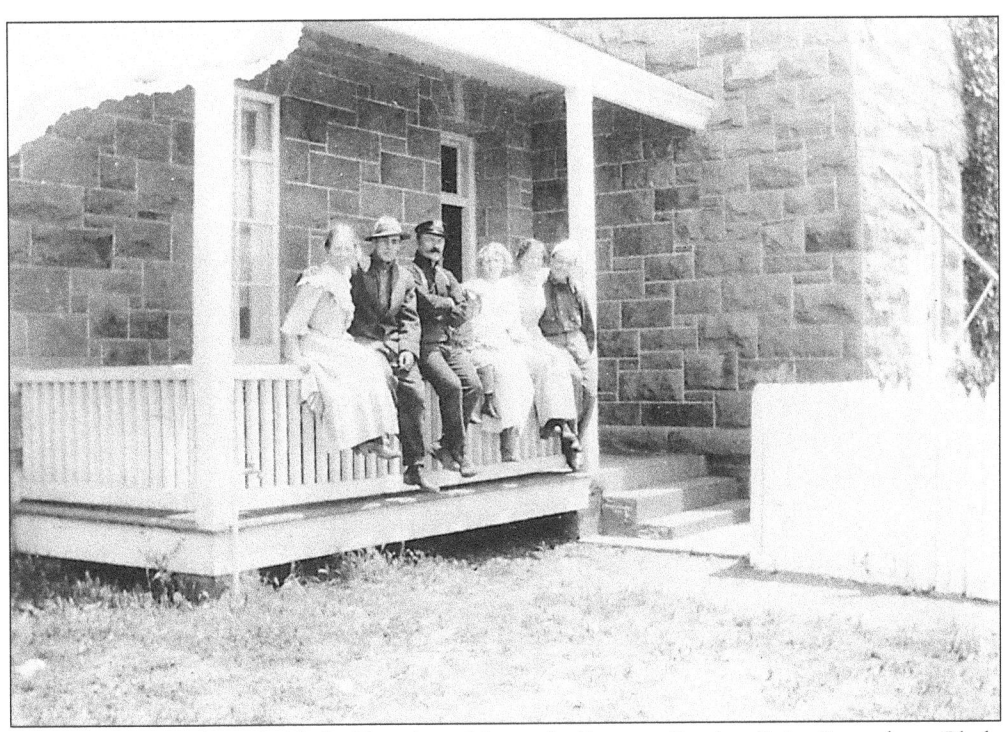

Between 1913 and 1915, Clyde Church and his wife, Frances, lived at Point Sur, where Clyde was an assistant keeper. Frances told her children that the two years she spent at Point Sur were some of the happiest of her life. Frances and Clyde are the first two people on the left in this photograph, taken on the porch rail of the triplex. (Courtesy Elsie Church Goff.)

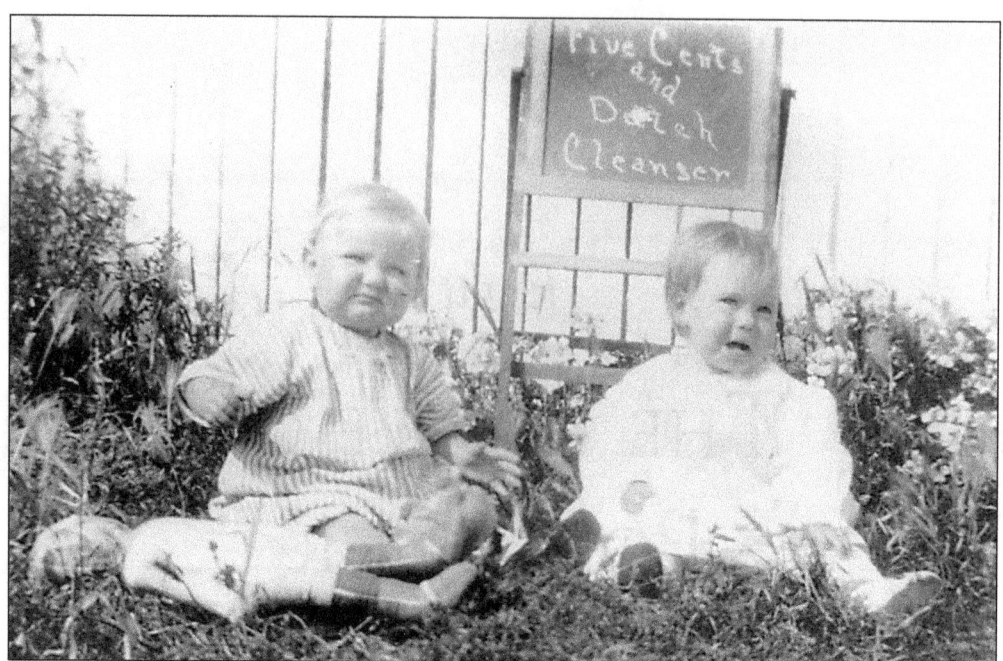

All the children were under school age. Families with school-aged children were usually sent to stations closer to schools. Young Elsie Church, on the right, is not happy with the picture taking. The sign on the chalkboard reflects an advertisement from the era. (Courtesy of Elsie Church Goff.)

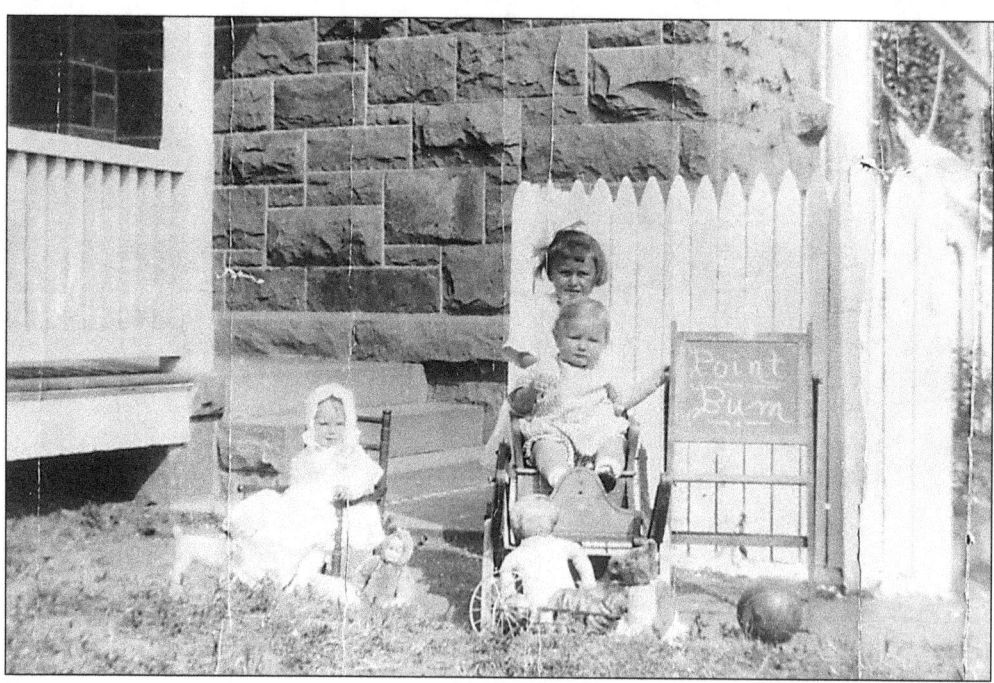

Point Sur's children are displayed with their dolls and a sign that may reflect the number of diaper-clad youngsters at Point Sur at this time. Elsie Church is on the left. (Courtesy Elsie Church Goff.)

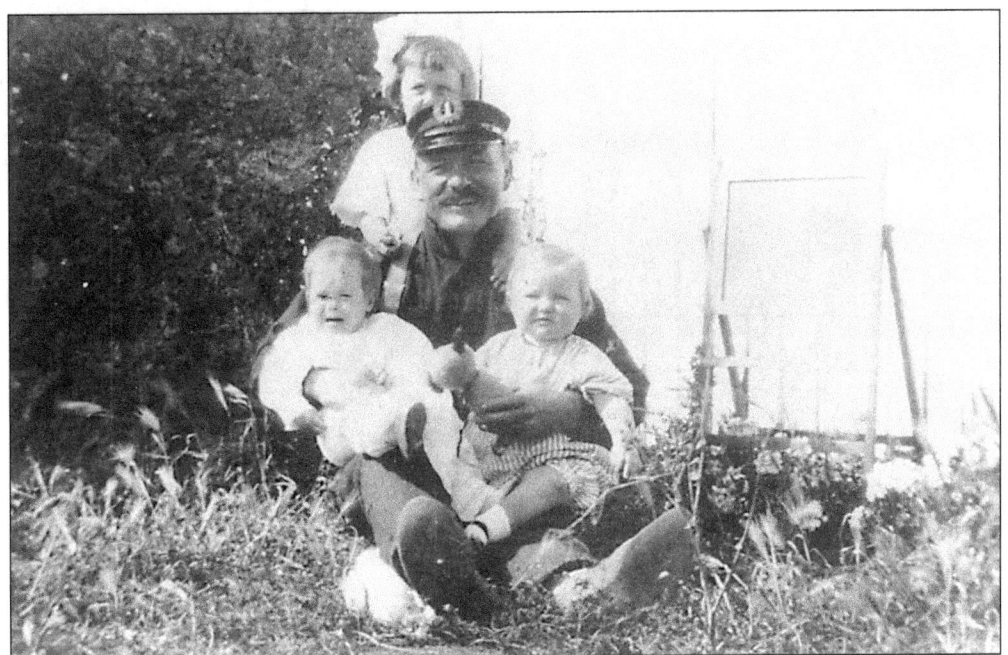

Not even this burly lightkeeper can comfort Elsie Church (crying baby on the left). When Frances Church became pregnant at Point Sur, she took the toddler and went back to her parent's home in St. Louis to give birth. Elsie cried the whole way. There were no hospitals near Point Sur-the closest was in Monterey, a day's travel away. Clyde followed when his two-year term as a lightkeeper was up. (Courtesy Elsie Church Goff.)

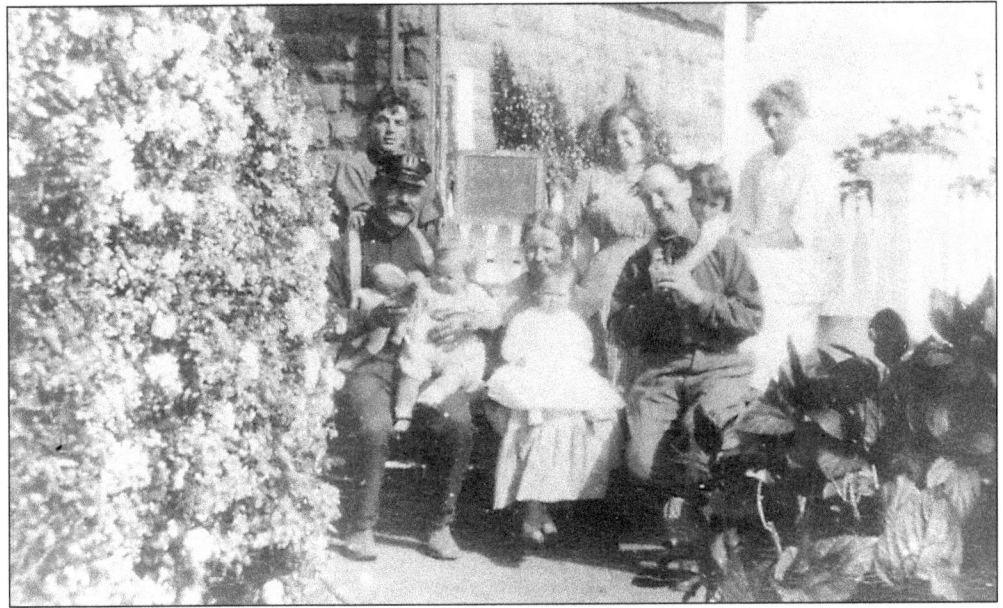

Clyde Church on the left, rear, and Frances in the middle (holding Elsie) pose with a group in front of the head keeper's house. Note that the big ocean-side picture window had not yet been installed. The chalkboard now reads "Point Sur" and has a drawing of a lighthouse. (Courtesy Elsie Church Goff.)

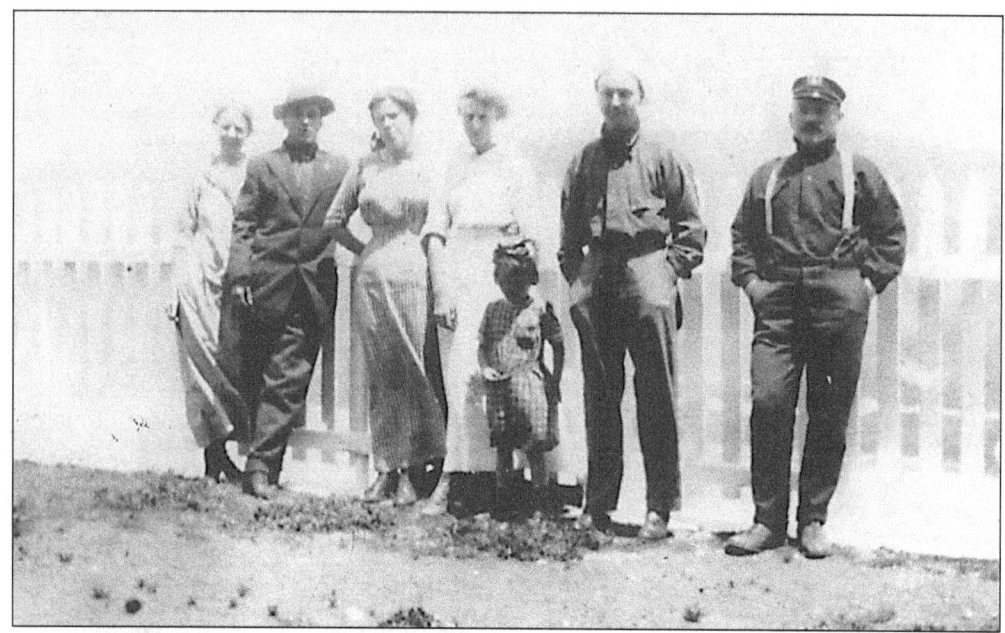

Frances and Clyde stand with the other keepers along the east side fence. Clyde had finished an enlistment in the U.S. Army in the Philippines and was working as a firefighter when he met Frances in Manila. Frances' father was a civil servant. When they married in 1912, Clyde was 25 and Frances was 19. They returned to the states with Frances's parents and Clyde worked as a shipyard carpenter in Alameda, before receiving his appointment as a lighthouse keeper. (Courtesy Elsie Church Goff.)

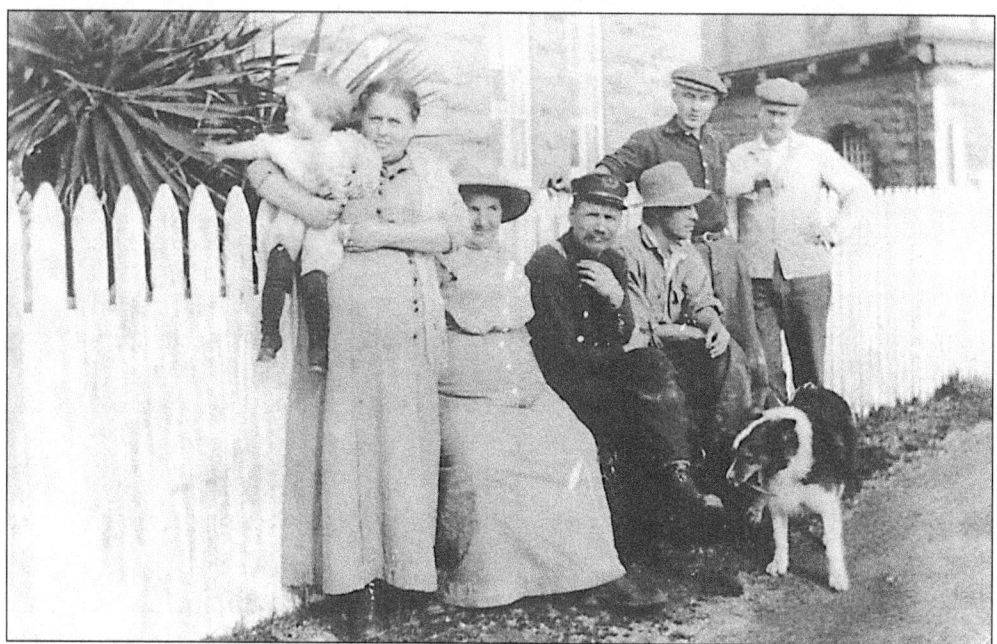

Clyde Church, in the fedora, is in the center of this group posed along the fence on the west side of the triplex. The family dog, Bonnie, once got in trouble for stealing eggs, and Rome the horse is remembered for getting into the garden and rolling in it. (Courtesy Elsie Church Goff.)

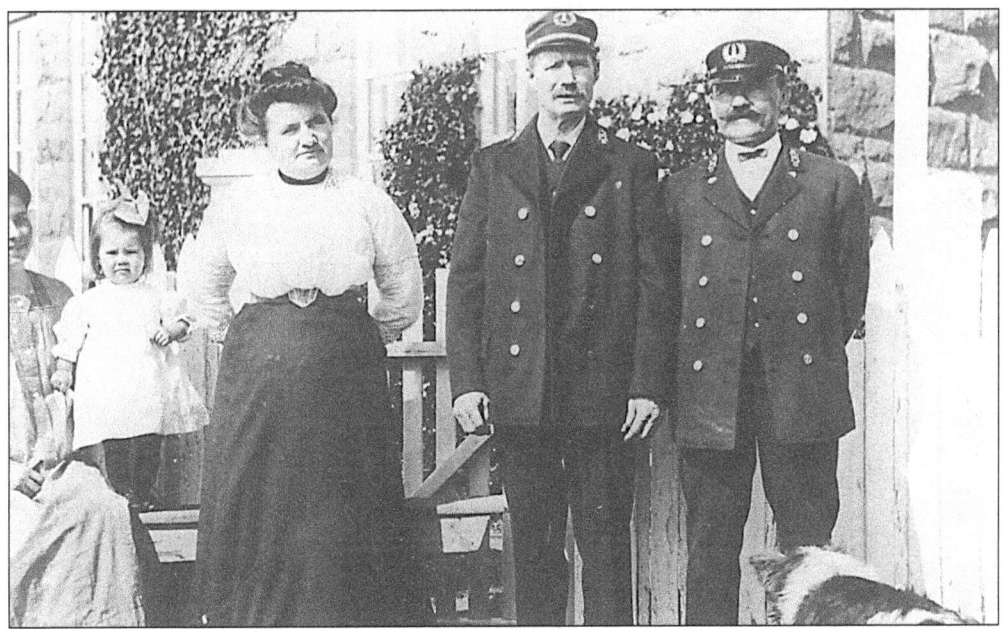

In 1916, head keeper John Astrom and his wife, Alice (center), had their picture taken with another keeper. The keepers dressed in their best uniforms. Astrom was the head keeper from 1909 until his retirement from the Lighthouse Service in 1927. John Astrom was a colorful figure who was born in Sweden, became a merchant seaman at age 13, spent 20 years in the U.S. Navy, and then spent another 27 years in the Lighthouse Service. He was on duty at the East Brother Lighthouse in San Francisco Bay when the earthquake hit in April 1906. (Courtesy Wallace Stasek.)

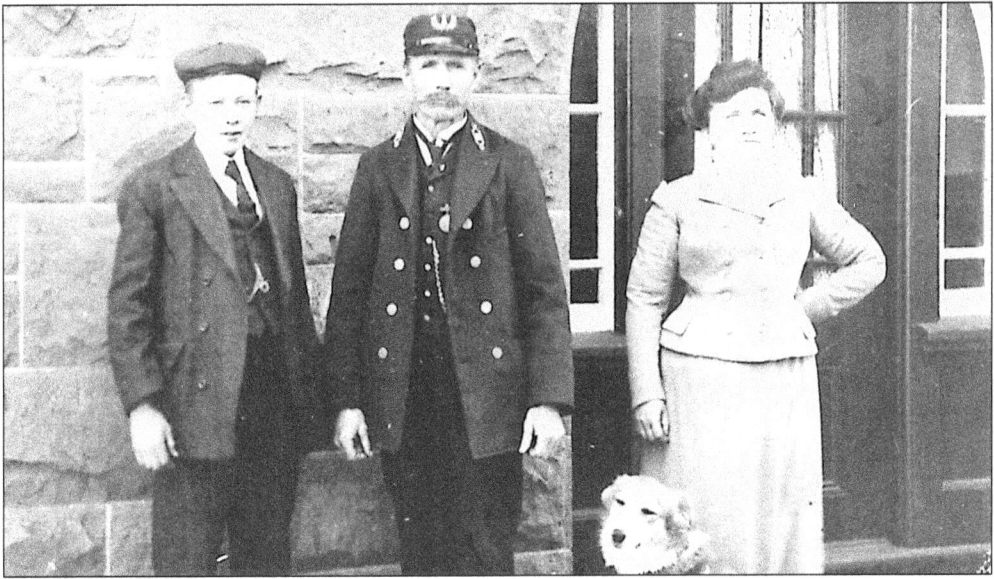

From left to right, Oscar, Alice, and John Astrom pose outside of the head keeper's house in 1916. Oscar, the Astrom's only son, died of tuberculosis in 1918 at age 23 after John unsuccessfully petitioned the Lighthouse Service to get him into a Public Health hospital. The request was turned down because Oscar was not an employee. (Courtesy Wallace Stasek.)

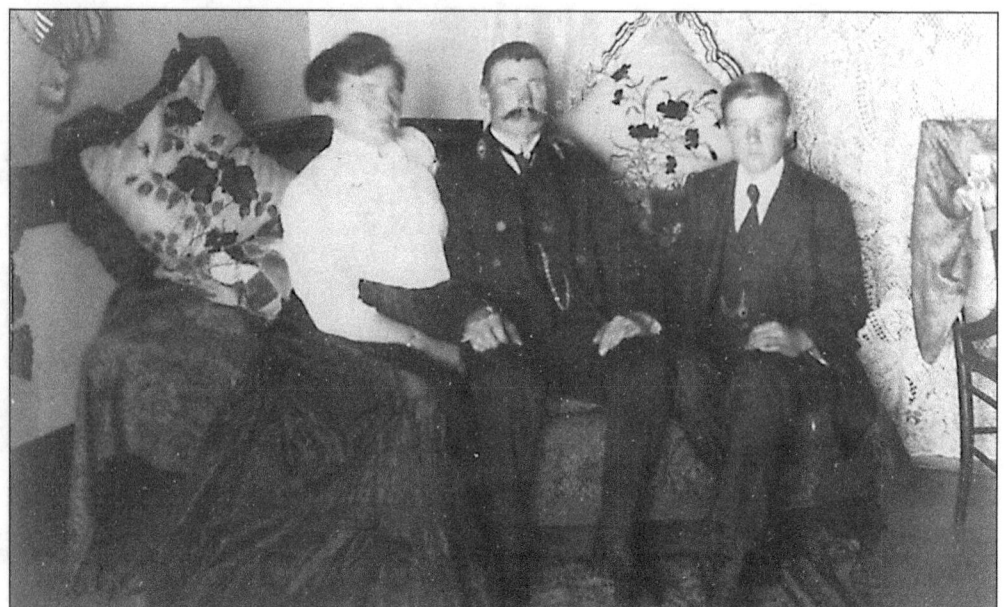

This 1916 photograph, showing the northwest corner of the head keeper's house, is the first interior shot ever taken in that structure. On the couch are, from left to right, Alice, John, and Oscar Astrom. The painted concrete floor, reflecting the building's earlier use as a hoist house for the station's railway, was later covered with wood. (Courtesy Wallace Stasek.)

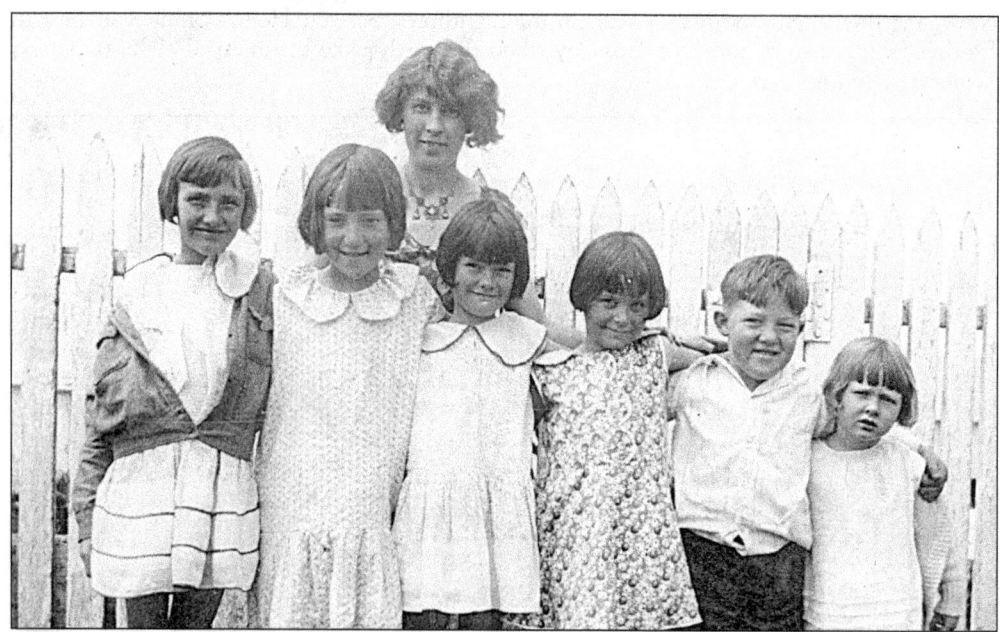

In 1928, the keepers at Point Sur petitioned Monterey County for their own teacher. The county required six children to establish a school. Point Sur only had five children of school age, but Billy Mollering advanced a year or two, at least on paper, so that the lightstation might meet the requirement. Here the children pose with Miss Young, who later married an engineer building Highway 1. From the left to right are Leota Miller, Jeanette Mollering, Margaret Day, Hanna Miller (?), Billy Mollering, and Elvina Fraser. (Courtesy Elvina Fraser La Riviere.)

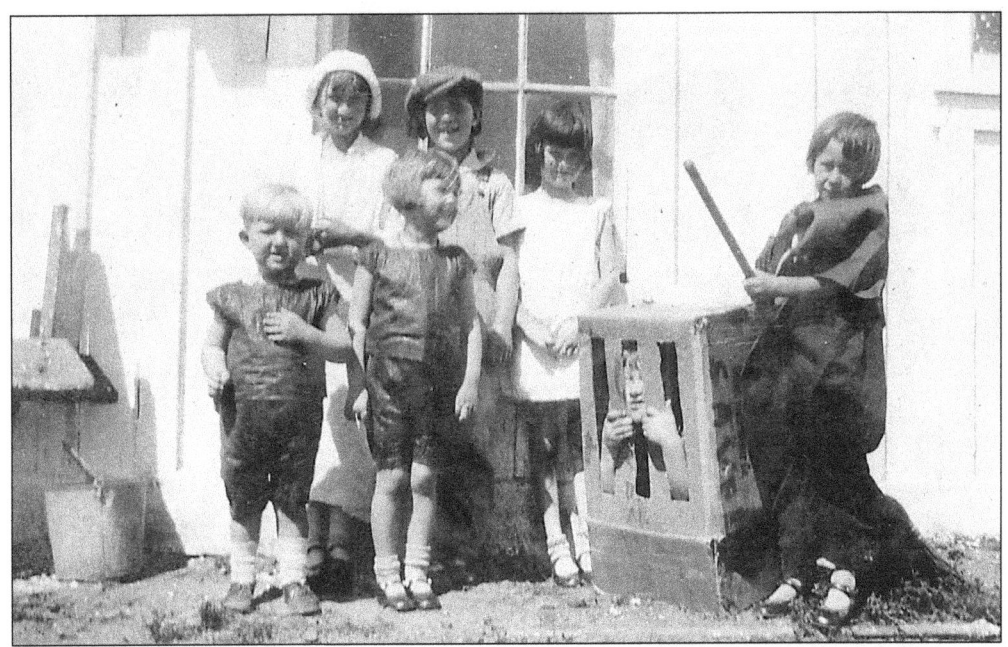

Dramatic school programs were a staple of the school, where students ranged from kindergarten to fifth grade. This is a picture from the production of *Hansel and Gretel*. From left to right are Bobby Fraser as a Gingerbread Child, Leota Miller as Mother, Jeanette Mollering as Father, Elvina Fraser as a Gingerbread Child, Marguerite Day, Billy Mollering (in jail) as Hansel, and unidentified student with broom as the Witch. (Courtesy Elvina Fraser La Riviere.)

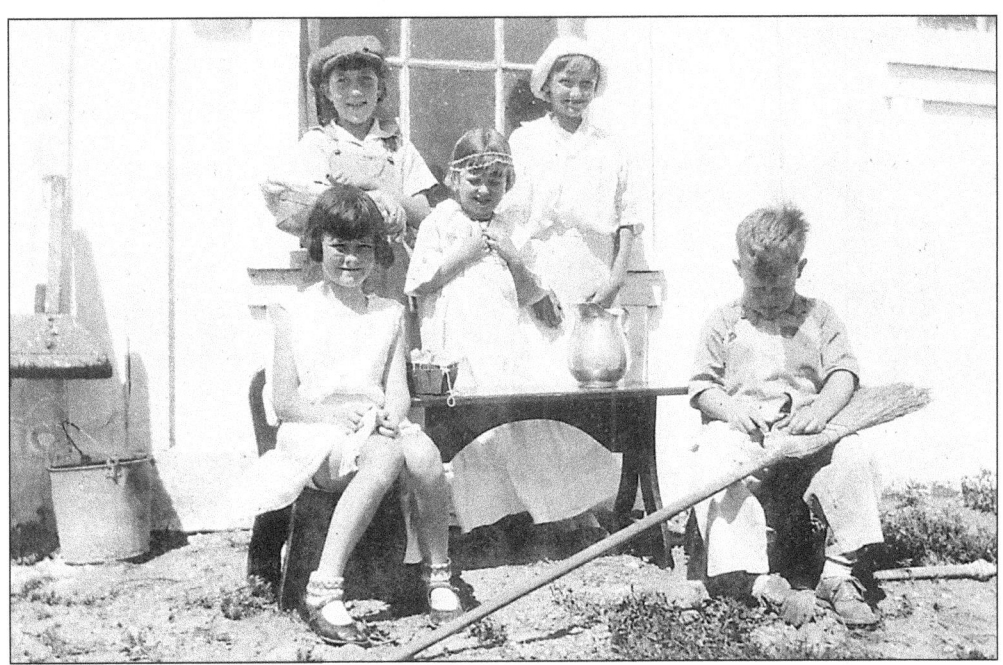

In another scene from *Hansel and Gretel*, the kids pose for a picture. From left to right are Hannah Miller as Gretel, Jeannette Mollering, Elvina Fraser, Leota Miller as Mother, and Billy Mollering. (Courtesy Elvina Fraser La Riviere.)

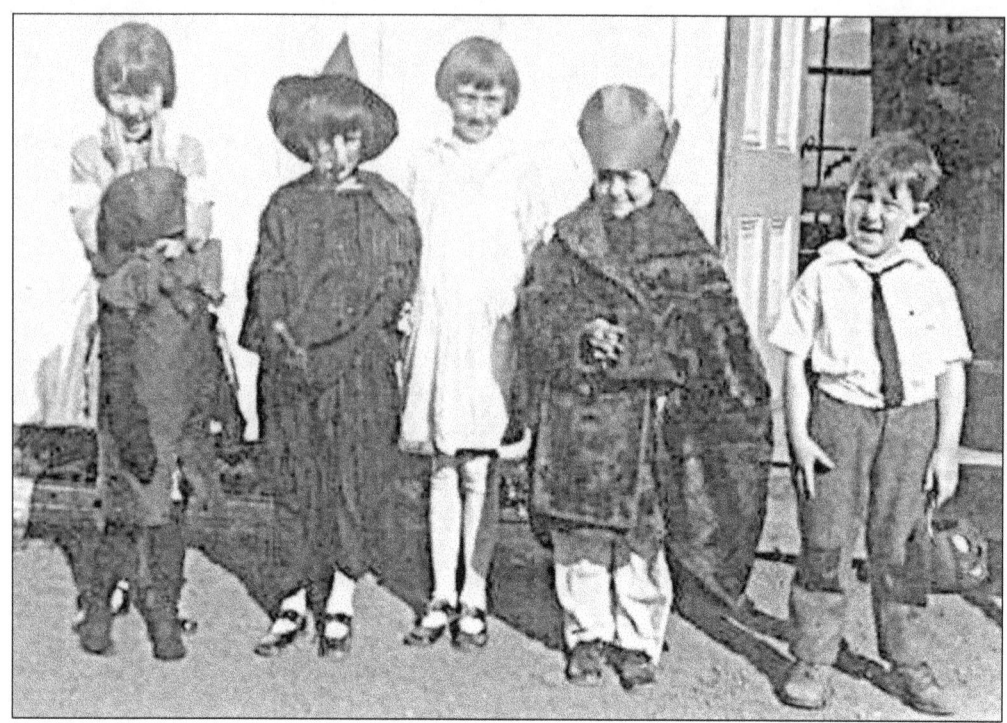
In 1928, students presented a Halloween play. Billy Mollering is on the right. (Courtesy Elvina Fraser La Riviere.)

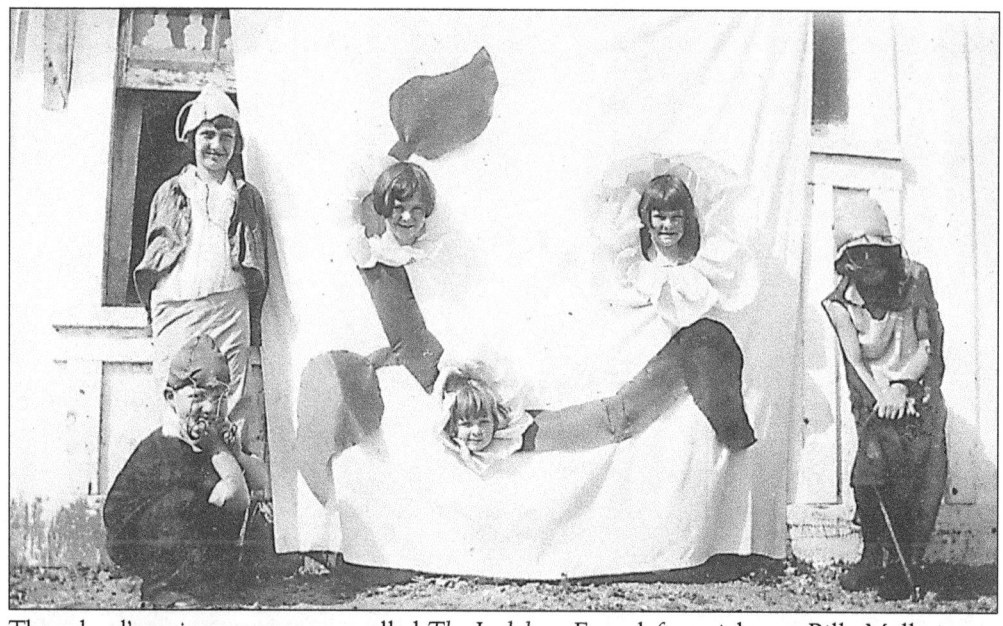
The school's spring program was called *The Ladybug*. From left to right are Billy Mollering as Aphis, Leota Miller as Tommy-tip-toe, Hannah Miller as Heart of the Rose, Elvina Fraser as Rose Bud, Marguerite Day as Rose Bud, and Jeanette Mollering as Ladybug. (Courtesy Elvina Fraser La Riviere.)

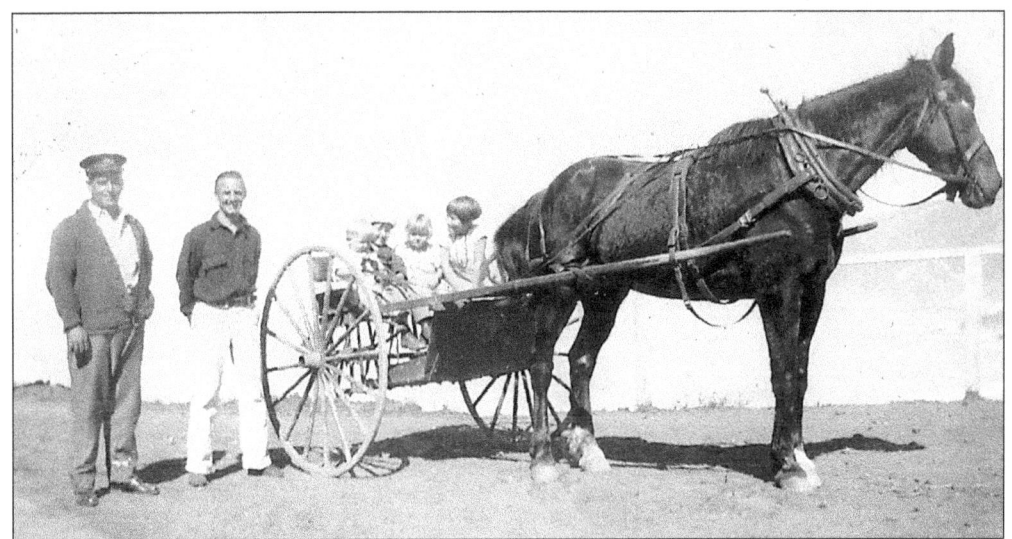

In the 1920s and 1930s, the light keepers had a horse named Prince, who was a "doped" racehorse and presumably a bargain since he could never race again. He had a stall in the barn and a small paddock next to the barn. In 1929, he stood patiently harnessed to a cart carrying some of the station's children while keepers Bill Mollering (left) and Bill Fraser looked on. Keepers used the cart once a week to get groceries and mail from the Pfeiffer Resort, eight miles away. (Courtesy Elvina Fraser La Riviere.)

Prince wasn't the principal mode of transportation. Even in the 1920s, before Highway 1 was completed to Big Sur, the keepers had cars. Some of the children can be seen playing inside Bill and Ann Fraser's 1928 Chevy. (Courtesy Elvina Fraser La Riviere.)

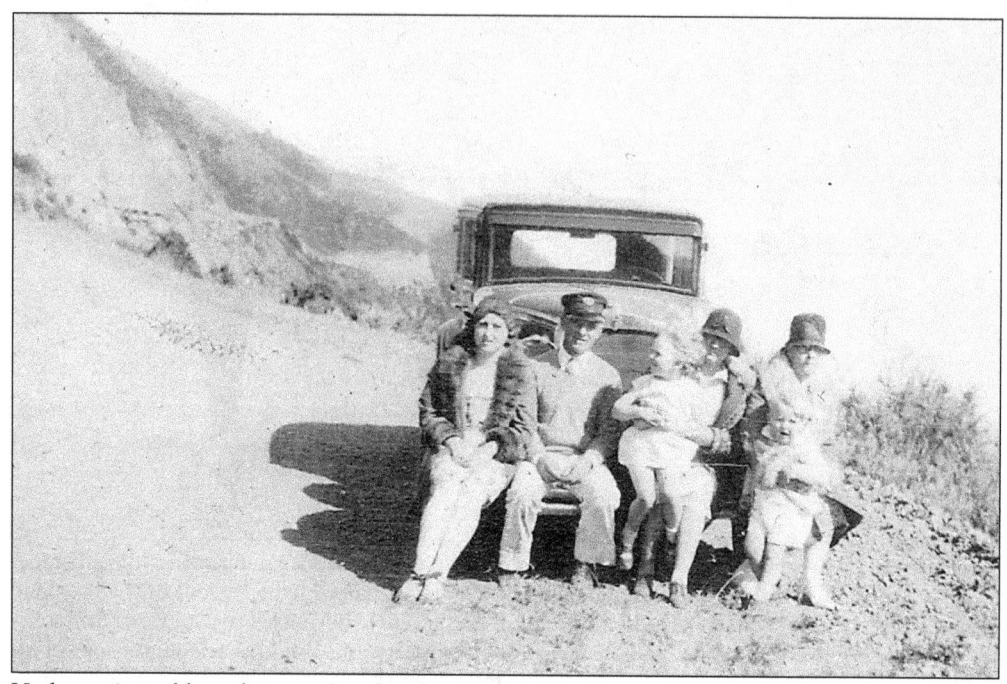
Highway 1 would not be completed and opened to Big Sur until 1932. A group from the lighthouse managed to stop and pose for this photograph around 1930 along the not-yet-opened road. (Courtesy Elvina Fraser La Riviere.)

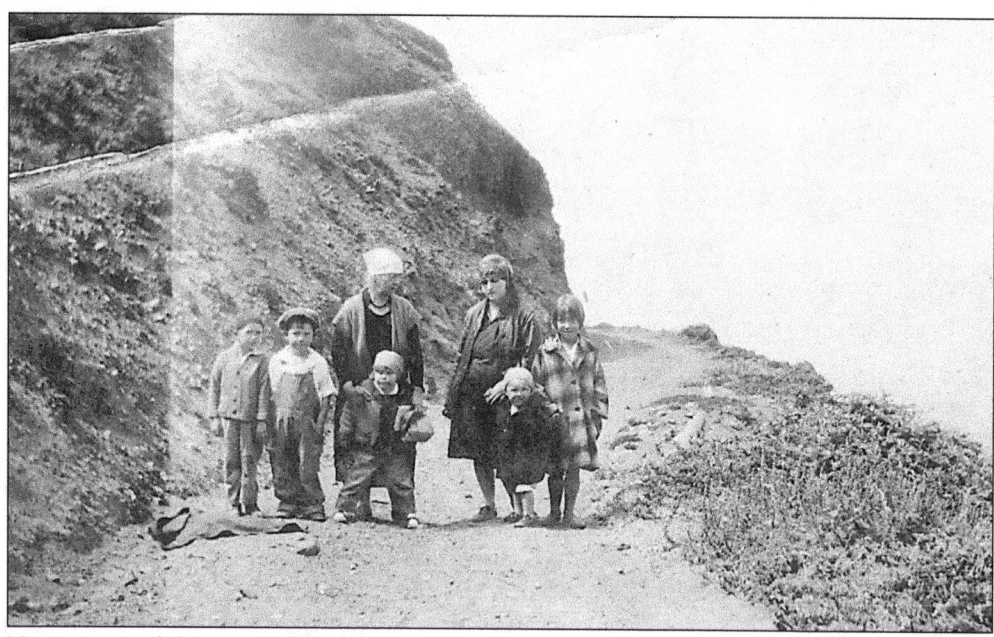
Having a car didn't mean the end of walking, because cars often couldn't get across the sand flats due to shifting dunes or flooding. When they could get across, chains were often required. Sometimes the keeper cars were left miles away near the county road. In this c. 1930 photograph, a hearty band of women and children walking up Point Sur are seen just passing Macon Point. (Courtesy Elvina Fraser La Riviere.)

In 1930, people did not have to walk up the road to the top of Point Sur, they could always walk up a long stairway from the lower road to the keepers' quarters at the top. The stairs followed the path of the earlier railroad tracks, rising almost 100 feet in elevation from the fork in the road to the lighthouse. (Courtesy Elvina Fraser La Riviere.)

Young Harry Miller was photographed near the top of the east side stairs, where they took a turn to get over the retaining wall at the top. The outflow pipe for wastewater from the keepers' quarters can also be seen in this photograph. Until recent times, sewage was sent over the side, right into the ocean. (Courtesy Harry Miller.)

Usually, keepers walked down the dirt trail from the keepers' quarters at the top to the lighthouse on Point Sur's north end. In this c. 1930 photograph, Mrs. Dickman walks down the trail with Bobby Fraser. (Courtesy Elvina Fraser La Riviere.)

Having visitors always brought out the cameras. Here, an unidentified group poses in 1930 near the triplex. The picket fence in the background outlines the keepers' yards and gardens. (Courtesy Elvina Fraser La Riviere.)

Keeper Bill Fraser (center, in cowboy hat) was showing some friends around the station when this photograph was taken c. 1930. Note the bridge to the light tower in the background. (Courtesy Elvina Fraser La Riviere.)

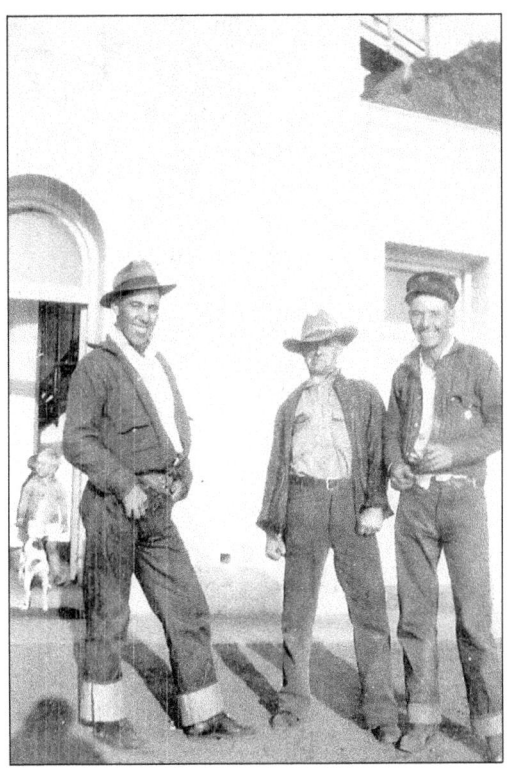

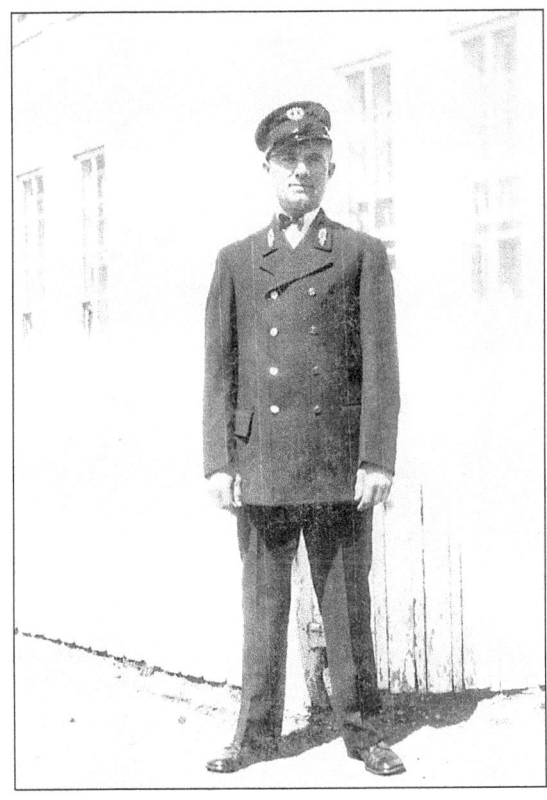

Keeper Bill Fraser, in his dress Lighthouse Service uniform, poses for this picture with considerably more decorum than in the previous photograph in which he wore a cowboy hat. (Courtesy Elvina Fraser La Riviere.)

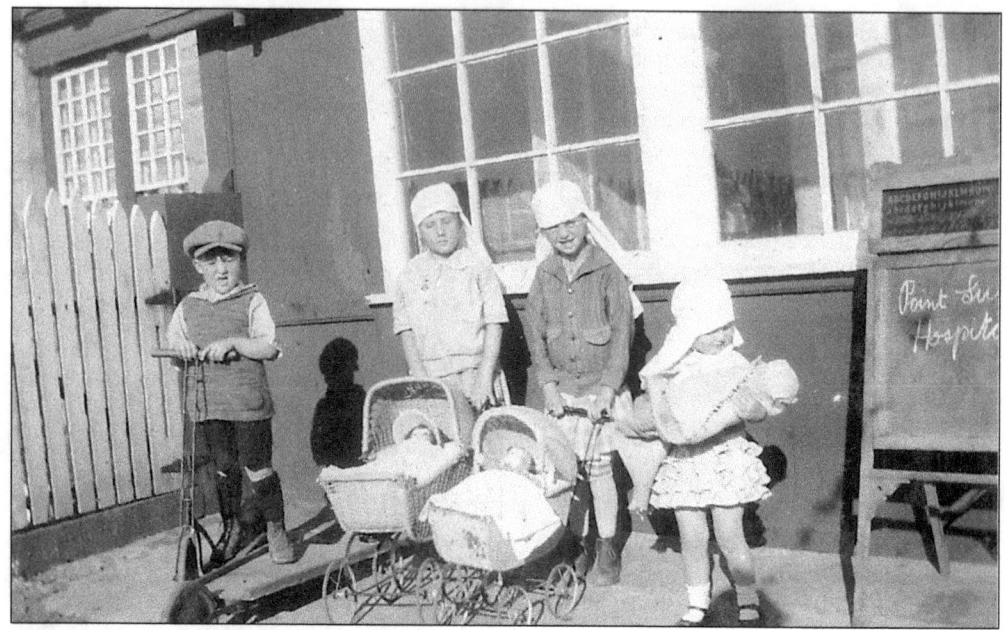

Lightstation children played together and had rich make-believe lives, as seen in this c. 1930 Point Sur "Hospital." From left to right are Billy Mollering, Jeannette Mollering, unidentified, and Elvina Fraser holding her doll. (Courtesy Elvina Fraser La Riviere.)

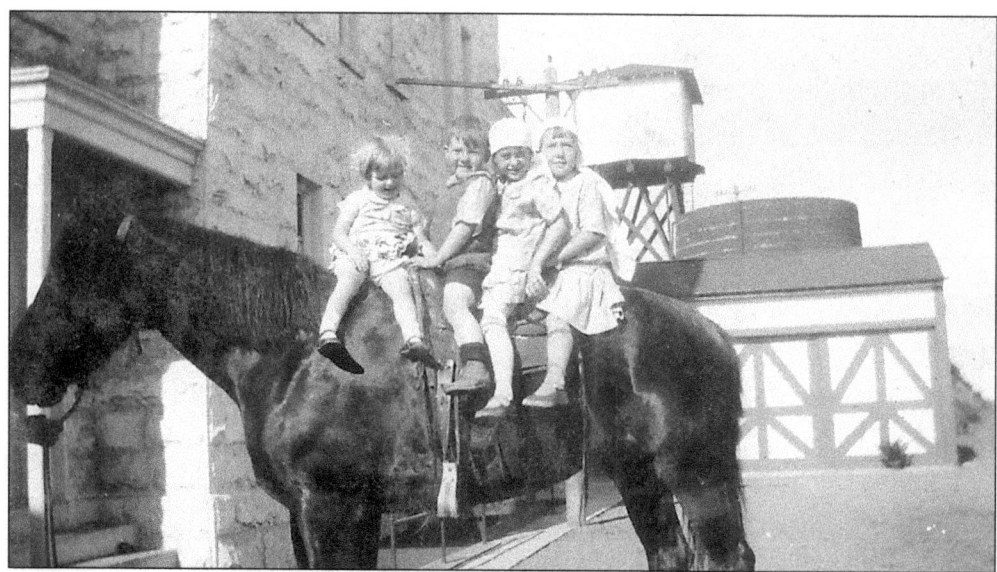

Later, still dressed in their nurse costumes, the kids climbed on Prince for another picture. From the left are Elvina Fraser, Billy Mollering, unidentified, and Jeannette Mollering. (Courtesy Elvina Fraser La Riviere.)

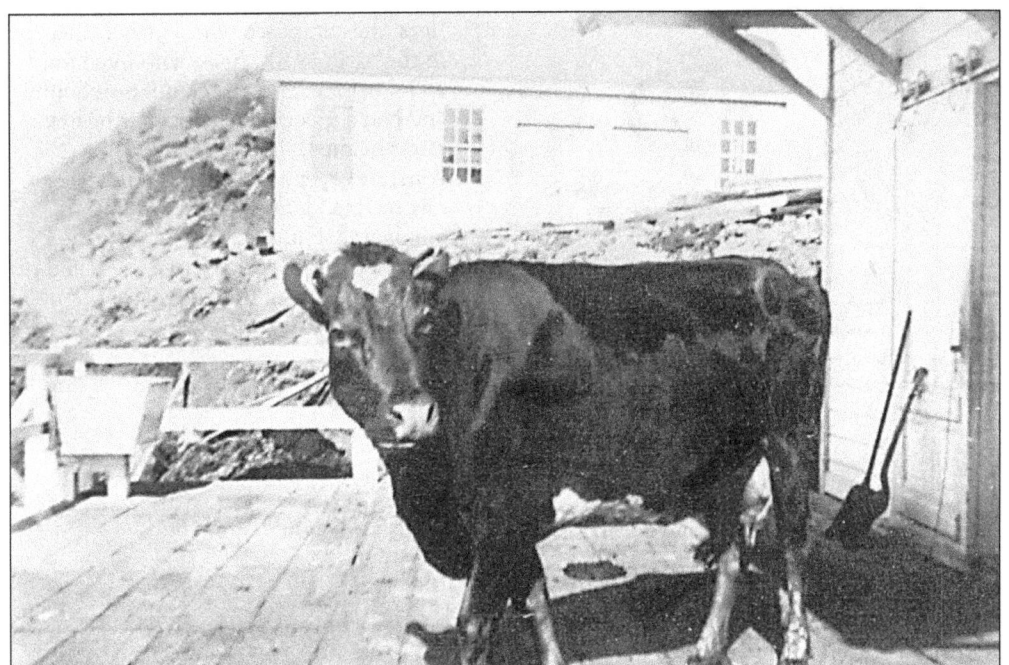

Beauty, the station cow in the 1930s, had a prime spot on the deck by the barn. In the early 1940s, the cow was Daisy, and she was allowed to roam all around the rock. Daisy was often found grazing at the bottom of the rock when the kids came home from school and followed them up to the barn to be milked. (Courtesy Elvina Fraser La Riviere.)

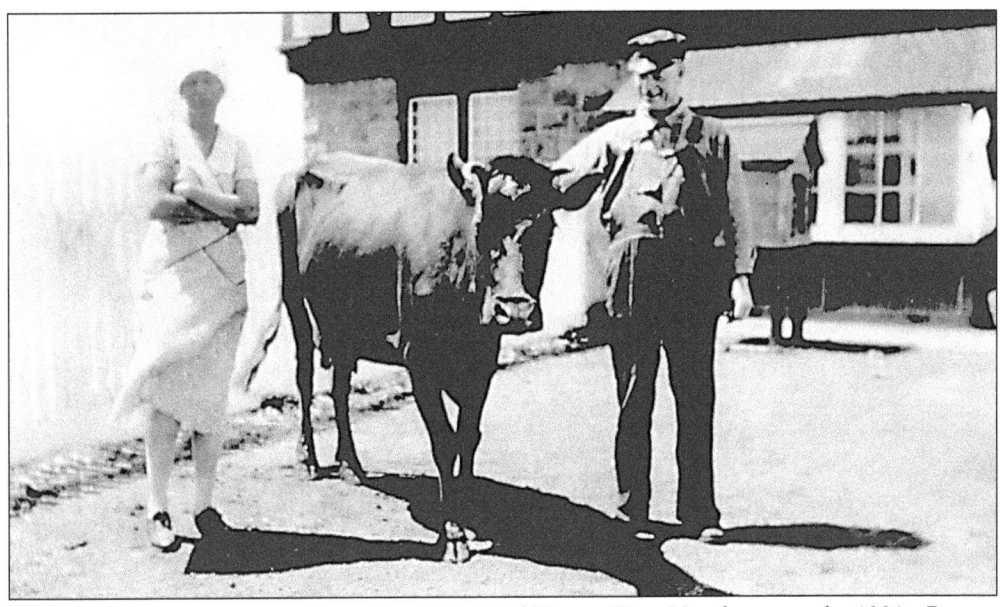

Beauty posed again for Mrs. Verna Henderson and Keeper Tom Henderson in the 1930s. Beauty was at the heart of a reported controversy between keepers because she was allowed to roam freely on the rock. The story goes that another keeper complained and Henderson told him he didn't have to drink the milk. Even after apologies, the other keeper had his milk delivered to the lightstation gate by Highway 1, almost a mile away. (Courtesy George Henderson family.)

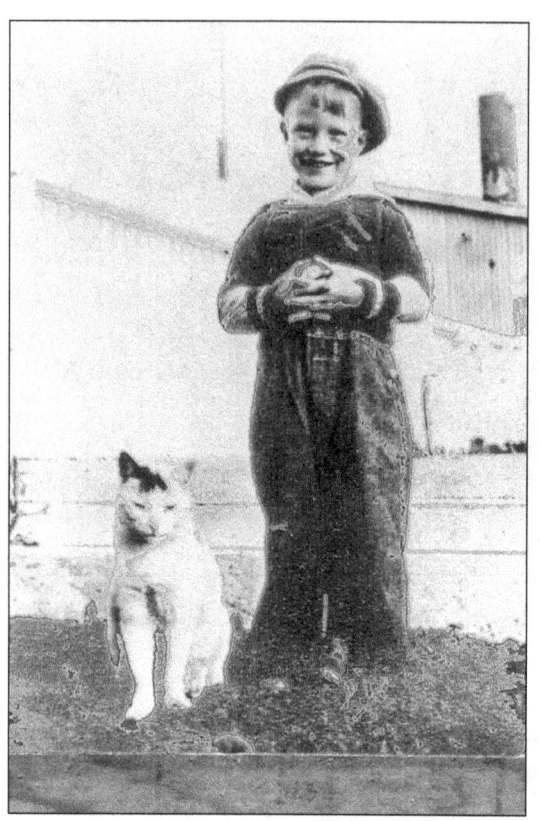

Jiggs, the cat, posed with Harry Miller in the early 1930s. Jiggs, who lived until 1936, belonged to the Henderson family and had a special place in their hearts. After he died, Jiggs was placed in a concrete crypt hand-made by teenager George Henderson. Later, when the family was sent north to Point Pinos Lighthouse in Pacific Grove, Jiggs and his crypt were part of their baggage. (Courtesy Harry Miller.)

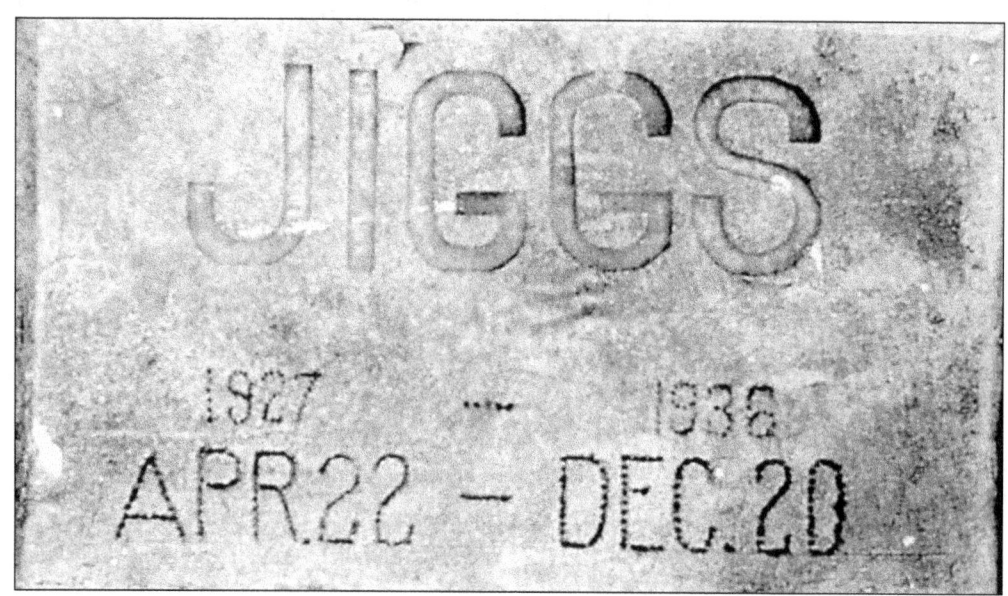

Jiggs' crypt still lies under the trees next to the Point Pinos Lighthouse. (Courtesy Dawn Cope.)

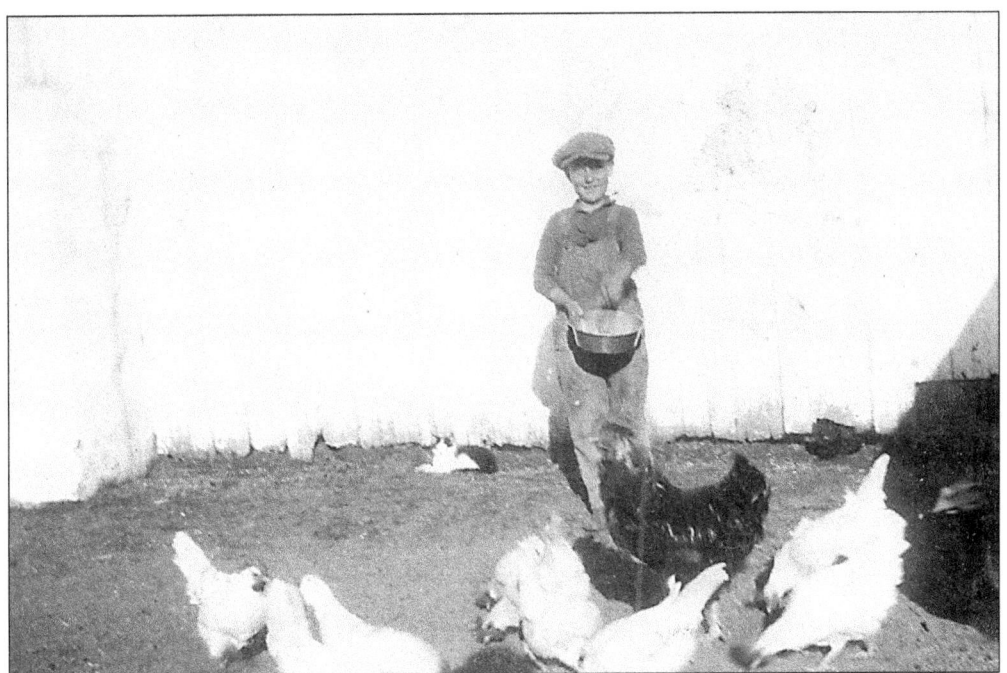

Other animals also called Point Sur home. The keepers usually kept chickens, such as these being fed by Jeannette Mollering in the early 1930s. An unverified Point Sur story says that it was sometimes so windy that they tethered their chickens by the legs. (Courtesy Elvina Fraser La Riviere.)

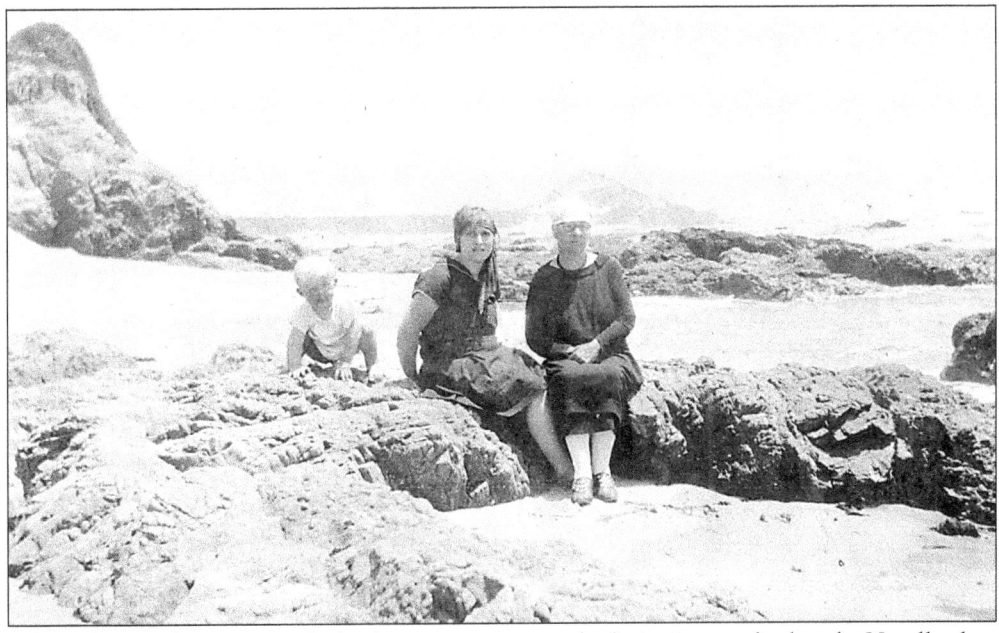

When the weather was good, the keepers sometimes had picnics on the beach. Usually they went to the south beach, which is out of the prevailing northwest winds. In this 1930 view, Bobby Fraser, his mother Anne Fraser (center) and his grandmother Susan Fraser enjoy the sun. (Courtesy Elvina Fraser La Riviere.)

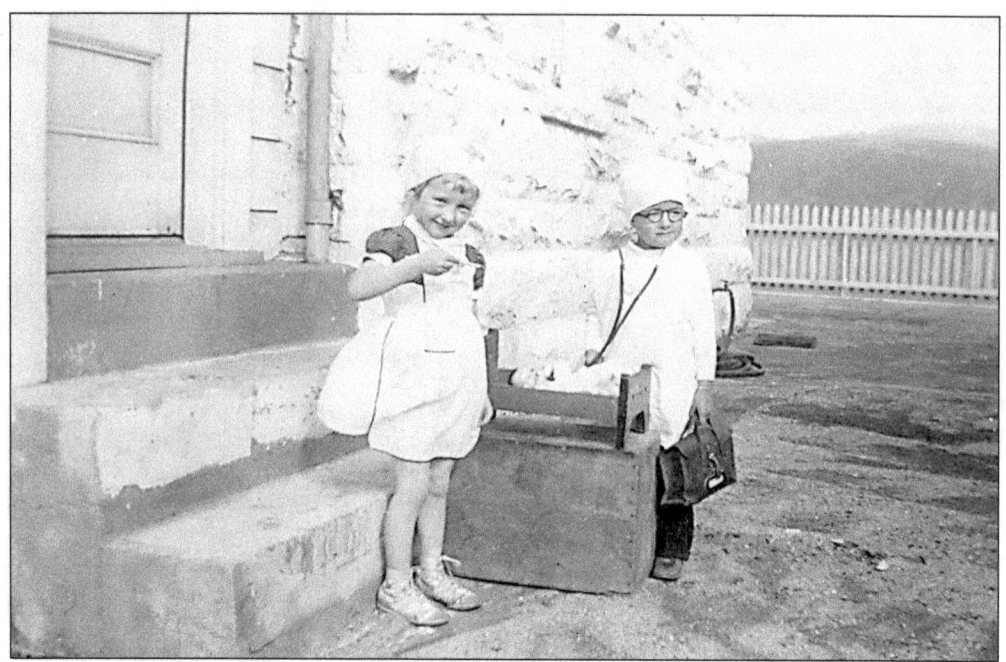

Decade after decade, children played the same games in the same places at Point Sur. In the early 1940s, Ruth Coursey (left) and another lighthouse child played hospital with an unidentified friend. A doll is the patient. (Courtesy Ruth Coursey.)

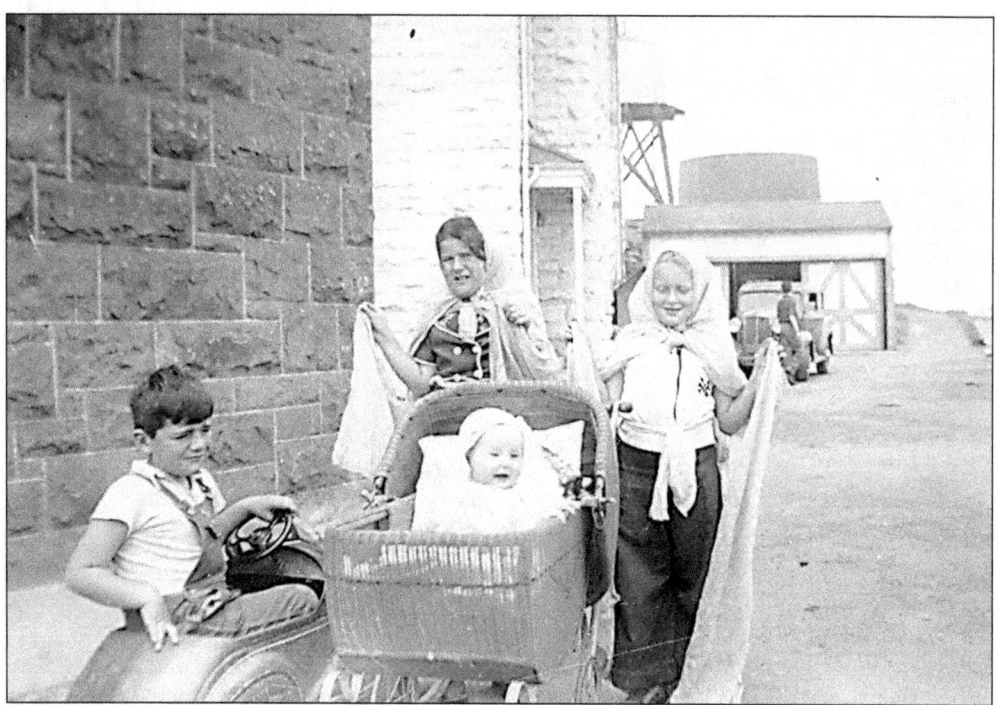

A couple of years earlier, Ruth was a baby in the carriage when the kids played with her in the protected area behind the head keeper's house. Her sister Eula is directly behind her. The other children are unidentified. (Courtesy Ruth Coursey.)

Even though the roads were not paved, hard-packed areas near the quarters were good enough for tricycles and bikes for the bigger kids. Harry Miller shows off his tricycle, c. 1930. (Courtesy Harry Miller.)

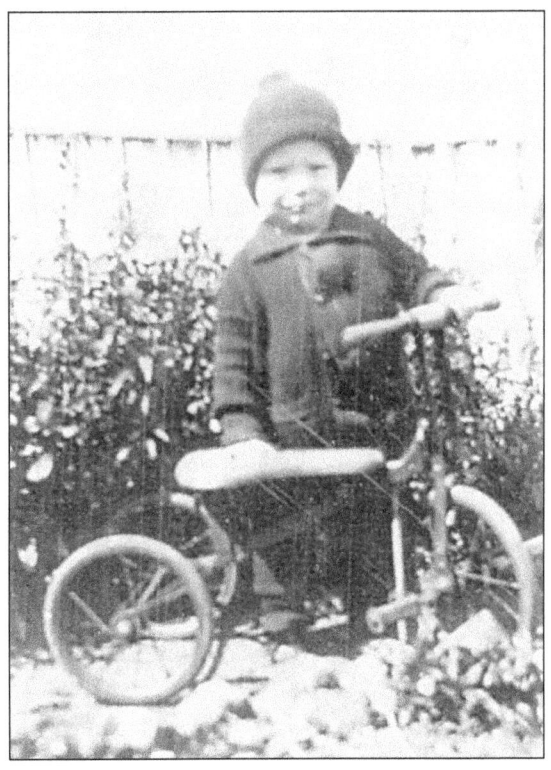

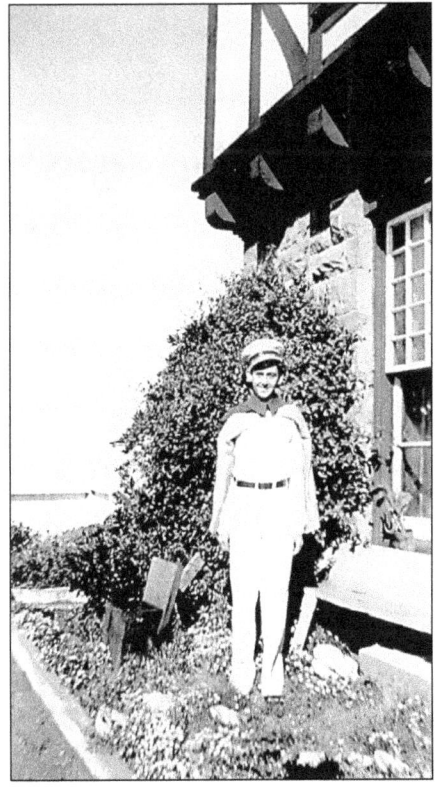

Young children lived, played, and went to school near the lightstation. Life was more difficult for teenagers, who had to go into Monterey to high school. Sometimes they had to board with other families during the week. After Highway 1 opened, they could take a bus. In this 1937 photograph, Norman Day shows off his Monterey High School band uniform. Keeper Henderson's son George was also in the band. (Courtesy George Henderson family.)

In 1934, Head Keeper Tom Henderson (left) posed with Assistant Keeper Bill Owens and the fish they caught. Fishing was a favorite activity for many of the keepers over the years. Owens went on to a distinguished career in the Lighthouse Service, spending many years at Point Cabrillo Lighthouse in Mendocino. (Courtesy George Henderson family.)

Ruth Coursey (right) and her sister Eula Coursey posed in 1942 at the south end of Point Sur in front of the cold frame that the keeper's families used to start plants. Wind and lack of soil were two of the challenges for gardening at Point Sur. Luckily, earlier keepers had brought in soil. (Courtesy Ruth Coursey.)

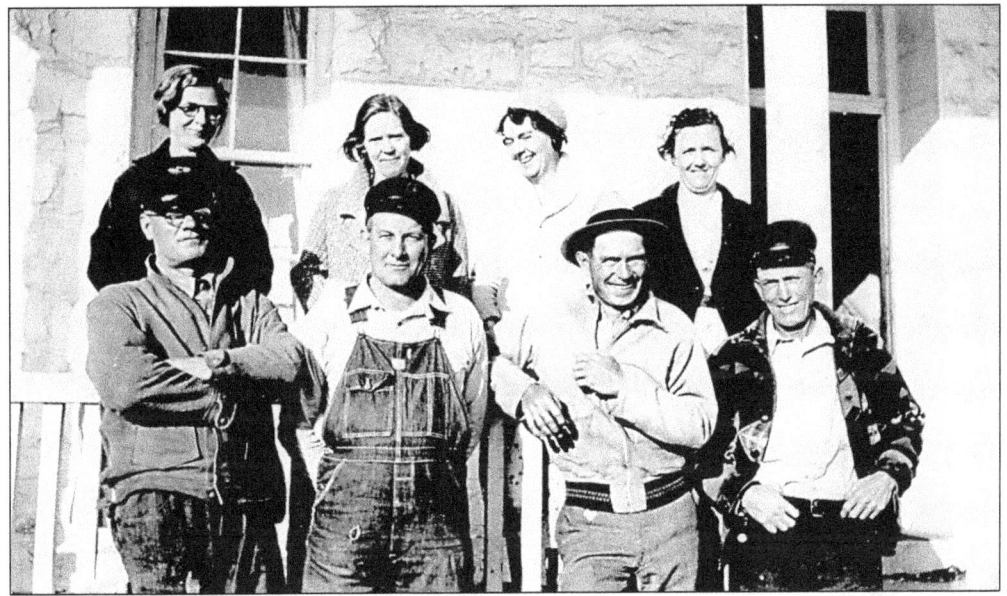

Keepers and their wives posed for this photograph in 1932. From left to right are the following: (front row) Thomas Henderson (head keeper), Harmon Day (2nd assistant keeper), Mr. Gross (3rd assistant keeper), and Harry Miller (1st assistant keeper); (back row) Verna Henderson, Margaret Day, Mrs. Gross, and Mrs. Miller. (Courtesy George Henderson family.)

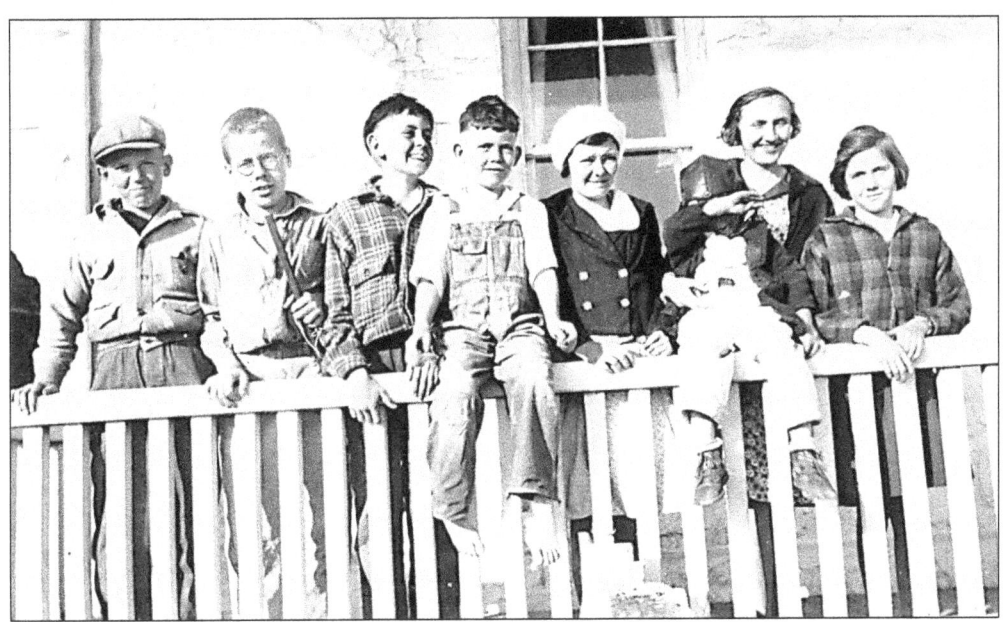

Then the kids lined up to have their photographs taken. From left to right, the kids are Burton Gross, George Henderson, Norman Day, Paul Day, Hannah Miller, Russell Miller, Leota Miller, and Marguerite Day. (Courtesy George Henderson family.)

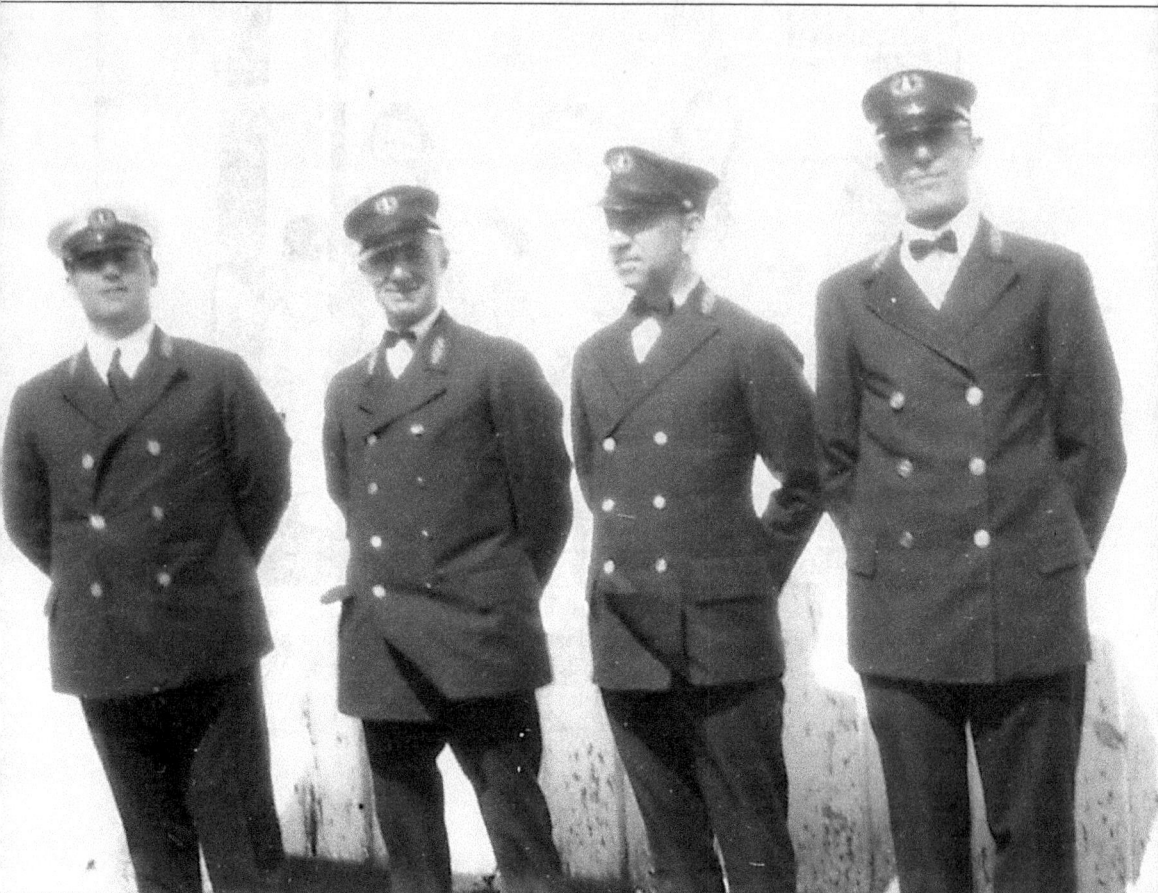

For 83 years, professional lighthouse keepers from the Lighthouse Service, and later the U.S. Coast Guard, kept the Point Sur Lighthouse operational, until advancing technologies allowed the light to operate without on-site keepers. This vital aid to navigation saved countless lives just by being there. In 1928, (from left to right) keepers Mollering, Fraser, McGonegal, and Miller stood for this portrait. Today, the Point Sur Lighthouse is still guiding the way with only the ghosts of keepers-past on hand to mind the light. (Courtesy California State Department of Parks and Recreation.)

Visit us at
arcadiapublishing.com

www.ingramcontent.com/pod-product-compliance
Lightning Source LLC
Chambersburg PA
CBHW081418160426
42813CB00087B/2207